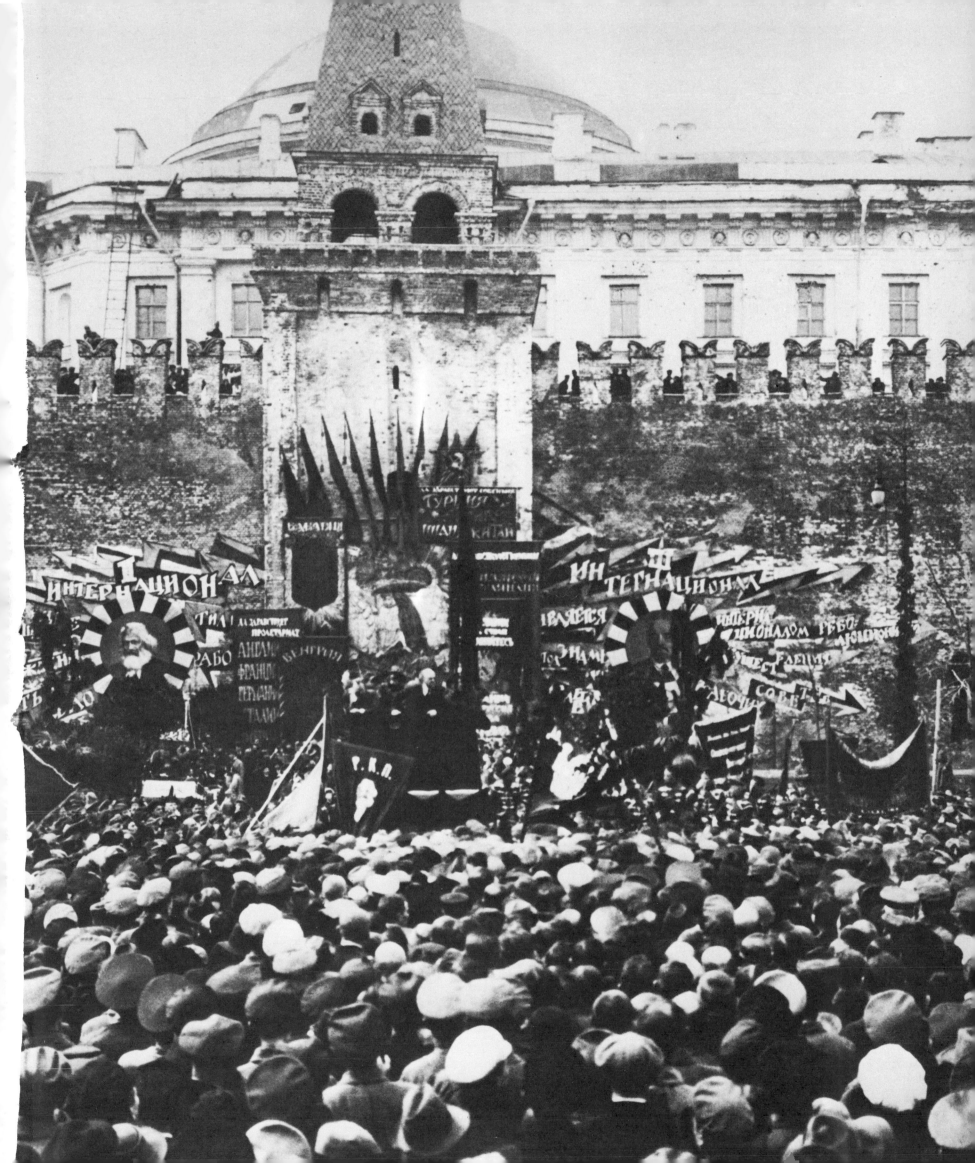

ART OF THE

Compiled and introduced by Mikhail Guerman

OCTOBER REVOLUTION

Harry N. Abrams, Inc., Publishers, New York

PUBLISHER'S NOTE

The remarkable and fascinating editorial material for this book was
prepared under the supervision of Aurora Art Publishers, Leningrad.
The text, written by a leading Soviet art historian, represents the latest
research and expresses current feeling in the USSR about a subject
which has recently aroused strong interest elsewhere in the world.
We are pleased to offer this authentic view of an important period in
twentieth century art for the English-language reader.

DOCUMENTARY PHOTOGRAPHS FOR THIS PUBLICATION WERE KINDLY SUPPLIED BY
THE CENTRAL ARCHIVES OF THE INSTITUTE OF MARXISM-LENINISM ATTACHED
TO THE CENTRAL COMMITTEE OF THE CPSU, THE CENTRAL ARCHIVES OF FILM
AND PHOTOGRAPHIC RECORDS, THE MUSEUM OF THE GREAT OCTOBER SOCIALIST
REVOLUTION, THE LENINGRAD THEATRE MUSEUM, AND THE SHCHUSEV MUSEUM OF
ARCHITECTURE AND ARCHITECTURAL RESEARCH.

Frontispiece:
Lenin making a speech in Red Square, 1 May 1919. Photograph

Layout of the plate section:

ALEXANDER KOKOVKIN

Translation from the Russian:

W. FREEMAN, D. SAUNDERS, and C. BINNS

Library of Congress Catalogue Card Number: 77-020741
International Standard Book Number: 0-8109-0675-9

Published in 1979 by Harry N. Abrams, Incorporated, New York

Printed and bound in Finland

"With all your body, all your heart and all your mind, listen to the Revolution," wrote Alexander Blok in 1918.

In order to "hear the Revolution" and not lose one's bearings as a centuries-old monarchy fell, talent alone was not enough. The artist had to possess a courageous and wise talent. To overcome not only hunger and cold, but also his own doubts, to see the important rather than the inessential, the artist had to be fearless. Only then could his art make other people see, could show them how to "listen to the Revolution," a revolution that had no equal in history.

The October Revolution of 1917 changed the destiny of Russia abruptly and decisively. The Bolshevik party, headed by Lenin, led the people to their long-awaited victory. The Soviets of Workers', Peasants', and Soldiers' Deputies gained power. The land was given to the peasants, and the factories became the property of the workers. Nothing like it had ever been seen.

The new Soviet Russia immediately had to defend the freedom it had won in battle. Counterrevolutionary insurrections, the advance of White armies, foreign intervention — all this meant long months, even years, of struggle. Fields were burned, and cities and factories were destroyed. Soviet power not only had to be defended, but also the country's economy had to be reestablished.

True artists had long expected the Revolution. Some had awaited it with fear, others — indeed, most artists — looked forward to it with hope. The Revolution, when it came, lent a new meaning to their work. There were, of course, no more rich customers, no more well-born patrons. It might seem that, in cities torn by battle, rocked with gunfire, and shaken by fateful and drastic changes, art was a matter of little or no concern. But that was not the case. Art continued to have an audience: people who sought answers in art, who used art as a means of understanding what was going on around them.

True artists had been brimming over with anger, anxiety, and expectation long before 1917. They were learning how to look reality straight in the face, to see the conflicts of the time and the tragedy in the world around them. The ruthless laconism of Sergei Ivanov's *The Massacre* (plate 2 of plate section following text) shows how clearly he understood the nature of tsarist Russia. It also testifies to his search for a lucid style capable of reflecting such a significant theme. Valentin Serov, in contrast, painted the chillingly grotesque *"Soldiers, soldiers, heroes every one . . ."* (plate 1) in which, with his characteristic merciless sarcasm, he depicted Cossacks breaking up a demonstration.

"Eternal battle. Of peace we only dream . . ." wrote Blok. The pleasant dreams of a fading tranquillity and idyllic images of the past still beckoned to many artists and writers before 1917. But the future was even more enticing. In 1912, Kuzma Petrov-Vodkin displayed his painting *Bathing the Red Horse* (plate 8). This work retains much of the old Russian style of painting, but it is by no means obsessed with the past. Here the artist turned to the roots of national art, as if to brush away the hustle and bustle of daily life and look more boldly into the future. As early as 1915, this picture was described as the "flame of a banner held high." It became a subtle and stern symbol of the events to come.

At the turn of the century, realist art branched out, as never before, into many different currents. Everything was questioned. The best Russian artists, even those who died before the Revolution — Valentin Serov, Mikhail Vrubel, Victor Borisov-Musatov, and many others — were seeking a new language, a new way of looking at reality. Russian art had long known how to feel the pulse of the times, how to engage in an ardent search for the

truth. The changes that were imminent generated particular tension, and the complex issues of the day reverberated in many pictures, statues, and drawings. The passionate search for truth and justice in these stormy years became the basis for subsequent developments in the postrevolutionary period. The art of Soviet Russia valued these traditions highly and built upon them.

Certainly, the profound and uncompromising search for the truth was sometimes overlooked among the noisy declarations that promised so much. The public was both shocked and fascinated by the wild declamations of the Futurists.

The unusual artistic methods were alluring; they seemed to be part of the new world of machines, a world marked by spiritual tension and presentiments of war. Russian art looked watchfully to the West. The searchings of the French Cubists and the Italian Futurists evoked serious interest. More frequently, however, the reaction to trends in the West was deeply national. Although the Jack of Diamonds group frankly revealed a debt to Cézanne, imitations of Cézanne could not hold their attention for long. They retained what was essential in Cézanne's work — a knowledge of how to express form by color and, above all, a passion for "bringing one's sensations to life." Among the Jack of Diamonds members, these sensations were entirely Russian. Vladimir Tatlin greatly admired Picasso but plunged into experiments that were even more startling than Picasso's. Kasimir Malevich, who only briefly yielded to the temptation to imitate the Cubists, began, even before the war, to experiment with nonrepresentational painting. As a result, he later became famous as one of the founders of abstract art. Even earlier, Vasily Kandinsky had displayed nonrepresentational works; his compositions differed from the strict geometry of Malevich's paintings in their skillful improvisation with luminescent blurred shapes, associated, according to Kandinsky, with music. The "rayonnism" of Mikhail Larionov also had affinities with nonobjective art. (Larionov's individuality, however, is more clearly revealed in his primitivist works, which cleverly and artistically modernized the traditions of peasant woodcuts.) This abundance of new (and pseudo-new) forms is even today surprising. It reveals prerevolutionary Russia as the birthplace of many avant-garde trends.

It is easy in this respect, however, to fall prey to commonplaces and deceptive appearances. The Cubo-Futurists, the nonrepresentationalists, the Rayonnists, the Jack of Diamonds group, the Constructivists, and the adherents of the other trends and groups that sprang up so rapidly were simply more noticeable than the others. At first glance, many appear to fit easily into the general flow of the European avant-garde. They tried to do away with tradition. They captured the imagination. They irritated the philistines. They bewildered the experts. They dazzled the young.

Their novelty seemed revolutionary, but it was often only in appearance; in rejecting the past, they rejected everything indiscriminately, including both arid academicism and genuine classics of art. Moreover, they claimed it was necessary to destroy "the old." After the Revolution, Blok wrote: "Even while destroying, we are still the slaves of our former world: the violation of tradition itself is part of that same tradition . . ." The avant-garde thus in fact threatened to become a kind of negative academicism, an antisystem, so to speak.

A common compassion for their oppressed, overtaxed, and poorly run country united artists of all generations and all styles. Both before and after the October Revolution, the works of the most talented artists revealed a trait peculiar only to Russia, a trait which ran through Russian culture from Pushkin to Mayakovsky. Namely: responsibility, belief in the noble mission of art and its ability to be the nation's conscience and guide.

In this kaleidoscope of stunning novelty, real talent was developing. An art was maturing by taking the best and rejecting the worst. This was the art that was destined to become the true basis of revolutionary art, the art of new Russia.

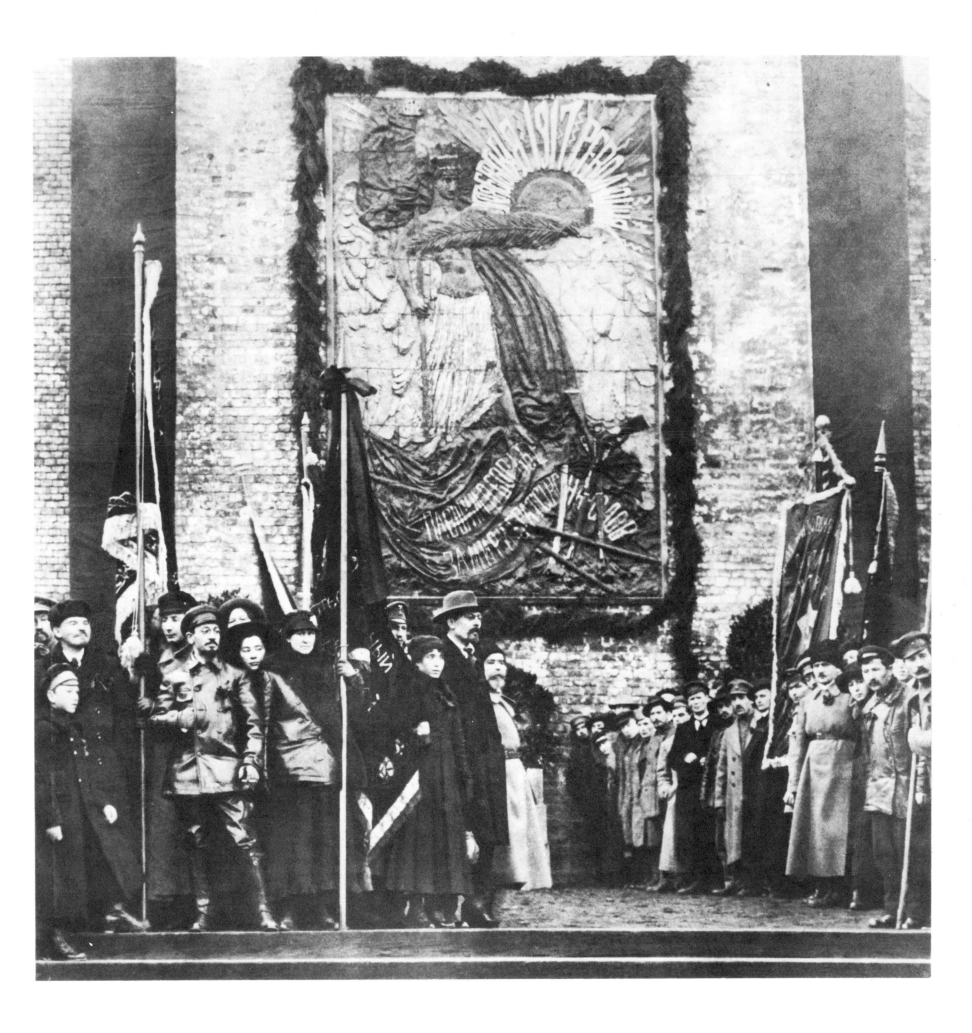

1 LENIN AND SVERDLOV AT THE UNVEILING
OF THE MEMORIAL *TO THOSE WHO FELL FIGHTING*
FOR THE CAUSE OF PEACE AND THE BROTHERHOOD OF NATIONS
IN RED SQUARE IN MOSCOW, 7 NOVEMBER 1918

ДЕКРЕТ

О ПАМЯТНИКАХ РЕСПУБЛИКИ.

Во ознаменование великаго переворота, преобразившаго Россию,
Совѣтъ Народныхъ Комиссаровъ постановляетъ:

1/ Памятники воздвигнутые въ честь царей и не представляющіе интереса ни съ исторической ни съ художественной стороны подлежатъ снятію съ площадей и улицъ и частью перенесенію въ склады часть использованія утилитарнаго характера.

2/ особой Комиссіи изъ Народныхъ Комиссаровъ по Просвѣщенію и Имущества Республики и Завѣдующаго Отдѣломъ Изобразительныхъ Искусствъ при Комиссаріатѣ Просвѣщенія поручается по соглашенію съ Художественной Коллегіей Москвы и Петрограда опредѣлить какіе памятники подлежатъ снятію.

3/ Той же Комиссіи поручается мобилизовать художественныя силы и организовать широкій конкурсъ по выработкѣ проектовъ памятниковъ долженствующихъ ознаменовать великіе дни Россійской соціалистической революціи.

4/ Совѣтъ Народныхъ Комиссаровъ выражаетъ желаніе, чтобы въ день 1-го мая были уже сняты нѣкоторыя наиболѣе уродливые истуканы и выставлены первыя модели новыхъ памятниковъ на судъ массы.

5/ Той же Комиссіи поручается спѣшно подготовить декорированіе города въ день 1-го мая и замѣну надписей Эмблемъ названій улицъ, гербовъ и т.п. новыми отражающими идеи чувства и революціонной Россіи.

6/ Областные Губернскіе Совѣтамъ приступаютъ къ этому не иначе какъ по соглашенію съ вышеуказанной Комиссіей.

7/

12 апрѣля 1918г.

Предсѣдатель Совѣта
Народныхъ Комиссаровъ

Народные Комиссары:

Управляющій Дѣлами Совѣта Народныхъ Комиссаровъ

Секретарь

2 MANUSCRIPT OF THE DECREE "ON THE REPUBLIC'S MONUMENTS,"
THE BASIS OF LENIN'S MONUMENTAL PROPAGANDA PLAN

In commemoration of the great turning point which has transformed Russia, the Council of People's Commissars decrees that:

1. Monuments erected in honor of the tsars and their servants that are of no historic or artistic interest be removed from squares and streets and either transferred to storehouses or used for utilitarian purposes.

2. A special commission consisting of the People's Commissars for Education and for State Property and the Head of the Fine Arts Department of the Ministry of Education be entrusted with the task of determining, with the agreement of the Artistic Boards of Moscow and Petrograd, what monuments are to be removed.

3. The same commission be charged with mobilizing artistic forces and organizing a large-scale competition for working out designs of monuments intended to commemorate the great days of the Russian socialist revolution.

4. The Council of People's Commissars expresses the wish that by the first of May some of the ugliest monstrosities be removed and the first models of new monuments be submitted to the verdict of the masses.

5. The same commission be charged urgently to prepare for the decoration of towns for the May First celebration and the replacement of emblems, street names, coats of arms, etc., by new ones that reflect the ideas and sentiments of revolutionary Russia.

6. Regional and provincial Soviets should start this work only with the agreement of the above-named commission.

7. The necessary sums of money be allocated after estimates have been submitted and practical needs assessed.

12 April 1918

Chairman of the Council
of People's Commissars *V. Ulyanov (Lenin)*

After the Revolution, a general enthusiasm and a desire to work for others, for all, for Russia, to some extent brought artists of disparate creative trends together. The names are surprisingly varied: Boris Kustodiev, Kuzma Petrov-Vodkin, Isaac Brodsky, Vladimir Lebedev, Mitrofan Grekov, Sergei Konionkov, Matvei Manizer, Vera Mukhina, as well as Marc Chagall, Tatlin, and Malevich. Yet it remained to be seen what the Revolution, the working people, would accept. Which artists would the Soviet Republic need? For artists, the situation of putting one's convictions, one's vision, to the test by a socialist revolution was unprecedented.

Of course, not every artist found fulfillment in the Revolution. Some were carried away by seeing "the world in its critical moments" (F. Tiutchev); however, for them, the fate of their country served only as the backdrop for their artistic experiments. Others could not bear the burdens of everyday life. Still others preferred to go abroad, simply because life was easier there; in the West, art did not have to keep pace with the rapid pulse of the Revolution. Some of those who lived in the West did not return; a number of them even turned hostile toward their country.

In the words of Mayakovsky, the "colors of humdrum life were painted over once and for all." The October Revolution brought with it joy and hope inseparably mixed with anxiety, deprivation, and a feverish tempo of life. Ever since the French Revolution, the art of the people had taken to the streets once victory was achieved. Louis David had designed huge propaganda processions for revolutionary holidays. After the October Revolution, people in Russia also began to contemplate mass street performances and celebrations.

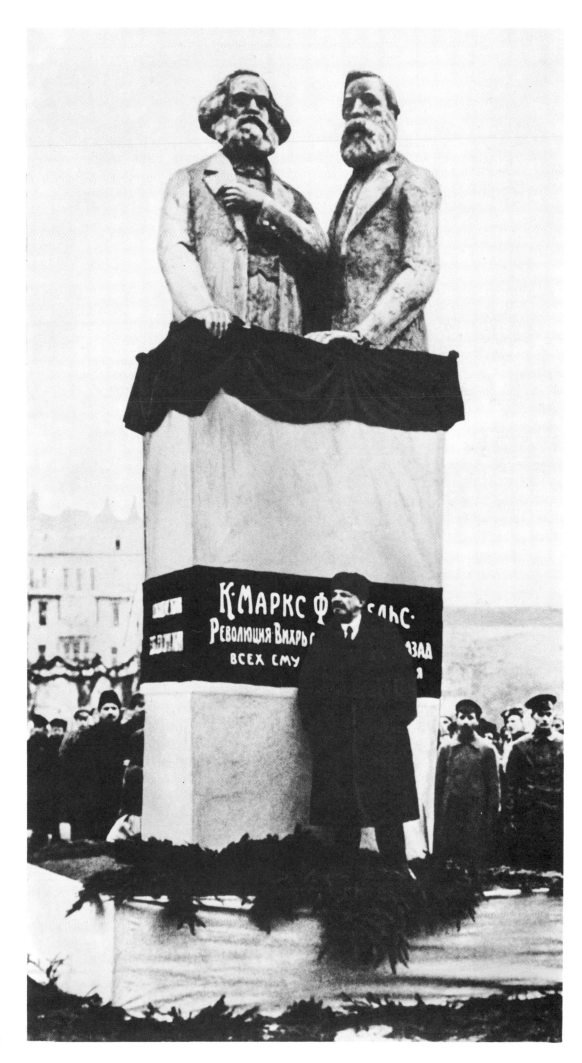

3 LENIN MAKING A SPEECH AT THE UNVEILING OF THE MEMORIAL
 TO KARL MARX AND FRIEDRICH ENGELS IN MOSCOW, 7 NOVEMBER 1918

Открытие памятника А. И. Герцену.

В воскресенье, 23-го февраля, на Арсенальной набер., у Литейного моста состоялось торжественное открытие памятника великому писателю — революционеру А. И. Герцену.

Памятник, по поручению Отдела Изобразительных Искусств, исполнен скульптором Л. В. Шервудом.

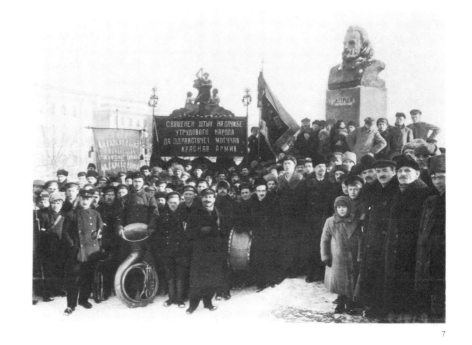

7

Открытие памятника Гарибальди.

Торжественное открытие памятника великому итальянскому революционеру Гарибальди, состоявшееся 9-го марта у Московских ворот на Международном пр., приняло характер грандиозной демонтрации, в которой участвовали, кроме петроградских рабочих, и члены III Интернациала, приехавшие в Петроград накануне торжества.

На торжестве присутствовали представители Отдела Изобразительных Искусств П. К. Ваулин, Н. Н. Пунин и Н. И. Альтман.

5

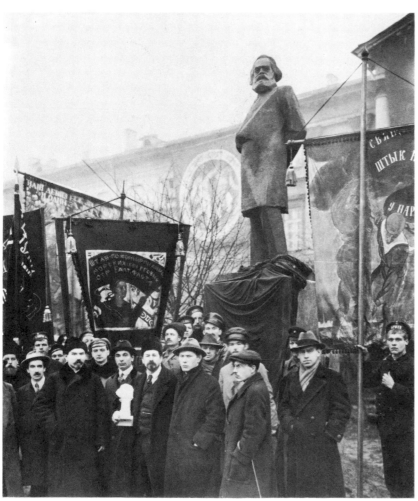

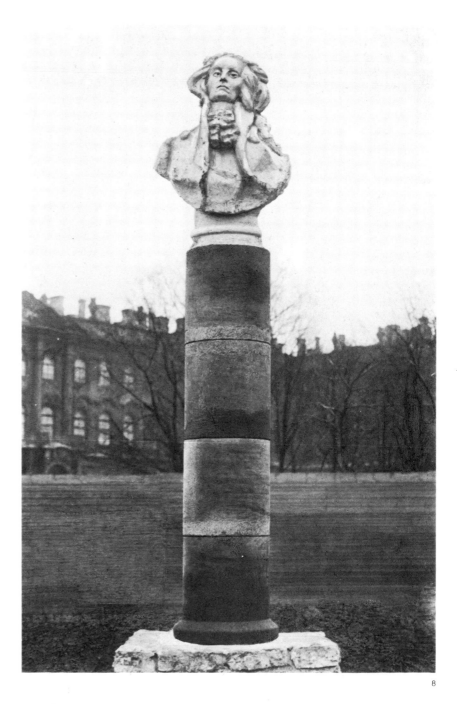

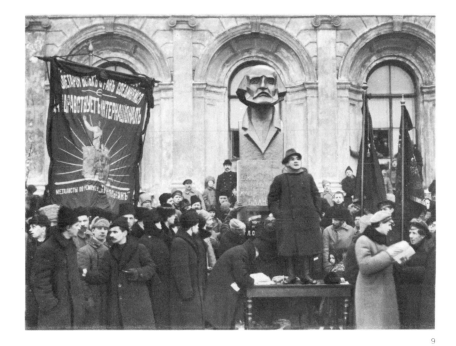

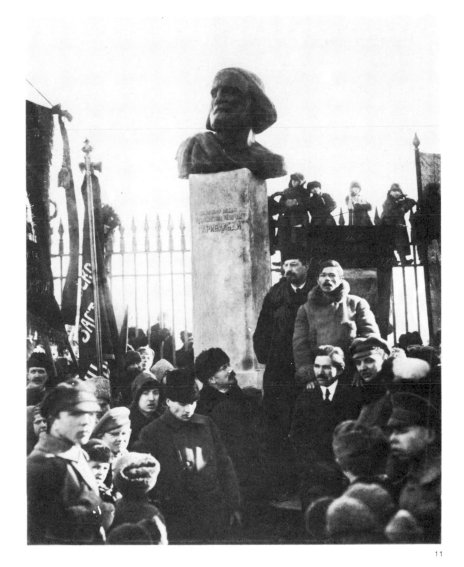

9

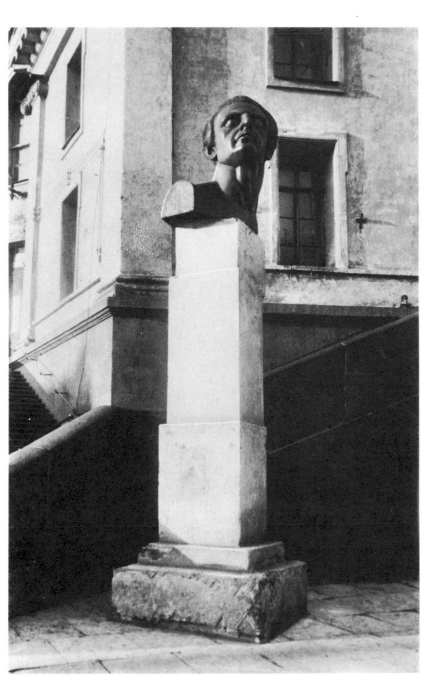

11

4 FROM THE NEWSPAPER *ART OF THE COMMUNE*, 2 MARCH 1919

5 FROM THE NEWSPAPER *ART OF THE COMMUNE*, 16 MARCH 1919

6 UNVEILING OF THE MEMORIAL TO KARL MARX IN FRONT OF SMOLNY.
 PETROGRAD. 1918.
 SCULPTOR A. MATVEYEV

7 UNVEILING OF THE MEMORIAL TO ALEXANDER HERZEN. PETROGRAD. 1919.
 SCULPTOR L. SHERWOOD

8 MEMORIAL TO ALEXANDER RADISHCHEV. PETROGRAD. 1918.
 SCULPTOR L. SHERWOOD

9 UNVEILING OF THE MEMORIAL TO LOUIS BLANQUI. PETROGRAD. 1919.
 SCULPTOR T. ZALKALNS

10 MEMORIAL TO FERDINAND LASSALLE. PETROGRAD. 1919.
 SCULPTOR V. SINAISKY

11 UNVEILING OF THE MEMORIAL TO GIUSEPPE GARIBALDI. PETROGRAD. 1919.
 SCULPTOR K. ZALE

10

Lenin, furthermore, proposed something entirely new: *monumental propaganda.* Although these two words together form a paradox, they are intimately linked to the concept of revolution: *propaganda,* by its very nature, is dynamic and contemporary; *monumentality,* on the other hand, tends toward the timeless. What Lenin had in mind was to connect the past, present, and future. Memorials to the most eminent figures in history, and especially to freedom-fighters, were to stand on city streets and squares. In the spring of 1918, Lenin talked with Anatoly Lunacharsky, the People's Commissar for Education, about "erecting monuments to the great revolutionaries"; Lenin also approved a list of those to whom it was proposed "to raise monuments in Moscow and the other cities of the RSFSR [Russian Soviet Federated Socialist Republic]." Along with the names of Marx and Engels and the great Russian revolutionaries of the eighteenth and nineteenth centuries Radishchev, Pestel, Herzen, Chernyshevsky, Khalturin, and Sophia Perovskaya were the names of Danton, Marat, Saint-Simon, Fourier, Garibaldi, Blanqui, and Jaurès. Writers, scholars, and composers were also included. Altogether it was planned to set up sixty-seven pieces of sculpture.

Lenin paid special attention to the way in which his program of monumental propaganda was carried out. He constantly reminded people of its importance and insisted that the artists involved be given all possible help. Lunacharsky also did a great deal to promote the plan. There were many shortages to be dealt with – of workshops, firewood, lighting, clay. Nor was there much time. Work went on hurriedly, to the point of exhaustion; at the same time, the artists, weak and underfed because of bread shortages, could not work at full strength. There was no bronze, no marble, no granite. The artists had to make do with concrete and plaster-of-Paris castings. Although they held the conviction that the statues of this "new world" had to be different from the sculptures of the past, the artists had no clear conception of what they ought to look like. Almost none of the resulting work has survived to the present day. The materials used were not durable, and sometimes the artists' conceptions themselves were not lasting. Some statues expressed their creators' ardent emotions instead of carrying out the task at hand – the enshrining of the memory of great men and women.

The first statue to be unveiled was Leonid Sherwood's monument to Alexander Radishchev (plate 286) in Petrograd (a replica was erected in Moscow). By October 1918, the first anniversary of the Revolution, several more had been finished. Sergei Konionkov's memorial polychromatic relief on the Kremlin wall, *To Those Who Fell Fighting for the Cause of Peace and the Brotherhood of Nations* (plate 282), combined a sad grandeur with echoes of Art Nouveau. The contemporary press highly acclaimed the work, commenting that its "colors, the rising sun, and the movement of the figure" gave excellent expression to the artist's conception. A quite different approach characterizes Boris Koroliov's monument to the nineteenth-century revolutionary Mikhail Bakunin (plate 278), in which Bakunin's face and body are barely distinguishable in the frantic conglomeration of angular forms and shapes. The artist had evidently tried to apply the principles of Cubism in order to express new ideas. The sculpture was by no means a success, even though Koroliov's sincerity and talent are unquestionable. If this particular work had survived to the present day, it would be regarded not just as a monument to Mikhail Bakunin, but rather as a monument to the audacious searchings of the Revolution's first sculptors.

Many artists nonetheless still clung to a more classic laconism: Victor Sinaisky's sculpture of Lassalle (plate 291) is both a fine portrait and a plastic symbol. The abrupt juxtaposition of the facets and the extreme generalization reveal a leaning toward the art of antiquity, a desire to invest the sculpture with a seething intellect and a spiritual dynamism. There were also large sculptural groups: for example, Konionkov's *Stepan Razin and His Men* (plate 283), which was erected in Red Square, near the Moscow

Kremlin. Where once tsarist ukases (edicts) were proclaimed now stood an unusual, chaotic, formidable, and brave crowd of rough wooden figures. However, there was no genuine monumentality in these figures, and the group was out of place alongside the old Russian architecture of the Kremlin.

The people's judgments during these years were sharp and uncompromising. Those works whose complexity of form or deliberate primitivism gave rise to protests were taken away, as were formalist works. Art began to depend on popular opinion. For the first time, the common people entered into a dialogue, even into argument, with art. This, too, was propaganda, and it was at times no less effective than the brittle concrete statues themselves. The inexorable force of public opinion had in fact a great deal to do with the feverish inspiration on the part of the sculptors. They felt they had to work quickly and that they had to create works that were new, unprecedented, great; but the muse of sculpture, according to Diderot, is "silent and elusive." Despite everything, though, many of these hastily done sculptures have a place in history. They have a certain naive and proud splendor. They are at once straightforward and metaphorical.

And so, its failures and impermanence notwithstanding, monumental sculpture achieved its purpose. The monuments were unveiled solemnly, before large crowds of people. As Lenin said, "Let every such unveiling be an act of propaganda and a modest holiday; thereafter, on the anniversaries, one can further remind the people of a great historical figure, each time, of course, linking him closely with our Revolution and its tasks." Lenin himself, as well as other members of the government, often appeared at such ceremonies. The people understood that these were their celebrations, that the artists were working for *them* in attempting to perpetuate the memory of those whom the Soviet Republic held dear.

There were also undisputed successes among the monuments of this period. The obelisk *The Soviet Constitution* by Nikolai Andreyev and D. Osipov (plate 280), with Andreyev's *Statue of Freedom* (plate 281), deserved a longer life. Its grandeur, restrained by the terseness of the ascetic form, and the obelisk's frank traditionality, which underscores the buoyant tension of the figure of *Freedom*, combined to create a classic work of art looking toward the future, thus linking the past and the future.

Other artists looked toward the future, and only toward the future, as if wishing to forget the past and lose themselves among the towering heights of bold and utopian concepts. One of the most striking creations of postrevolutionary art in Soviet Russia was Tatlin's *Tower-Monument to the 3rd International* (plate 295). Tatlin made only a model of wood and wire, but the monument itself was conceived as a gigantic building, set at an angle from the perpendicular, a tower of glass and metal that would dwarf the highest skyscrapers. Inside a sparkling spiral shape, a cube and, above it, a pyramid and a cylinder, were to rotate, each with varying speeds. The unprecedented, slanting, shining colossus would slowly change its silhouette, as if living its own solemn and momentous life, like the grandiose creation of a science-fiction writer. But there was no science fiction then. Tatlin's work was a three-dimensional prototype. Ilya Ehrenburg, who had seen the model in the Trade-Union Hall, recalled: "It seemed to me as if I had looked through a chink and seen the twenty-first century." Today, we realize that Tatlin's bold experiment has a great deal in common with modern architectural ideas, as well as with mobiles.

The various buildings and structures of the future were very much on the minds of artists and others at that time, but it was still not possible to "build for posterity." One of the few structures that have survived until now has indeed turned out to be worthy of its great aims and its long life. This is the memorial *To Those Who Fell Fighting for the Revolution* (plate 290), designed by the architect Lev Rudnev and erected on the Field of Mars in Petrograd. The quiet, solemn rhythm of the low granite walls echoes

Торжественное открытие памятника Софье Перовской.

Отдел Изобразительных Искусств возобновил после краткого перерыва, вызванного отъездом народного комиссара по просвещению А. В. Луначарского в Москву, открытие временных агитационных памятников политическим и общественным деятелям, писателям и художникам.

Первым после перерыва был открыт агитационный памятник великому вождю партии „Народной Воли" Софье Перовской.

Памятник, исполненный скульптуром О. Гризелли, поставлен на площади Восстания (б. Знаменская площадь), недалеко от входа в Николаевский вокзал.

Торжественное открытие памятника, состоявшееся в воскресенье, 29-го декабря, в 12 час. дня, собрало многочисленную публику. Среди присутствовавших были А. В. Луначарский, З. И. Лилина, шлиссельбуржец Н. А. Морозов, заведующий Отделом Изобразительных Искусств Д. П. Штернберг, Н. Н. Пунин и др.

На торжество прибыли со своими знаменами две депутации от железнодорожников Николаевской жел. дороги.

12 FROM THE NEWSPAPER *ART OF THE COMMUNE*, 6 JANUARY 1919

13 UNVEILING OF THE MEMORIAL TO HEINRICH HEINE. PETROGRAD. 1918.
SCULPTOR V. SINAISKY

14 MEMORIAL *THE RED METALWORKER* IN FRONT OF THE PALACE OF LABOR.
PETROGRAD. 1918.
SCULPTOR M. BLOCH

12

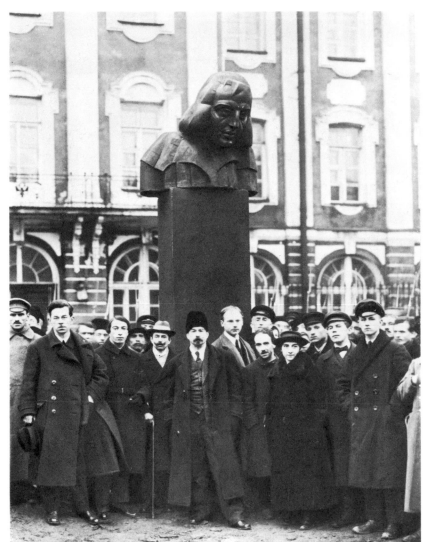

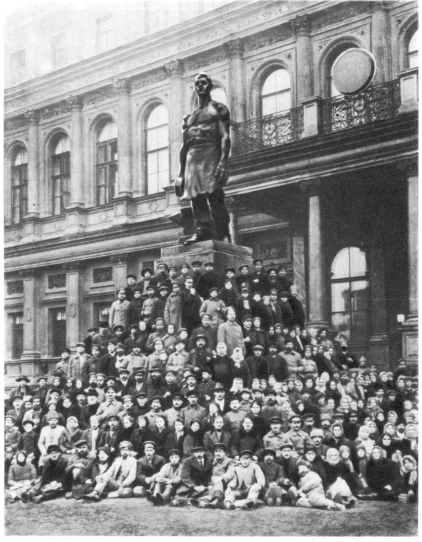

13

14

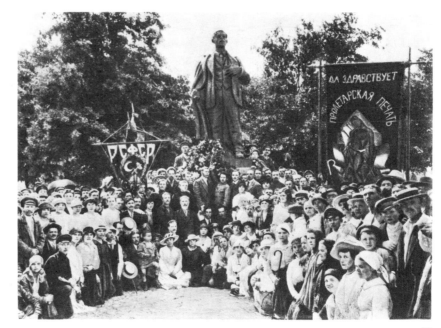

15 EXHIBITION OF DESIGNS FOR A MEMORIAL TO KARL LIEBKNECHT
AND ROSA LUXEMBURG. PETROGRAD. 1920

16 UNVEILING OF THE MEMORIAL TO SOPHIA PEROVSKAYA.
PETROGRAD. 1918.
SCULPTOR O. GRIZELLI

17 UNVEILING OF THE MEMORIAL TO V. VOLODARSKY. PETROGRAD. 1919.
SCULPTOR M. BLOCH

18 UNVEILING OF THE MEMORIAL TO THE UKRAINIAN POET TARAS SHEVCHENKO.
PETROGRAD. 1918.
SCULPTOR J. TILBERG

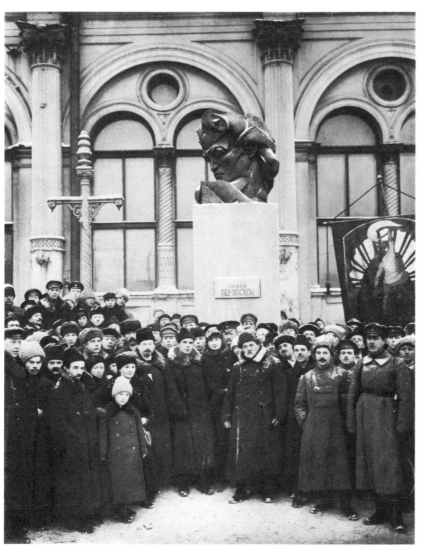

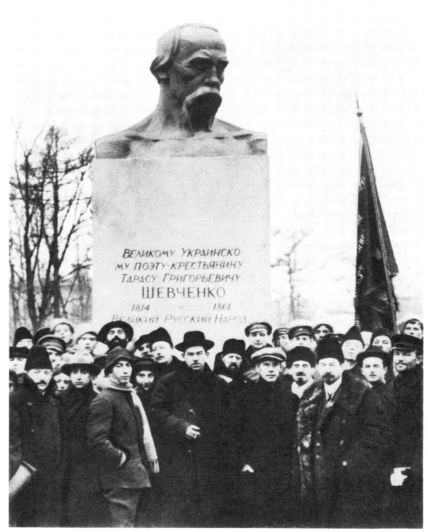

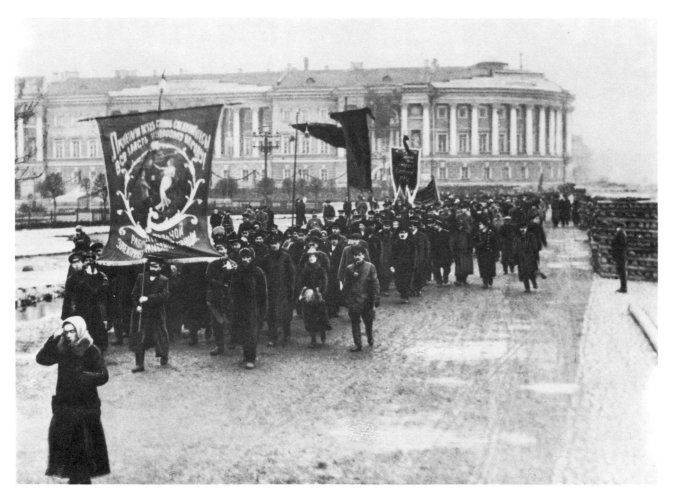

19 WORKERS' DEMONSTRATION IN SENATE SQUARE. PETROGRAD. 1918

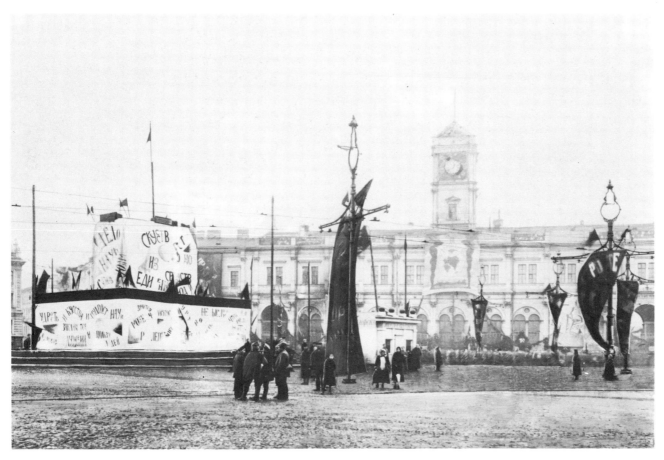

20 THE SQUARE IN FRONT OF MOSCOW RAILWAY STATION DECKED OUT FOR A FESTIVAL. PETROGRAD. 1918

Lunacharsky's words inscribed on the stone: "He who fell for a great cause is immortal. He who laid down his life for the people, he who fought and died for the common good, will live forever among the people." Lunacharsky's words on the granite blocks of the walls were in complete accord with Lenin's idea of "revolutionary inscriptions" with which the city was to be adorned and which were to appeal to the hearts of the people.

The young Soviet Republic still lacked the means to realize all its conceptions in durable materials. Projects designed for the distant future in the end remained only projects. The artists of the period, sparing neither time nor effort, busied themselves with their customary everyday activity, often not only with art but with organizational matters as well. The artistic boards of Moscow and Petrograd included the architects Zholtovsky, Shchuko, and Rudnev; the painters Mashkov, Kuznetsov, Chekhonin, Tatlin, and Falk; the sculptors Matveyev and Konionkov; and many other well-known and as yet unknown names. Art led a feverish existence. In April 1919, artists of many different schools and trends — from the Wanderers (members of the Society for Circulating Art Exhibitions) to the World of Art group — staged an enormous exhibition in the Winter Palace. More than three thousand works were displayed. As early as the autumn of 1917, an Appeal of the Soviet of Workers' and Soldiers' Deputies stated: "Citizens, our former masters have gone away, leaving a huge legacy behind them. It now belongs to all the people. Citizens, take good care of this legacy, all these pictures, statues, and buildings. They embody your and your forefathers' spiritual strength."

The state nationalized and took under its protection picture galleries, art collections, and architectural monuments. Lenin himself signed the decrees that nationalized the Tretyakov Gallery, the collections of Sergei Shchukin, Ivan Morozov, and others; even in its most difficult moments, the Soviet government did not forget art. Large numbers of workers and soldiers visited the former estates of the tsar and the nobility. As Lenin stated, "Proletarian culture must consist of the logical development of the knowledge that mankind gained under the yoke of capitalist society, under the yoke of the landlords and bureaucrats."

In addition to the gigantic exhibition in the Winter Palace, individual and group exhibitions were held. The state somehow found the means to purchase the artists' works and provide the artists with studios. The artists worked with a rare enthusiasm. Even posters and holiday decorations, which by their very nature are destined to a short life, were attended to with more than just passion. They were produced with great care and scrupulous professionalism. Every artist, each in his own way, felt himself to be involved with history as it was being made.

A very strange thing had happened: a country that Europe had considered backward had in fact turned out to be advanced; its ideas and art drew the attention of the entire world. But life in the Soviet Republic was not easy. For its artists to write, to sculpt, to draw, month after month, in a constant state of undernourishment — this required the courage of talent too. In his still life *Herring* (1918; plate 170), Petrov-Vodkin has transformed ordinary objects of everyday life (food rations of the period) into a valuable and meaningful artistic image. The picture is thus in many ways a symbol of the times, for it conveys the message that life's scarcities can be overcome by one's richness of vision, that any small bit of reality reflects the boundless radiant world of which it is a part.

Herring rations and the like were attractive to artists not because they provided a means of depicting the misery of those hungry years but because they were ordinary objects lying on a table. By making use of such objects, the artists could express their own perceptions and reconstruct space, as did Cézanne in his still lifes with the apples of Provence. David Sterenberg employed almost the same motif as Petrov-Vodkin, but his *Lamp and Herring* is quite different in its rigorous harmony of ascetically simple forms and in the flattened, compressed, seemingly imaginary space.

Many still lifes were done in this period. The artist, his thoughts disturbed by the onrushing and elusive flow of events and opinions, often sought relief in the simple things of life. He peered into the mirror of ordinary impressions in order to apprehend the movement of his own vision more exactly. But the times made violent incursions even into the narrow world of the still life. They laid bare and illuminated something more than the artist's subject matter — namely, his attitude to the world around him. The artist's work became an echo of his reflections, of the transvaluation of values, where the usual appears new and unusual and is transformed into the aeolian harp of the artist's thoughts.

The still life was an intimate creative laboratory where the artist shaped his ability to link the great and small and to perceive simple objects as parts of a broader, more agitated world. Art, which had rushed into the streets after October, now faced a stern test in the studios and workshops. What might seem to be fervent improvisation was often based on a dedicated professionalism and a ruthless fastidiousness. Of course, not all artists painted still lifes, but still lifes, at times, could be quite stunning in their manner of execution, technique, and subject matter.

The art of this period is strikingly lavish, even to the point of excess, and it reveals a constant striving for a mass audience. The artists who, in their unheated studios, sought the inner secrets of plastic harmony, never wavered; they set out to do something that had never been done before in Russia — to make decorations for revolutionary holidays and mass street spectacles. All this is closely linked to the brilliantly diverse theatre of the period: the gloomy sumptuousness of Golovin's *Masquerade,* the sophisticated yet simple staging of *Princess Turandot* in Vakhtangov's theatre, and Stravinsky's *Petrouchka,* which is one of Alexander Benois's most interesting pieces of theatrical scenery (plate 320).

The theatre sought, in addition to new plays, new principles of direction and stage design. In this respect, alongside such famous theatre names as Tairov and Meyerhold, the name of Mayakovsky is especially prominent. His *Mystery-Bouffe* is not only a new play in every way; it is new theatre. Its first performance, on November 7, 1918, combined the fantastical, the grotesque, the sarcastic, and the unfailingly optimistic. The direction of Meyerhold and Mayakovsky himself (who, incidentally, played several roles) and the odd rhythmics of Malevich's stage design, which, in his conception, was to harmonize with the lighting and the actors' movements, gave rise both to delight and to debate among the public. As it turned out, the play was both contemporary and long lasting. Later, while working on a new version of the play, Mayakovsky himself did the design sketches (in a poster style; plates 304–7). *Mystery-Bouffe* has changed with and adapted itself to the changing times. It is no accident that it was presented in German in a circus arena — once again in a new setting — for the delegates to the 3rd Congress of the Comintern in 1921. The new Soviet theatre thus made its first successful steps on the international stage.

Serious artistic quests were sometimes reflected in the interiors of cafés designed and decorated by well-known artists. A contemporary recalls that the interior of one café was "strikingly dynamic. There were different kinds of figures made of cardboard, plywood, and cloth, figures such as lyres, wedges, circles, funnels, and spiral-like designs. In some cases lamps were placed inside the figures. Everything was bathed in light, everything whirled, vibrated, and it seemed as if the entire decor were in motion." Is this one of the first instances of kinetic art? Of course, it was a flagrant, albeit talented, attempt to shock and surprise rather than a real artistic discovery.

What was completely new was the staging of revolutionary holidays. To decorate Rossi's or Zakharov's architectural ensembles, which are masterpieces in themselves, and to create a holiday spectacle that both harmonized with the old city and transformed it — these were tasks that had no parallels.

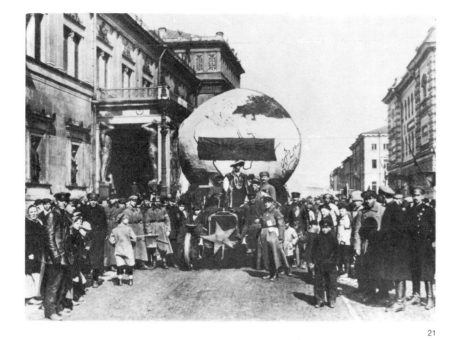

21 COLUMN OF DEMONSTRATORS IN A FESTIVAL. PETROGRAD. 1920

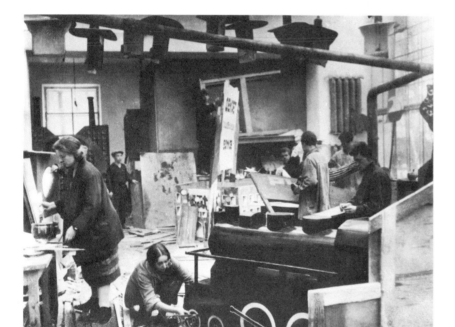

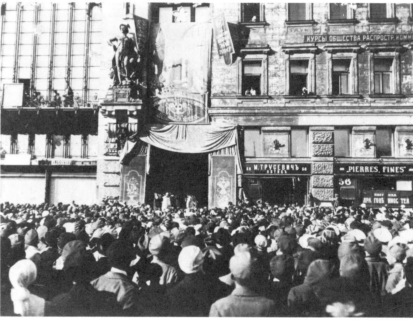

22 PREPARING A COLUMN OF DEMONSTRATORS FOR A FESTIVAL

23 CIRCUS ARTISTS IN A COLUMN OF FESTIVAL DEMONSTRATORS. MOSCOW. 1919

24 MASS PERFORMANCE IN FRONT OF THE ENTRANCE TO THE THEATRE OF MUSICAL COMEDY.
 PETROGRAD. 1921

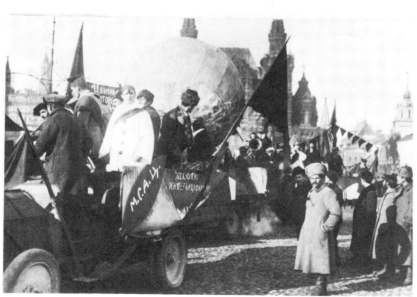

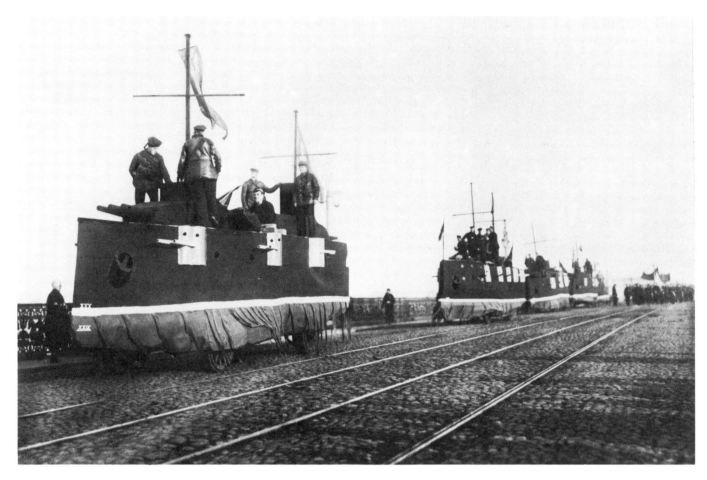

25 COLUMN OF RED FLEET MEN IN A FESTIVAL. PETROGRAD. 1919

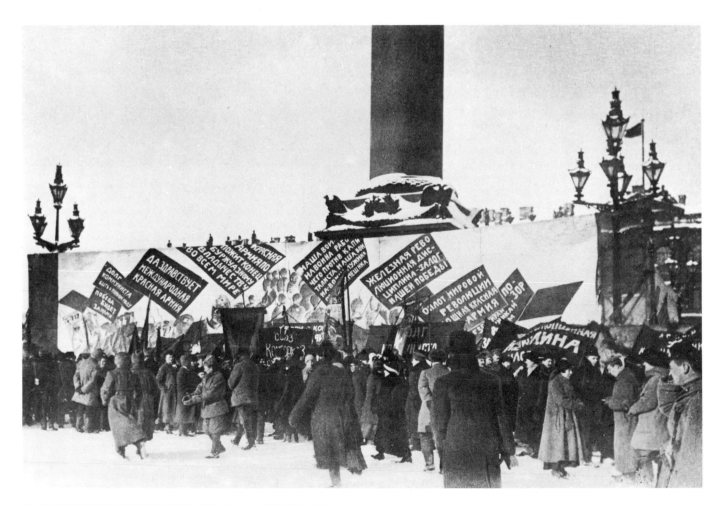

26 CELEBRATING THE RED ARMY'S FIRST ANNIVERSARY. PETROGRAD. 1919

The celebration of the Revolution's first anniversary was particularly impressive, especially in Petrograd. The festive city became an open-air display of visual debates among artists of various schools and disparate talents. Nathan Altman's powerful chords of bright angular surfaces burst apart the clear-cut austerity of Palace Square (plate 263), thereby replacing the customary unity of the architecture with the emotional unity of violent colors. The Alexander Column was piled high with jagged, flame-colored panels. Mstislav Dobuzhinsky, on the other hand, made the Admiralty "even more of an Admiralty": he accentuated its design and made it yet more reminiscent of the old Petersburg by covering the revenue houses between the Admiralty's two wings with a forest of masts and ship's banners (plates 151, 153). Both approaches were symbolic; the city had its lost past restored and its future opened up to it. Kustodiev decorated one city square with festive and witty panels (plates 187–93). The workers, artisans, and peasants depicted on them recalled the jolly characters seen on shop signs or in popular prints.

The bridges, transformed into long triumphal arches, were especially impressive on holidays. Bright flags and painted placards flapped in the autumn wind, and the rich and painstakingly decorated garlands, obelisks, and standards turned the bridges over the Neva and its many branches into enchanting sights. Not a single bridge was like another.

Petrov-Vodkin, Sterenberg, Sergei Chekhonin, Lebedev, Shchuko, and many others worked on the decoration of Petrograd. Likewise, Alexander Vesnin, Victor Vesnin, Alexander Kuprin, and Sergei Gerasimov helped decorate Moscow. Aristarkh Lentulov and Pavel Kuznetsov staged the holiday performances there. The decoration of Moscow did not contain such marked contrasts as that of Petrograd; it had fewer artists concerned with the avant-garde or with the deliberate use of traditional elements.

For all their excellence, the surviving designs and drafts are not numerous enough to give a full picture of the reality of life more than fifty years ago. This is so not only because they are merely designs and not the actual decorations. One also has to take into account the fact that in 1918, Moscow (which was now the new capital) and Petrograd were the two largest cities in a country three-quarters occupied by counterrevolutionary and foreign troops. Hunger was chronic. There was not enough fuel. In the evenings, only a few street lamps burned. Cold rooms were lit by dim and flickering wick and kerosene lamps. Residents stood guard at the entrances to their homes to protect themselves from bands of looters roaming the cities. Shooting often broke out. Queues formed before dawn at the shops. But despite all the hardships of everyday life, the strong pulse of the Soviet Republic could still be felt. The working people were of one mind, confident that everything the Revolution's enemies had destroyed could be restored, that all Russia would gain its freedom. Factory workers, conscious of their mission, put in long hours; the enemy was near, the fledgling Red Army had no equipment, and the country's industry had to be rebuilt. The All-Union Central Executive Committee declared the country an armed camp, and the people gave all they had to the cause of victory. Life was hard, by no means a holiday. "The city was empty," wrote Victor Shklovsky about Petrograd during the Civil War, "the streets had grown so wide that it seemed as if a river of cobblestones were lapping at the banks of the houses." But then he added: "The city lived, it burned with the red flame of Revolution." These last words are of course a metaphor. But revolutionary holidays brought the metaphor to life. The wonderful panels by the country's best artists, the strings of lights, the festive columns, the blue beams of searchlights — it all seemed as if the future had suddenly arrived, as if all that lived, despite everything, in the souls of the people had suddenly materialized.

Similar celebrations were held even in small towns and villages. Obviously time has not spared many of the decorative panels and holiday placards; few have survived. One can only regret how short-lived these wonderful spectacles were and how many names will remain forever unknown.

"Neither science nor literature could then serve as the stepping-stones to a career," wrote Shklovsky of this glorious period. "We were born into bourgeois times but were set free by the unselfishness of the Revolution, which raised us high and made us think again."

Indeed, many of the events of the period were unprecedented, and a number of them came within the sphere of art. "Agit-prop (agitation-propaganda) trains" and "agit-prop ships" left for the distant corners of the country and for the front lines of the Civil War. Sometimes they showed up in places where people had never seen art or where heavy battles had recently been fought. The train walls and ship decks displayed pictures and "monumental posters." These trains and ships were designed to serve many functions: to stage a holiday, to provide information, and to give the first lessons in how to appreciate art. People who walked alongside the trains reacted with delight; they laughed and talked animatedly. Naturally, both narrative and allegorical forms of expression were employed. But no matter how detailed or lifelike the pictures – as, for example, on the walls of the "Red Cossack" train – the general effect was never lost. Such agit-prop trains and ships were used as festive overtures to meetings with government officials and lecturers. The trains were called "All-Union Central Executive Committees on wheels."

How can one measure the terrible burden on the poster artists, who often had to paint a poster, one that would touch the heart, in a single day or even overnight? The most celebrated posters were the innumerable ROSTA windows (cycles of posters issued by the Russian Telegraph Agency). Mikhail Cheremnykh proposed that posters be hung in empty shop windows to provide a kind of illustrated quick news service. The very first poster received an enthusiastic response from onlookers. Mayakovsky alone did several hundred of these posters, not only drawing them, but also composing verses to accompany the drawings. "The ROSTA windows," he said, "are telegraphic news transformed in a flash into a poster; they are decrees in the form of folk verses." There were few newspapers then, and many people could barely sound out the syllables of the words as they tried to read. But the simple and witty colored drawings, which were changed almost every day, caught the people's eyes. The ROSTA windows were at once a visual treat and an avidly absorbed news source. Little by little, they instructed the people; they even taught good taste – most of the ROSTA windows were done by artists of uncommon talent. In Moscow, Victor Deni and Cheremnykh worked along with Mayakovsky. In Petrograd, Lebedev and Vladimir Kozlinsky did many ROSTA windows. These political posters combined the traditional Russian popular print and the vivid expressiveness of the latest artistic discoveries. Their succinctness and utter simplicity appealed to the public's tastes and at the same time met a vital need. They included other elements as well: a narrative, the exactness of a moral message, the directness of a slogan, and complete comprehensibility.

Of course, not all the ROSTA windows and posters were masterpieces. But some were not only of artistic merit, they have also become part of the history of art. For example, consider Lebedev's poster *The Red Army and Fleet in Defense of the Frontiers of Russia* (plate 15), a bold combination of angular blocks of color. The syncopated rhythm of the black lines and surfaces breaks up space. The style is characterized by a blend, rare in art, of dramatic tension and the grotesque. The figures of the soldier and sailor are rigid hieroglyphs of unbending determination. In their silhouettes, the essential swinging movement in the military uniforms of the period has been captured. It is uncommon to see an image of the artist's own time so depicted.

An irreproachable example of graphic art, Dmitry Moor's *Help!* (plate 46), with its tragic grotesque, is notable not only for the novelty of its style. Neither the connoisseur nor the casual observer could walk by without stopping. As one looks at the frail and shrunken old man, whom a deadly dry wind seems to carry away into the dark depths, it is difficult

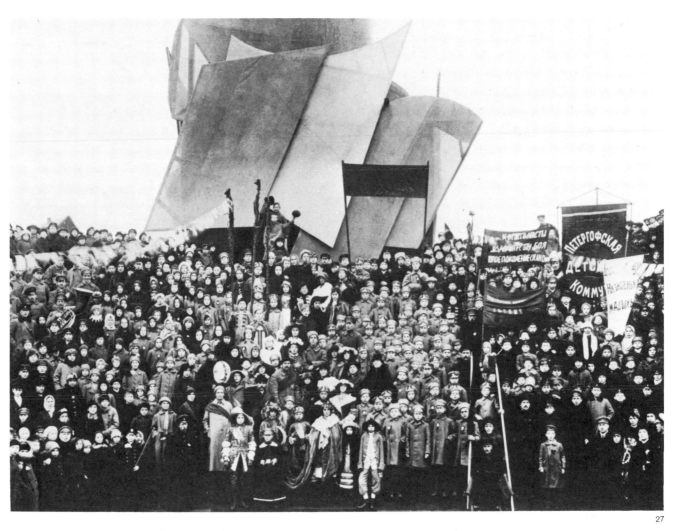

27, 28 PUPILS OF CHILDREN'S COMMUNES TAKING PART IN A MASS SPECTACLE IN PALACE SQUARE. PETROGRAD. 1918

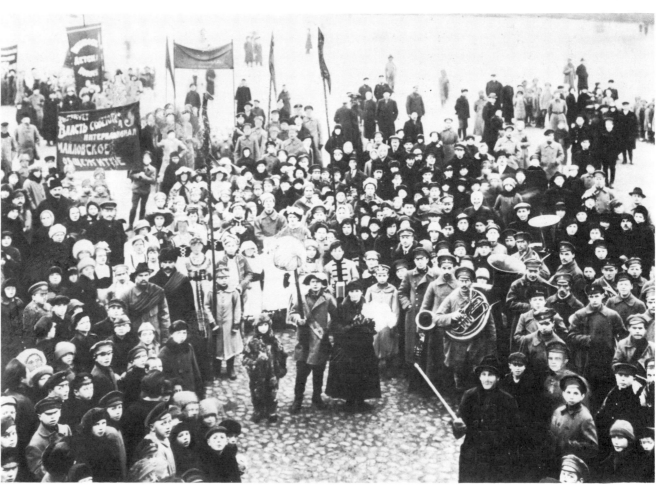

НАРОДНЫЙ КОМИССАРІАТЪ
по военымъ дѣламъ и
Окружной Военный Комиссаріатъ.

Вторникъ 2 іюля 1918 г

КОНЦЕРТЫ-МИТИНГИ

бывш. Алексѣевское военное училище,

циркъ Никитиныхъ,

циркъ Саламонскаго.

БЕЗПЛАТНО И ИСКЛЮЧИТЕЛЬНО ДЛЯ ПРИНЯТЫХЪ ПО МОБИЛИЗАЦІИ.

Начало въ 6 ч. веч.

29

ИСКУССТВО КОММУНЫ

Изданіе Отдѣла Изобразительныхъ Искусствъ Комиссаріата Народнаго Просвѣщенія. Цѣна 50 коп.

№ 10. Петербургъ, Воскресенье, 9 февраля 1919 г. № 10.

6-е ФЕВРАЛЯ — ГОДОВЩИНА ОТДѢЛА ИЗОБРАЗИТЕЛЬНЫХЪ ИСКУССТВЪ.

30

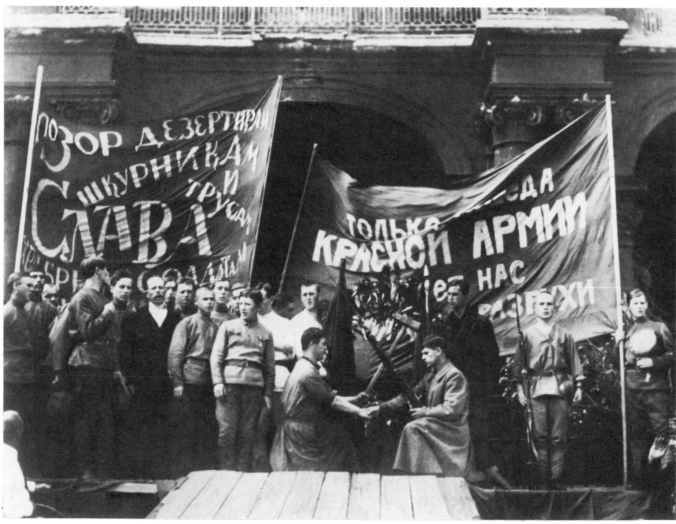

31

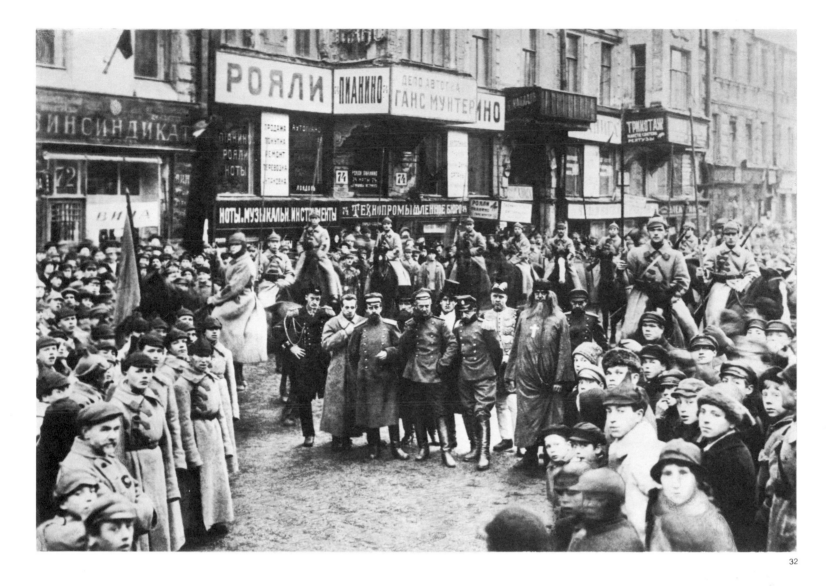

32

ОТ ОТДЕЛА ИЗОБРАЗИТЕЛЬНЫХ ИСКУССТВ
Комиссариата Народного Просвещения.

В Воскресенье, 13-го апреля, в 2 часа дня

В ДВОРЦЕ ИСКУССТВ

(Б. ЗИМНИЙ ДВОРЕЦ)

ТОРЖЕСТВЕННОЕ ОТКРЫТИЕ

ПЕРВОЙ ГОСУДАРСТВЕННОЙ СВОБОДНОЙ

ВЫСТАВКИ

ПРОИЗВЕДЕНИЙ ХУДОЖНИКОВ ВСЕХ НАПРАВЛЕНИЙ.

В 3¹/₂ часа дня на выставке состоится

МИТИНГ-КОНЦЕРТ

Вход на выставку БЕСПЛАТНЫЙ.

Выставка открыта ежедневно от 10 часов утра до 8 часов вечера.

33

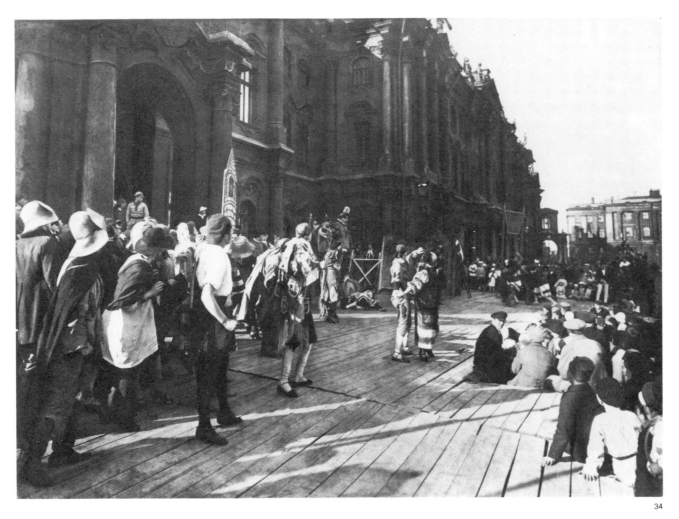

34, 35 BALLET-PANTOMIME *FUENTE OVEJUNA* BEING PERFORMED ON THE SQUARE IN FRONT OF THE WINTER PALACE. PETROGRAD. 1921

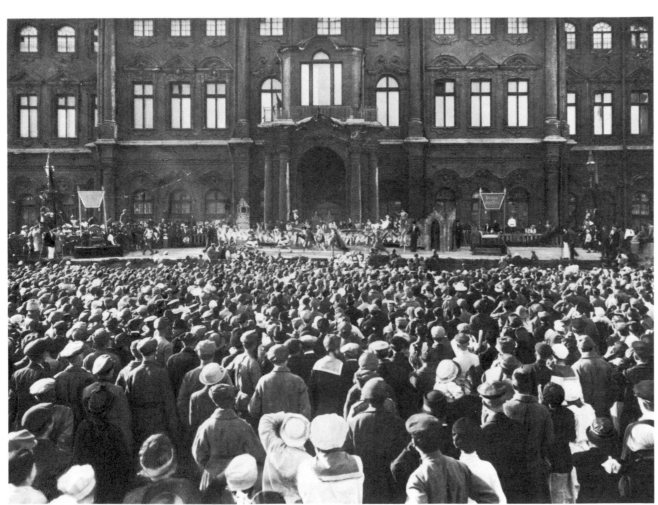

to think only of art and remain unshaken by the sheer force of human suffering depicted here. This impression is undoubtedly created by the artist's painstaking effort: the superfluous is cast aside, and the significant is accentuated. The bony hands are almost illusory, and the deathly face resembles a skull.

The posters of this period can give an impression of the ideas and notions of the time: the generosity and talent of the artists have made these posters not only historical documents, but also poetic recollections of an era. Kozlinsky's linocut posters sometimes depict human figures (Sailor; plate 107) and sometimes mass scenes (Meeting; plate 14). Many posters are notable in yet another respect: they are associated with an event itself, with a day, with an hour. Alexander Apsit's poster Defend Petrograd with All Your Strength! (plate 26) can by no means hold its own with Moor's or Deni's best posters. However, it bears witness to the dramatic moments when the White armies were not far from the city. Soldiers passed by this poster on their way to the front, many on their way to die.

Other posters, although they did not become famous, modestly served the everyday needs of the Revolution. They stirred men's thoughts, they explained, they taught a love for books, they taught how to subscribe to journals and how to give inoculations. But there were also posters that dealt with very important issues. "Have you volunteered?" asks the Red Army man (plate 24) in Moor's poster: during the war against Nazi Germany a version of this poster once again summoned people to defend their country.

It is difficult to distinguish the utilitarian posters of this period from genuine works of graphic art. Kozlinsky's linocuts, for example, stand on their own merit, and Lebedev's posters have achieved a second life, so to speak, as museum pieces, while Alexander Rodchenko's graphic compositions, even his book covers, are in their own way akin to posters. Indeed, art was quite cohesive and consistent in this period.

In graphic art — that form of art closest to reporting — there was a persistent pull toward monumentality and finished design. This was only natural: a statue made in several months almost always has an unfinished look about it, while a drawing or engraving can acquire, in the same time, an air of completeness.

It is little wonder, then, that one of the best and truly monumental depictions of Lenin is in fact a drawing. To be sure, Nikolai Andreyev's statue and bust of Lenin (plate 276) have become the pride of Soviet portrait sculpture. But Andreyev's remarkable drawing, which gives a three-quarter length view, has clearly grasped and defined the essential Lenin. It is a strikingly rare combination of strict and uncompromising accuracy and ascetic lyricism. It is at once a drawing and a memorial, a profound synthesis of what the artist saw and thought.

This portrait is in many ways similar to John Reed's description of Lenin in Ten Days That Shook the World: "Little eyes, a snubbish nose, a wide, generous mouth . . ." Then follows an overall impression, deeper and fuller: "Unimpressive . . . loved and revered as perhaps few leaders in history have been. A strange popular leader — a leader purely by virtue of intellect . . . uncompromising and detached, without picturesque idiosyncrasies — but with the power of explaining profound ideas in simple terms, of analysing a concrete situation. And combined with shrewdness, the greatest intellectual audacity."

Very few drawings for which Lenin posed have survived. They include the portraits by Altman, Brodsky, Philip Maliavin, and Chekhonin, all very dissimilar artists. But Lenin's spiritual energy, concentration, and natural manner, as it were, took hold of the artists and brought them together. Although the drawings differ in style, and each artist saw some new facet in Lenin's face, we sense in all of them the same emotional makeup, the same inner clarity, as if the intensity of Lenin's mental life has resulted in a corresponding intensity in the lines and shapes on the paper. These few portraits done from life are thus especially valuable.

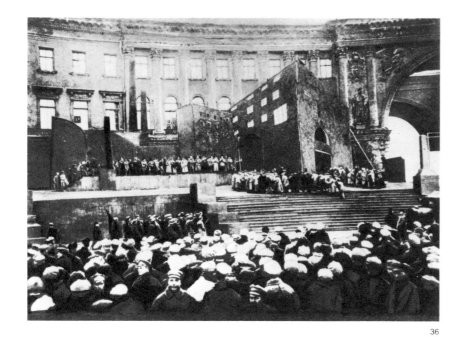

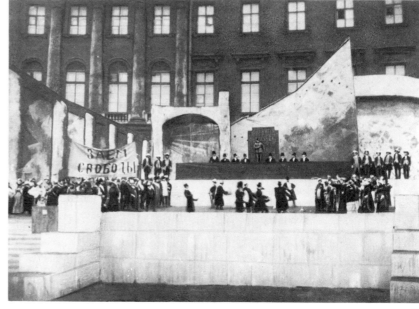

36

37

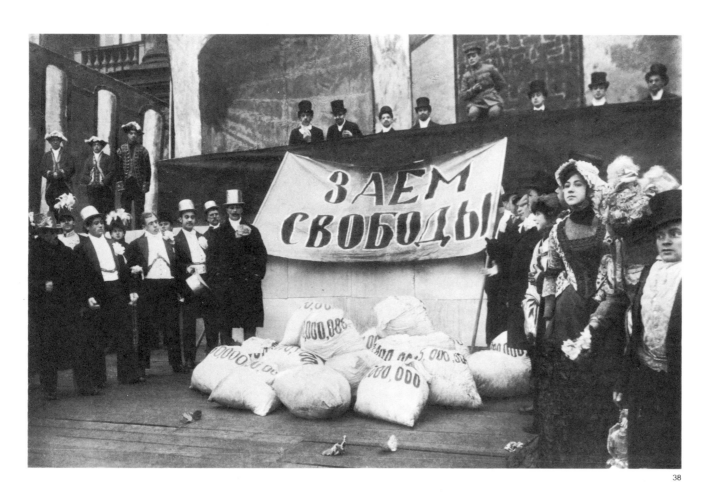

38

36–38 *THE OVERTHROW
OF THE TSARIST REGIME.*
MASS PERFORMANCE WITH
PARTICIPATION OF ACTORS FROM
THE DRAMATIC STUDIO OF
THE RED ARMY

Although by virtue of their work they lived in an intimate black-and-white world, the engravers, draftsmen, and illustrators had the same passions and thoughts as the artists of the period who worked in monumental dimensions. To be sure, tradition made itself felt more often in the graphic arts. Nonetheless, here too the better artists were able to combine their refined professional culture with a keen sense of the times. Long before the Revolution, Anna Ostroumova-Lebedeva's xylographic landscapes of Petersburg were famous. At first glance, her postrevolutionary engravings (plates 111–13) seem to have changed little; on closer examination, however, they do breathe with a new spirit. Spacious skies above the city's outskirts, sweeping vistas, and factory smoke reveal a

new face of the city, one that goes far beyond what was considered the traditional beauty of Petersburg. It is understandable that not all artists conceived of reality optimistically. Dobuzhinsky's *St. Isaac's in a Snow Storm* (plate 110) gives evidence of difficult days of hunger and ruin. Yet this troubled scene is viewed poetically – the artist had not lost his ability to admire even sombre beauty. For Dobuzhinsky, Dostoyevsky's *White Nights* provided an elegiac return to the past; the novel's touching sadness inspired one of the best illustrated cycles (plates 123–24) in Russian graphic art of the 1920s. Alexander Benois continued to improve his long-famous illustrations for "The Bronze Horseman"; after the Revolution, a new edition of the poem, for which he did the illustrations, was published (plate 121).

The new Soviet literature pushed artists ever more toward new forms. Yury Annenkov did the drawings for Blok's poem, "The Twelve" (plates 129–33). It would be out of the question, one would think, to illustrate such an unconventional poem so riddled with metaphors. But Annenkov was able to find a style that almost matched that of the poem. Blok later wrote the artist that many of Annenkov's concepts and discoveries "were unbearably near and dear" to him. The brittle figures crowding the imagination, the sharply drawn details, the rushing, arhythmical strokes – these indeed followed Blok's poem closely. It was as if two forms of art were groping for each other's pulse.

As tradition survived into this new period, it frequently assumed a new facet: for example, a popular, poster-like rhythm that bursts into Chekhonin's characteristic book cover for Reed's *Ten Days* (plate 16). Other tendencies broke decisively with the past. One of the founders of the new Constructivist book design, Lazar (El) Lissitzky, was nevertheless much more serious about the legacy of the past than its many detractors. As he asserted in an article he wrote jointly with Ehrenburg, "the classic models need not frighten off modern artists. Pushkin and Poussin can teach us much, not about the revival of dead forms, but about the immutable laws of clarity, economy, and uniformity." Lissitzky, Rodchenko, and other related artists put together a book out of its own essential components – the arrangement of the typeset text and the contrasts or harmonies between the various kinds of type, assembled in many unexpected ways. Photomontages were frequently included in such projects. The works of Rodchenko and Lissitzky were the "polygraphic flesh" of Mayakovsky's books. In 1921, Lissitzky said: "It is time to transform our intellectuals' meetings from idea bazaars into action factories." In contrast to the many artists who were fond of high-flown declarations, the artists in Lissitzky's circle proved their convictions in deeds. Their works often represented the new Soviet graphic art abroad, each time with unfailing success.

Even artists who were not at all inclined toward innovation were caught up in the spirit of the times. Those who designed luxury editions set to work on mass publications and began looking for new graphic techniques that could be used in cheap-paper books printed in large quantities. Dobuzhinsky, Benois, Vladimir Konashevich, Dmitry Mitrokhin, Lebedev, all experienced book designers, as well as painters who rarely dealt with books, tried to make inexpensive books beautiful and lively, books that spoke in "the language of books." It was only after the Revolution that a type of book satisfying two previously incompatible goals was realized: a mass-circulation book that was inexpensive and yet in impeccable taste.

All that appeared in the most varied spheres of art and at opposite poles of artistic debate gradually merged into a new visual style, giving the epoch its own distinctive image. The headlines of newspapers and journals, labels, announcements, document covers, money, postage stamps, advertisements, posters – although diverse in the extreme, they all bore the mark of an ascetic elegance, a special harsh and angular clarity. The *realia* of these years can be confused with no others. These creations were like a plastic handwriting that the times used in order to write their artistic chronicle.

The dashing and colorful insignia sewn on the front of Red Army greatcoats, the "diamonds" on the sleeves of the first Red Army commanders, the early decorations and medals, as well as the country's new heraldry — a state emblem, flags, and a whole new set of symbols — were all fresh and exciting.

Since art could find expression neither in massive buildings nor in magnificent homes and monuments, it built up a powerful potential energy. The urge to create something great, something sublime increased, but it did not always find an outlet. An architectural conception all too often remained only a model, a monumental painting remained only a sketch on paper. This drive to invest any artistic representation with a significance and with a rigorous and momentous form is especially noticeable in porcelain. It is no accident that artists other than porcelain painters decorated dishes and designed tableware. They thought that with time all these cups and dishes would become the everyday stuff of the new life and take up quarters once and for all in ordinary homes.

Several porcelain works were conceived as unique decorative objects, as, for example, the plates with Lenin's portrait (after Altman's drawing) or those displaying the portraits of the Decembrists. But most were conceived as items of general use. Consequently, many of them contained the day's most topical slogans and emblems. The inscriptions were at times naive and at times moralizing. But nearly all these objects were marvelously original. Earlier traditions in porcelain decoration were either completely rejected or else used to provide a particularly rich contrast with the new tendencies. For example, the pretty flowers that shimmer in the glazing of Chekhonin's plate (plate 358) emphasize the delicately rigid silhouette of the hammer and sickle. At the State Porcelain Works in Petrograd, a new decorative school appeared, with its own distinct style. The decorative elements in its designs took on an audacious, cleverly improvised form. The design and color are not deployed on the porcelain simply and gracefully, but as if taking part in a tense yet harmonious debate that finally comes to a well-formed synthesis literally before the viewer's eyes. Even the machine parts dovetail with this organic decorative pattern in an unexpectedly natural way. The flowering of early Soviet porcelain was rapid and splendid. It can only be regretted that the works in this period could not have been produced in still larger quantities, even though the artists, in their very first experiments, worried lest their works become "collector's pieces" or *objets d'art*.

The only art form that by its very nature remained to a certain extent confined to the studio was easel painting. It could not "take to the streets," as had posters, holiday decorations, and sculptures (albeit short-lived ones). Nor could it be circulated in inexpensive editions accessible to everyone. Nevertheless, it was painting — whether the painters realized it or not — that was central to the art of the period. It was to become the definitive point of departure in judging culture from the vantage of history. In museums and galleries it has forever remained the most profound, crystallized, and significant branch of art. All its traditional genres have flourished: the portrait, the landscape, scenes of everyday life, and battle scenes. It would be hardly necessary to add that a "field of tension" arose not among the genres but among the various modes of perception and representation.

It is easiest, of course, to recognize polar opposites, for instance, "figurative" and "nonfigurative" art. In this period, however, there was no place for "middle-of-the-road" art. Indifferent art was therefore alienated art. Who would deny that the influence of Kandinsky was enormous? For the adepts of "nonfigurative art," he will always be the messiah. But in the culture of revolutionary Russia his art and work were like an echo, like the art of a brief visitor. The point is not only that Vasily Kandinsky left his homeland forever in 1921; even from the beginning, his art and philosophy were introspective. He had little to do with surrounding reality not simply because he was a "nonrepresentational" artist, but also because, more than anything else, he followed his

39

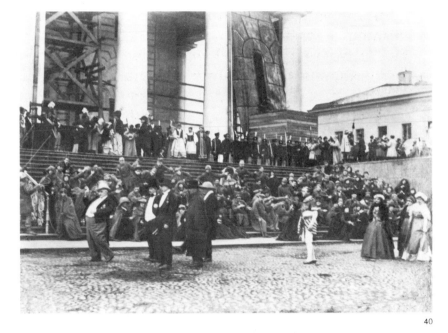

40

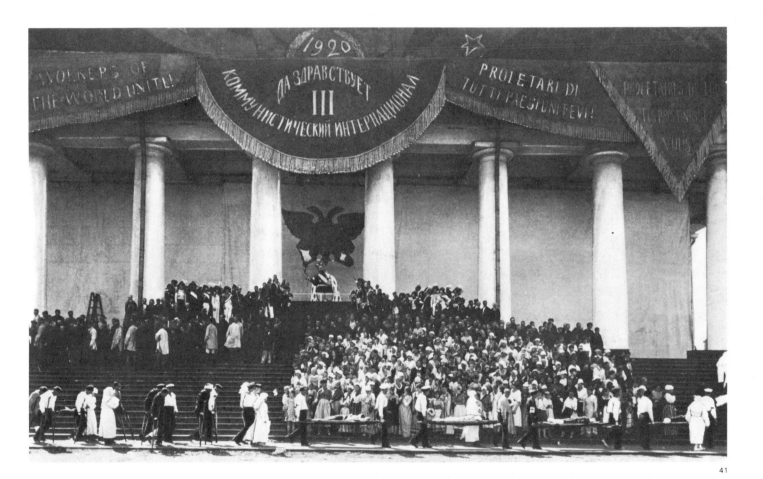

41

39–41 *TOWARDS
A WORLD-WIDE COMMUNE.*
MASS PERFORMANCE
ON THE STEPS OF
THE EXCHANGE BUILDING.
PETROGRAD. 1920

own fancies. In 1918, he wrote that the artist's eye "should be turned inward, his ear toward the voice of inner necessity." To be sure, Kandinsky was not the only one to make such a pronouncement. But Malevich, the creator of *White on White,* a man who became deeply absorbed in the search for abstract harmonies, placed little value on his fame abroad as an abstract artist. He tried to make his art useful to Russia in drafting such projects as homes of the future, porcelain molds, the stage design for *Mystery-Bouffe.*

There were many admirers of Suprematism, including Rodchenko, Liubov Popova, and Ivan Puni. Younger artists readily succumbed to the lure of Suprematism. They had an insatiable hunger for innovation, and it was of course easier and more "modern" to draw

geometric figures and give them fancy names than it was to comprehend the subtleties of drawing or classical perspective. The works of such artists displayed naive enthusiasm as well as blatant imitation. It was easier to shock the public than to make some sense of the world; the mania for form often sprang from moral blindness. In searching for abstract harmonies, one too easily lost interest in the living, breathing human being, in the spiritual drama, sufferings, and bright hopes of mankind. That which Émile Verhaeren had called "Grande heure où les aspects du monde changent" had no place in the aloof experiments of the Suprematists. On the other hand, they brought the spirit of passionate searching into art. Much arose under their influence, and much came out of the polemics they aroused. Suprematism fits easily into the general picture of European art at the beginning of the century. It is tempting to measure the art of the Revolution's first few years against Suprematism, but this approach is naive at best. The truth lies not in superficial judgments; as the French justly say, "Le doute est le commencement de la sagesse." There is a Russian saying, too — "You can't take a word from a song" — and, in Russian painting at that time, there were not only many words, but also many nuances.

It may seem that "leftist" (avant-garde) art would have quarreled first of all with strictly traditional painting, or in any case with painting that tried to reproduce the material world in detail. Of course, against the general background of early twentieth-century European art, the paintings of Brodsky, Alexander Moravov, Vladimirov, and Grekov look unusually realistic and, viewed superficially, old-fashioned. However, there is a reality that is in itself so meaningful that even its minor details are of value to art. Traditional realism hardly needs defending; history has long ago separated the good from the bad. Moravov's *Meeting of a Committee of Poor Peasants* (plate 155) is important precisely because of its uncompromising realism and its character as a poetic document.

Slowly and gradually, that which has always been the very essence of art began to emerge: a new vision of a new man. It is not just a question of bringing out a man's character, striking as it may be, but of revealing a character that typifies and personifies an epoch. Sergei Maliutin accomplished precisely this in his portrait of Dmitry Furmanov (plate 156). Furmanov was a commissar in Chapayev's division as well as a talented literary figure. In the portrait he is young, barely thirty, and he looks out at us, in a soft and penetrating way, with eyes that are still young and bright. But you also see in them the premature wisdom of a man who has experienced a great deal in his life. The composition and colors are purposely kept simple, so that artistic devices seem to fade into the background. It is thus the man that dominates the canvas, a man who knows the price of all the military hardships borne and who believes in the sense and worth of the new life that Furmanov and his comrades-in-arms were defending. At the same time, a slight, almost ironic smile softens the character's epic significance.

Russian painting in the postrevolutionary period requires a close and unbiased look if one is to understand where and how the times expressed themselves most fully, where and how the new ideas born of the socialist Revolution took shape. There is no "golden mean" in art; a computer cannot calculate its fate.

The artists of the period sought ways to match the scale of events. They perceived the Revolution as a cosmic event, and this in turn led them into allegories, such as Konstantin Yuon's *A New Planet* (plate 162). Kustodiev painted *The Bolshevik* (plate 9), a powerful giant holding a flag and striding over houses and crowds, a giant incommensurable with an older, smaller world. The artist's talent gives this unusual scene the vividness found in a joyful fairy tale. The poetic reality of a provincial town links the painting to an older world of art, into which the metaphoric image of the Revolution strides imperiously.

Sensitive artists saw the Revolution not as a series of specific events but as something that fundamentally changed their conception of the world. The usual became the unusual, and one's earlier perceptions vanished forever. Nature itself — as in a moment

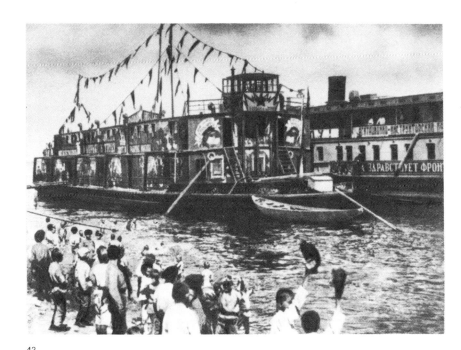
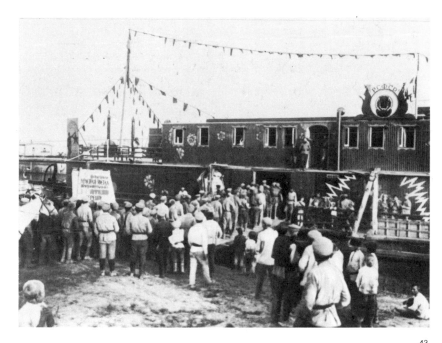

42

43

42, 43 AGIT-PROP STEAMER "THE RED STAR." 1920

of spiritual illumination – became a reflection of the artist's emotions. Arkady Rylov's *The Blue Expanse* (plate 159) is, in terms of subject and artistic techniques, quite like a traditional Russian landscape. But it also has something that catches at the spirit, an intoxicating joy. The waves, the deep blue sky, and the assured and proud flight of the swans make up not merely an epic and buoyant landscape. This is nature itself seen by a man who seeks something that resonates with his inner world. This is how reality looks in moments of joyous revelation.

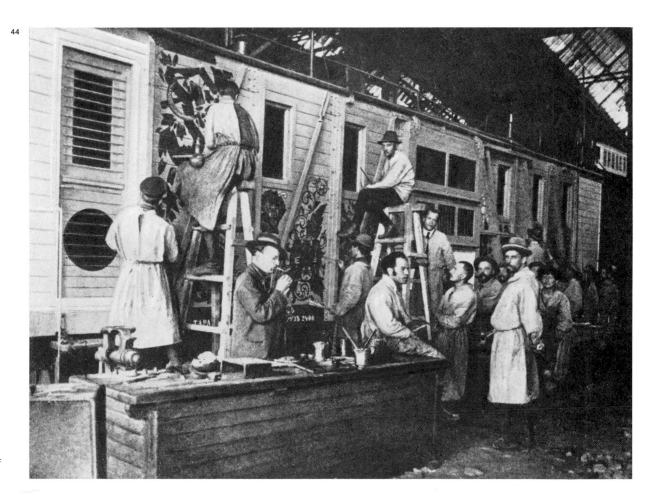

44

44 GROUP OF PAINTERS DECORATING A CAR OF
 AN AGIT-PROP TRAIN

Even in landscapes that lack this powerful epic impact a sense of the times is still present. In the paintings of various artists, young and old, the traditional (in the highest sense of the word) landscape continued to thrive. The age-old love of one's native land and a keen concern for it were gradually suffused with a new feeling: the lasting bond between the best of progressive Russian culture and the new culture of Soviet Russia. Nature was perceived as being open to any man able to see its boundless beauty. It is enough to recall Polenov's *Flood on the Oka* and Brodsky's winter landscapes.

In contrast is Boris Yakovlev's *Transport Returns to Normal* (plate 183), an unusual painting for its time. It depicts no nature and almost no people. Instead, there are rails, steam smoke, the rigid outlines of railway wagons, a locomotive, and telegraph poles moving away into the distance. The painting concentrates, seemingly, on the distinct and quiet rhythm of the good days to come. Simple things become symbols, but they do not lose their precise objectivity.

A clear note of optimism is also evident in the various art genres of the period. *Still Life with Samovar* (*Copperware*) by Ilya Mashkov (plate 206) is a holiday parade of things whose prosaic nature is transcended by the radiance of the painting, which is as impressive and festive as a solemn military march. Art's traditional genres — still life, landscape, portrait — absorb the joyful and troubled melodies of the epoch. During these years, many artists suddenly found fulfillment; the import of all that had happened brought them to an early maturity. Robert Falk had never depicted events, but he discovered anew for himself the world of people. His *Working Woman* (plate 254) — a woman of the 1920s — combines a felicitous spiritual tension and an austere tenderness. Falk's sensitive hand became more and more assured during this period, and an exultant restlessness suddenly appeared in his canvases. His *Red Furniture* (plate 253) and *Trunk and Earthenware* (*Heroic Still Life*) by Piotr Konchalovsky (plate 203), as well as the works of Kuznetsov, Rylov, Lentulov, and Kuprin, give clear evidence of the renewal and free search (where tradition became reconciled with the discoveries in the plastic arts during the stormy years of the Revolution) that made a triumphal entry even into ordinary motifs.

Not enough time had passed for a generalized and epic depiction of the Revolution to be achieved. This was to come later. But the ardent spirit and general outlook of the revolutionary years transformed and inspired painting. Artists naturally sought expression in more lasting forms, forms that were neither hackneyed nor fashionably avant-garde. In a word, they sought the forms of a new classic style.

The paintings of these years have preserved the many aspects of an extraordinarily complex reality. These are, for example, Rudolf Frenz's feverish pictures of nighttime Petrograd. Or Osmiorkin's paintings, which seem to hum with the fervor of restrained colors. Or the tormented, tireless quest of Pavel Filonov, who sought to encompass the contemporary world with his artistic yet difficult and nervous style. Confusion, searching, discovery — all this created a meaningful art that was no mere copying of reality and no mere dabbling with empty forms. Thus, there were many artists whose art, in one way or another, was both topical and timeless. Many not only "heard the Revolution with their heart" but left their heart and soul on canvas.

One exemplary painting in this respect is Petrov-Vodkin's *After the Battle* (plate 164), a true picture of the twentieth century. The wooden table and tin pot are strikingly tangible. They seem to form a bridge from the ordinary world of "things" to the silence of men whose thoughts still dwell on the hell of a recent battle, men whose faces are serene and forever sad. Behind them, as a haunting reminder, we see a slain comrade falling headlong on a huge planet Earth. This very fate may overtake *them* on the morrow. It is a reminder closely linked with reality — from the past, to the present and to the future. The time sequence represented here extends far beyond the picture's immediate realm. The art of old Russia reveals itself in the picture's quiet and courageous sadness and its

balance between the real and the imaginary. The future, or what is almost the future, appears in the subject itself; in the nervous fragility of the seemingly crystalline forms; and in the juxtaposition of everyday objects with nobility of thought and the unity of events that have occurred at different times.

One can also sense here the excitement of the art of the period: the rigorous accuracy of Grekov's battle scenes, the searching for refined artistic harmonies at the turn of the century, the Suprematists' experiments, and much else. Petrov-Vodkin is of course not the arithmetic mean for the art of the period. It is only that in his work, more acutely than in the work of any other artist, the formation of the early Soviet classicism is discerned. It is an art with deep roots and with visions that rush headlong into the future.

After the Battle was painted in 1923. For five years Soviet Russia had been in existence, and for five years art had "listened to the Revolution with its heart."

The previous year, 1922, had been a year of great change. The invalidity of the avant-garde position had by then been clearly revealed. The "left" had finally come to see, to understand that the people had not accepted their art, and many "leftists" themselves admitted that their position was untenable.

The need to organize realist artists, those who had won wide recognition among the new Soviet citizenry, became more and more pressing. As a result, the AARR — the Association of Artists of Revolutionary Russia — was formed. A new period in Soviet art had begun, a period of decisive evolution toward socialist realism. There is no single sculpture, painting or artist that can fully represent this epoch in history. Its most promising beginnings have had and will continue to have a future. The well-known Russian actress and remarkable social activist Maria Andreyeva said in 1918, on the first anniversary of October: "The October Revolution is the greatest event in the history of the world. It is the victory and holiday of the proletariat, it is joy and a firm bright belief in its final triumph. But the battle is not yet finished. Our blood and that of others still flows, and a holiday, it seems to us, should therefore be serious and austere. After all, there is still a proletariat, and there is still capital . . ."

These words are very appropriate for the art of the period from 1917 to 1922 and its meaning for the future. It was a "festive" art, but nevertheless "serious and austere."

This complex period in Soviet art needs neither praise, imitators, nor hasty judgments. For the first time in the world's history, this art accepted responsibility for the first steps taken by the culture of the first Soviet country. As it fades away into history, it still remains contemporary. This is of course the mark of classic art. In this case, however, it is a special kind of classic art — revolutionary classic art.

NOTES The information in the captions to the plates and the index of
names is given according to available data.
Dimensions are given only for paintings, prints, sculpture, and
surviving designs for the festive decoration of cities.
The imperfect technical quality of some of the reproductions is
due to the state of the original works used.
The size of the stamps (48–53, 360–371) and commemorative
medals (378–384) reproduced in the album is substantially large
than that of the originals.

In beginnings and in ends,
artists, let your faith be strong.
Know where hell and heaven await us.
It is your gift to measure all you see
with dispassionate eyes.
Let your gaze be firm and clear.
Rub out the incidental details
and you'll see the splendor of the world.
Find out where the light shines
and you'll know where lies the dark.
Let all that's sacred in the world,
and all that's wicked, pass in unhurried flow
through the fire of your heart and the cool of
your mind.

ALEXANDER BLOK. FROM THE POEM "RETRIBUTION"

VALENTIN SEROV

1 *"Soldiers, soldiers,
heroes every one . . ."* 1905.
Tempera and charcoal
on cardboard, 47.5 × 71.5 cm.
The Russian Museum, Leningrad

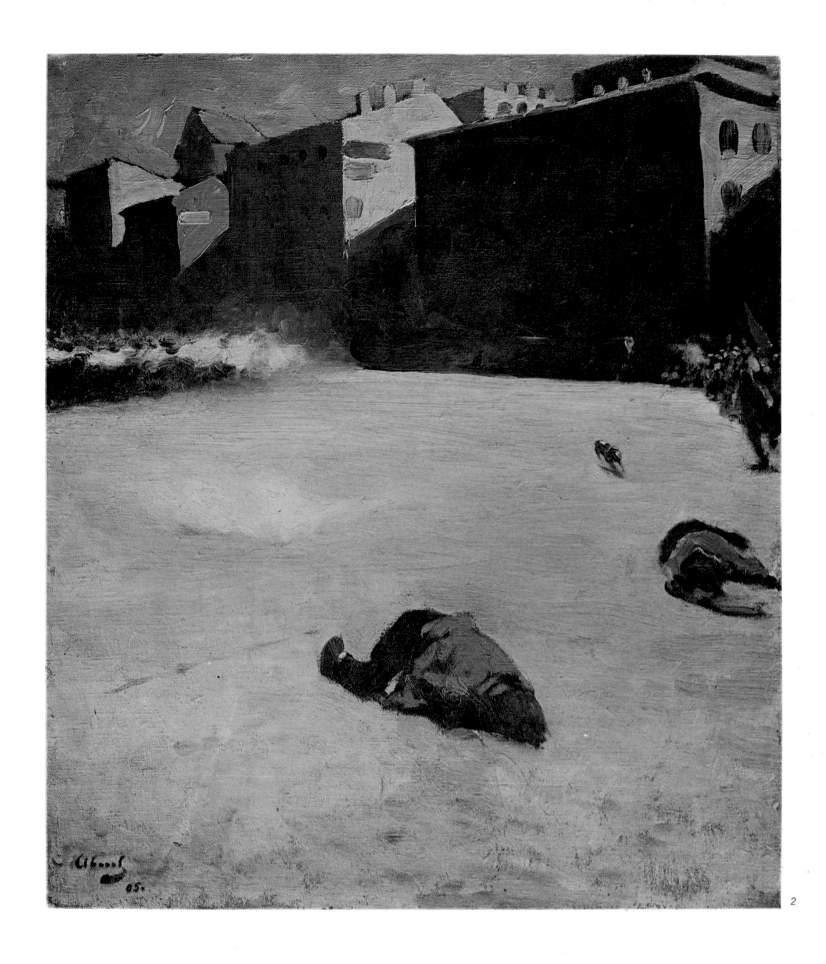

2

SERGEI IVANOV

2 The Massacre. 1905. Oil on canvas, 70 × 80 cm.
The USSR Museum of the Revolution, Moscow

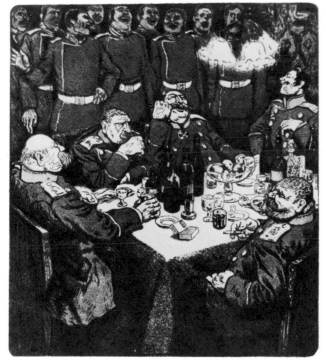

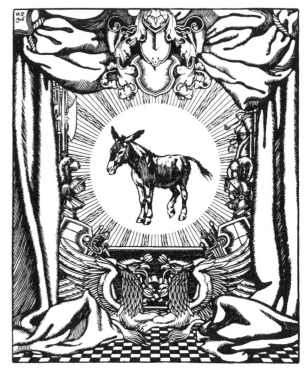

3

4

5

YEVGENY LANCERAY

3 *Feast after a Massacre.* Drawing for the satirical journal *Adskaya Pochta* (Hell's Post), 1906, No 2

MSTISLAV DOBUZHINSKY

4 *"October Idyll."* Drawing for the satirical journal *Zhupel* (The Bugaboo), 1905, No 1

IVAN BILIBIN

5 *Donkey in Glory.* Drawing for the satirical journal *Zhupel* (The Bugaboo), 1906, No 3

VALENTIN SEROV

6 *"Harvest."* 1905. India ink on paper. 25 × 36.5 cm. The Tretyakov Gallery, Moscow

7 *The Year 1905. After Quelling a Riot.* 1905. Black lead and crayons on paper, 29.8 × 25 cm. The Tretyakov Gallery, Moscow

6

7

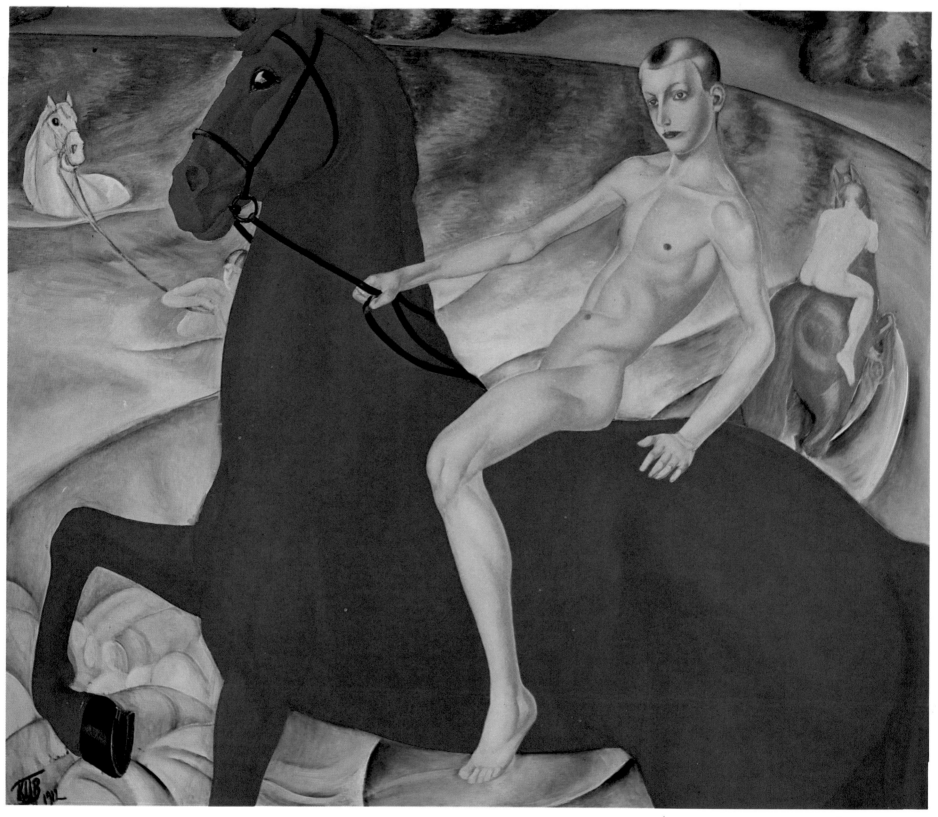

KUZMA PETROV-VODKIN

8 *Bathing the Red Horse*. 1912. Oil on canvas, 160 × 186 cm.
The Tretyakov Gallery, Moscow

We Russians are living through an epoch which has few equals in epic scale . . .
An artist's job, an artist's obligation is to see what is conceived, to hear that music
with which "the air torn up by the wind" resounds . . .

What then is conceived?

To redo everything. To arrange things so that everything becomes new; so
that the false, dirty, dull, ugly life which is ours becomes a just life, pure, gay,
beautiful . . .

"Peace and the brotherhood of nations" — that is the banner beneath which the
Russian revolution is taking place. For this its torrent thunders on. This is the music
which they who have ears to hear must hear . . .

With all your body, all your heart and all your mind, listen to the Revolution.

<div align="right">

ALEXANDER BLOK. FROM THE ARTICLE
"THE INTELLIGENTSIA AND THE REVOLUTION." 1918

</div>

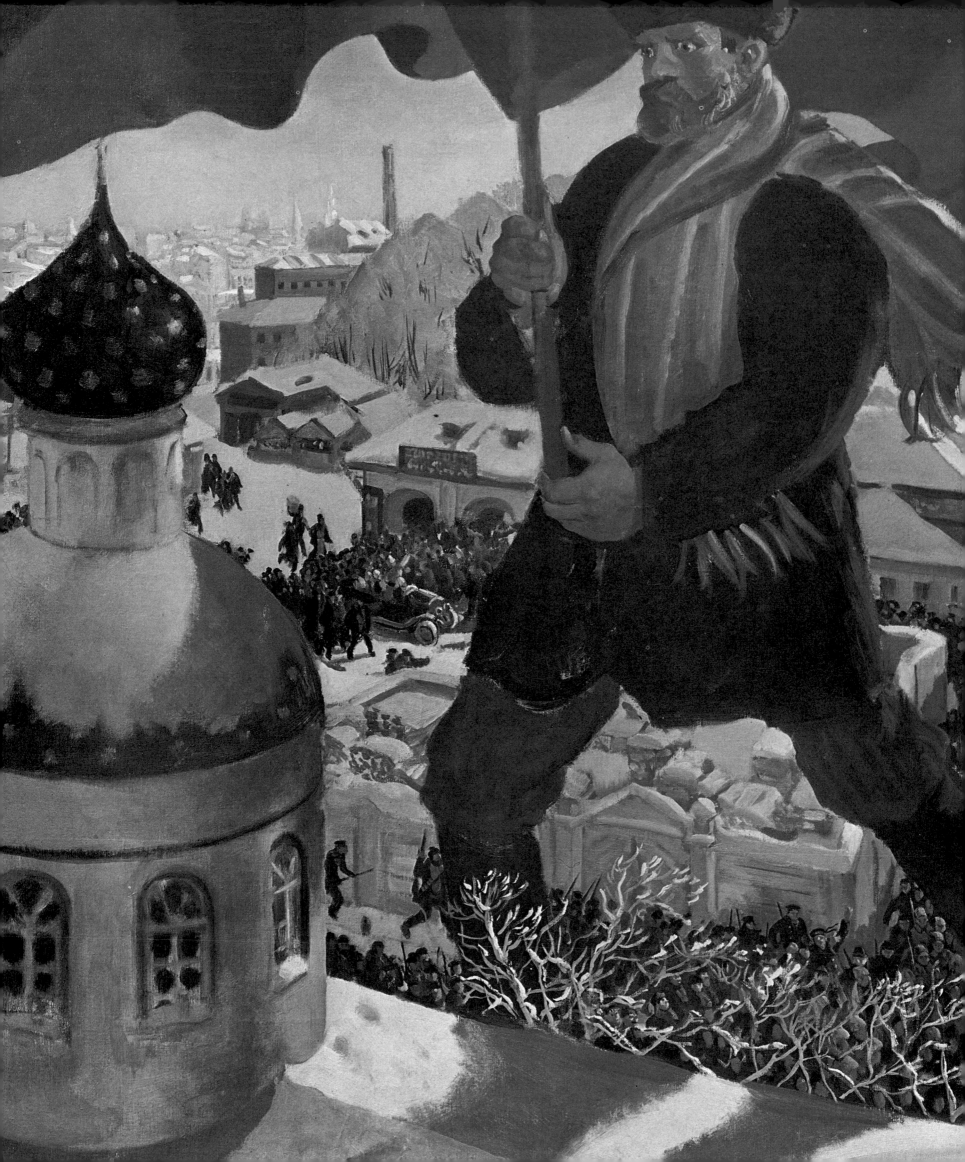

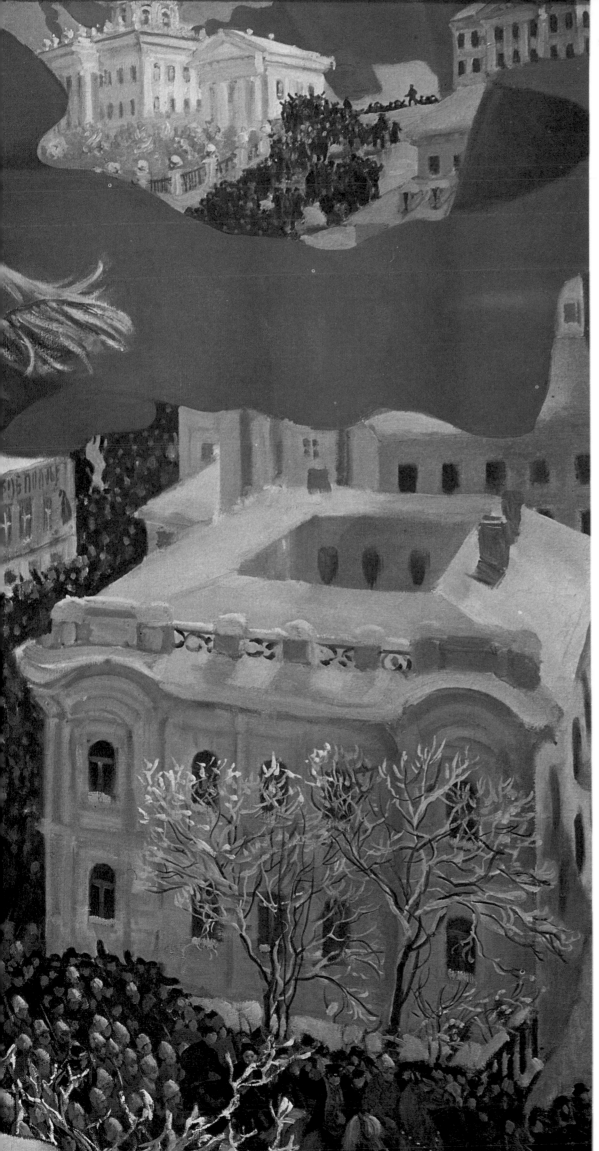

BORIS KUSTODIEV

9 The Bolshevik. 1920. Oil on canvas, 101 × 141 cm.
The Tretyakov Gallery, Moscow

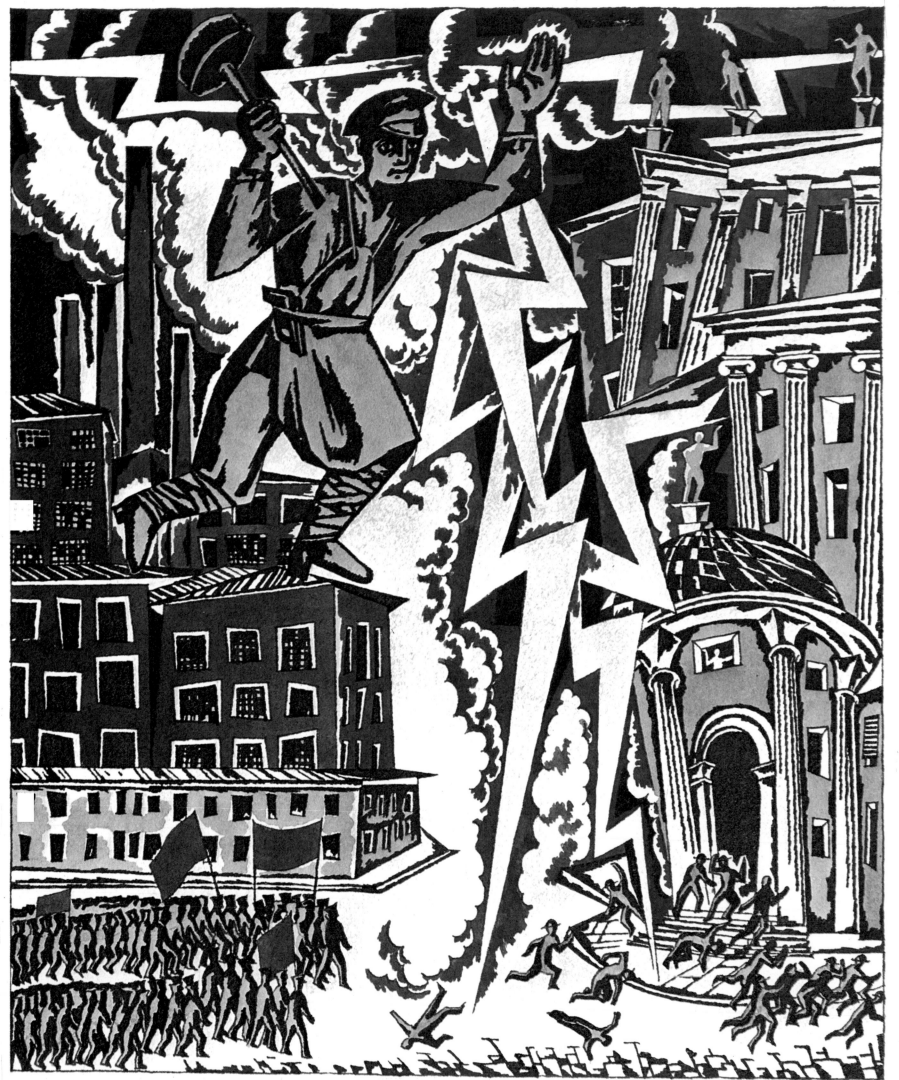

IGNATY NIVINSKY

10 Design for the poster *Red Lightning*. 1919.
The Central Archives of Literature and Art, Moscow

NIKOLAI KUPREYANOV

11 *The Cruiser "Aurora."* 1922. Xylograph, 11.7 x 22,2 cm.

Revolution is the roar of the streets,

the tramp of the crowd read aloud.

Only in Revolution

can one bare one's breast to bullets,

blowing them off like fluff.

NIKOLAI ASEYEV. "THIS IS THE REVOLUTION"

NIKOLAI KUPREYANOV

12 *An Armored Car.* 1918. Xylograph, 16.6 × 19.9 cm.

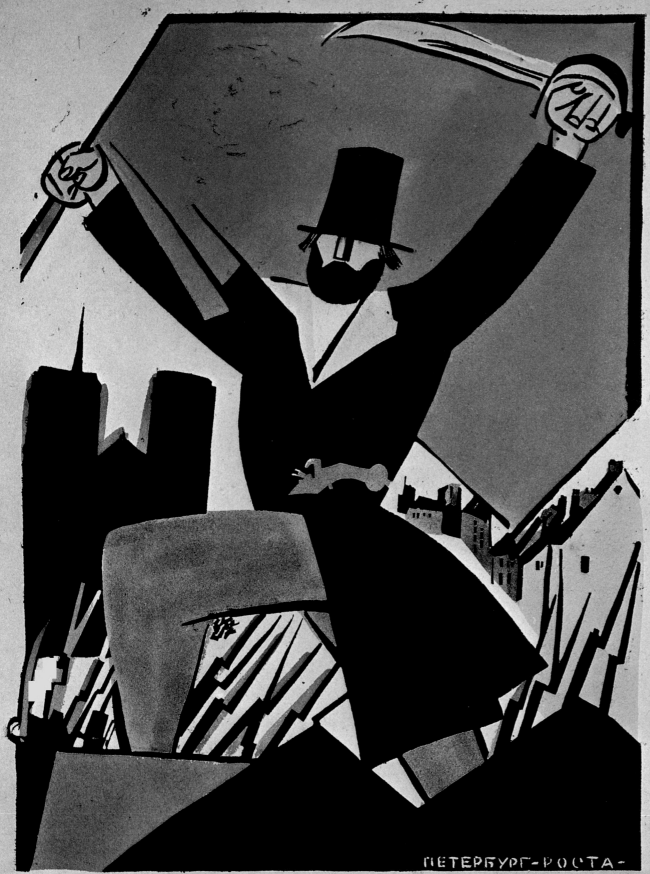

МЕРТВЕЦЫ *ПАРИЖ=СКОЙ КОММУНЫ* ВОСКРЕСЛИ ПОД КРАСНЫМ ЗНАМЕНЕМ СОВЕТОВ!

VLADIMIR KOZLINSKY

13 The Dead of the Paris Commune Have Risen under the Red Banner of the Soviets.
ROSTA window. 1921

14

VLADIMIR KOZLINSKY

14 *Meeting.* 1919.
Linocut, 32.6 × 22 cm.

Rally the ranks into a march!
Now's no time to quibble or browse there,
Silence, you orators!
You
have the floor
Comrade Mauser.
Enough of living by laws
that Adam and Eve have left.
Hustle old history's horse.
Left!
Left!
Left!

Ahoy, blue jackets!
Cleave skywards!
Beyond the oceans!
Unless
your battleships on the roads
blunted their keels' fighting keenness!
Baring the teeth of his crown,
let the lion of Britain whine, gale-heft.
The Commune can never go down.
Left!
Left!
Left!

There —
beyond sorrow's seas
sunlit lands uncharted.
Beyond hunger,
beyond plague's dark peaks,
tramps the marching of millions!
Let armies of hirelings ambush us,
streaming cold steel through every rift.
L'Entente can't conquer the Russians.
Left!
Left!
Left!

Does the eye of the eagle fade?
Shall we stare back to the old?
Proletarian fingers
grip tighter
the throat of the world:
Chests out! Shoulders straight!
Stick to the sky red flags adrift!
Who is marching there with the right?
Left!
Left!
Left!

VLADIMIR MAYAKOVSKY. "THE LEFT MARCH." 1918

VLADIMIR LEBEDEV

15 *The Red Army and Fleet in Defense of the Frontiers of Russia.* ROSTA window No 81. 1920

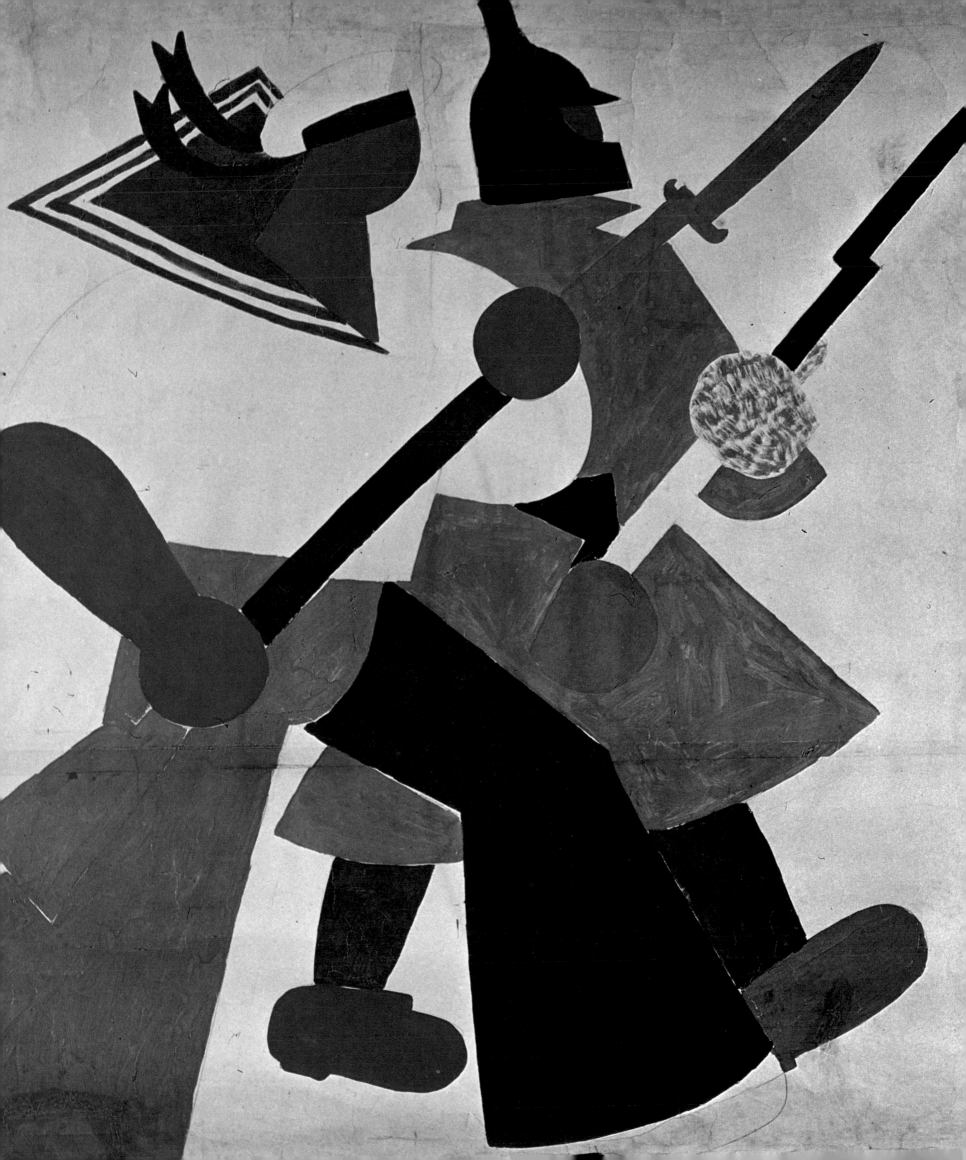

. . . So, with the crash of artillery, in the dark, with hatred, and fear, and reckless daring, new Russia was being born . . .

Like a black river, filling all the street, without song or cheer, we poured through the Red Arch . . . In the open we began to run, stooping low and bunching together, and jammed up suddenly behind the pedestal of the Alexander Column . . .

After a few minutes huddling there, some hundreds of men, the army seemed reassured and, without any orders, suddenly began again to flow forward. By this time, in the light that streamed out of all the Winter Palace windows, I could see that the first two or three hundred men were Red Guards . . .

A soldier and a Red Guard appeared in the door, waving the crowd aside, and other guards with fixed bayonets. After them followed single file half a dozen men in civilian dress – the members of the Provisional Government . . .

We came out into the cold, nervous night, murmurous with obscure armies on the move, electric with patrols . . . Underfoot the sidewalk was littered with broken stucco, from the cornice of the Palace where two shells from the battleship *Aurora* had struck; that was the only damage done by the bombardment.

It was now after three in the morning. On the Nevsky all the street-lights were again shining, the cannon gone, and the only signs of war were Red Guards and soldiers squatting around fires.

. .

Up the Nevsky, in the empty after-midnight gloom, an interminable column of soldiers shuffled in silence – to battle with Kerensky . . .

. .

In Smolny Institute the Military Revolutionary Committee flashed baleful fire, pounding like an over-loaded dynamo . . .

JOHN REED. FROM HIS BOOK
TEN DAYS THAT SHOOK THE WORLD. 1919

With the greatest interest and with never slackening attention I read John Reed's book, *Ten Days That Shook the World.* Unreservedly do I recommend it to the workers of the world. Here is a book which I should like to see published in millions of copies and translated into all languages. It gives a truthful and most vivid exposition of the events so significant to the comprehension of what really is the Proletarian Revolution and the Dictatorship of the Proletariat.

LENIN. FROM THE INTRODUCTION
TO THE AMERICAN EDITION OF JOHN REED'S BOOK
TEN DAYS THAT SHOOK THE WORLD. 1919

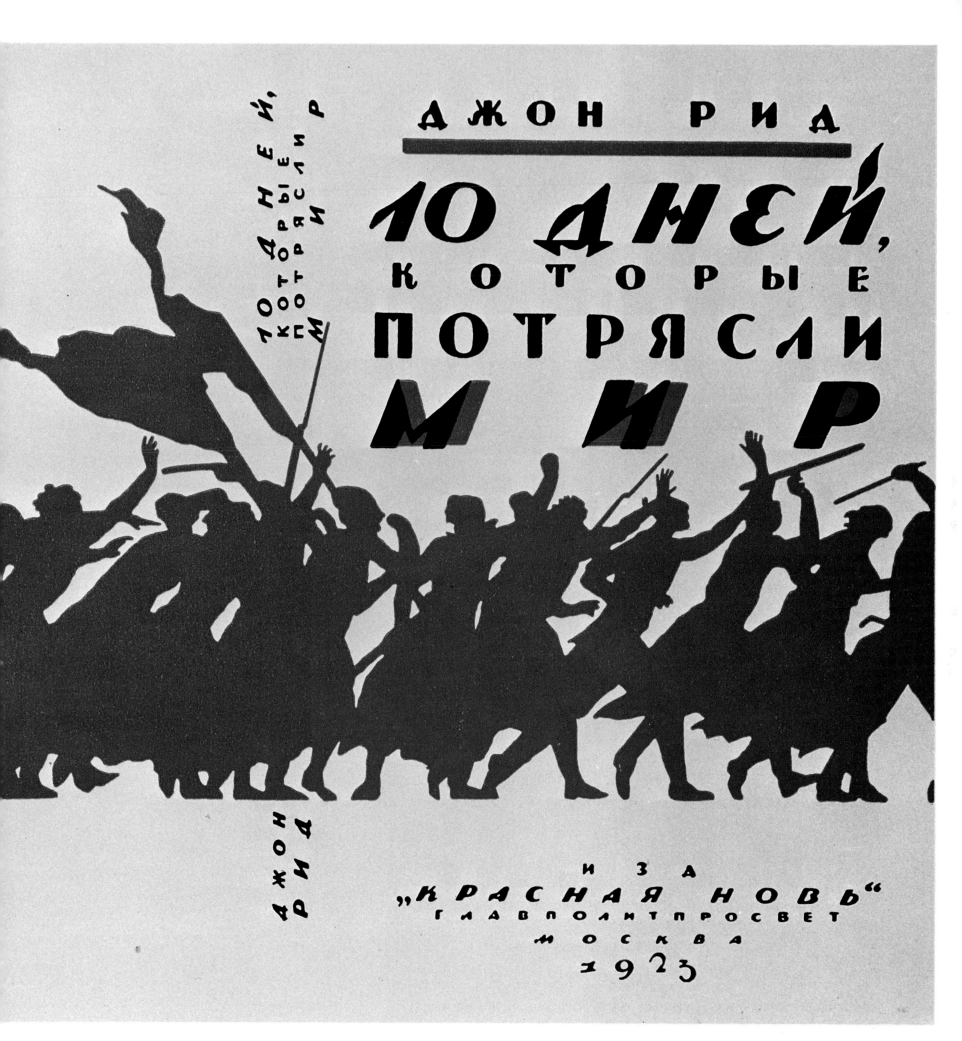

ДЖОН РИД

10 ДНЕЙ,
КОТОРЫЕ
ПОТРЯСЛИ
МИР

ИЗА
"КРАСНАЯ НОВЬ"
ГЛАВПОЛИТПРОСВЕТ
МОСКВА
1923

SERGEI CHEKHONIN

16 Cover for John Reed's book
Ten Days That Shook the World. 1923

17

19

18

A. NIKOLAYEV

17 *Long Live the World Communist Revolution!* Poster. 1918. Voronezh

DMITRY MOOR

18 *Death to World Imperialism.* Poster. 1919

VICTOR DENI

19 *Capitalism.* Poster. 1919

20 *The Entente Hiding behind the Mask of Peace.* Poster. 1920

21 *The League of Nations.* Poster. 1920

22 *Either We Destroy Capitalism or it Walks All over Us.* Poster. 1919

20

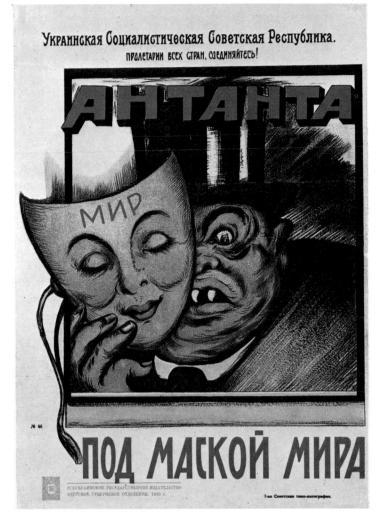

21

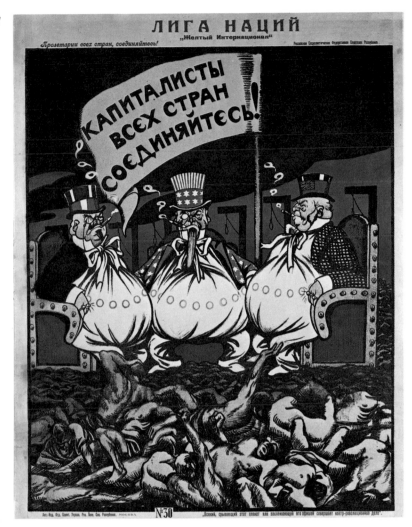

22

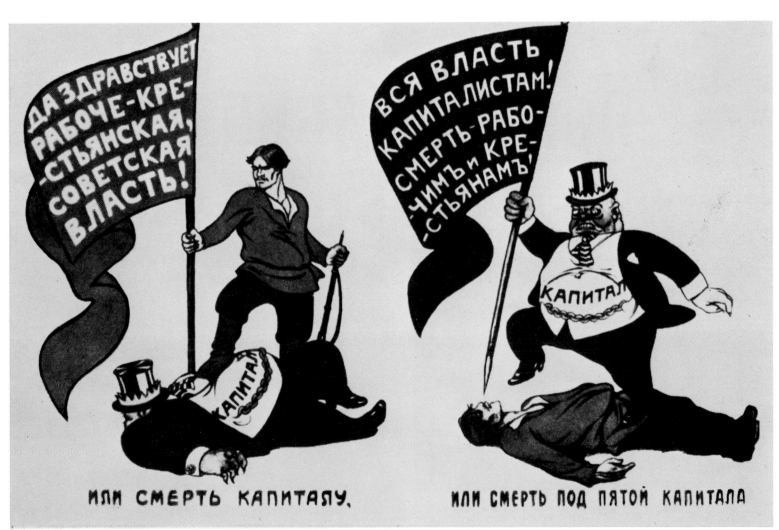

23

К ОРУЖІЮ, РАБОЧІЕ И КРЕСТЬЯНЕ!

ДА ЗДРАВСТВУЕТЪ
Рабоче-Крестьянская Красная Армія!
Всѣ въ ряды Красной Арміи!

КРАСНЫЙ ПЕТРОГРАД В ОПАСНОСТИ!

Белогвардейцы—русские, финские, эстонские, подкупленные и под-держиваемые англо-французскими буржуями, собрали все свои силы для решительного натиска на столицу мировой революции.

ОБЯЗАТЕЛЬНОЕ
ПОСТАНОВЛЕНIE
О МОБИЛИЗАЦІИ
КО ВСѢМЪ РАБОЧИМЪ ПЕТРОГРАДА И ГУБЕРНІИ

23 Appeals of 1918–20 to struggle against
the Intervention:
WORKERS AND PEASANTS, TO ARMS!
LONG LIVE THE RED ARMY OF WORKERS AND PEASANTS!
RED PETROGRAD IS IN DANGER!
BINDING DECREE REQUIRING THE MOBILIZATION OF
ALL WORKERS OF PETROGRAD CITY AND PROVINCE

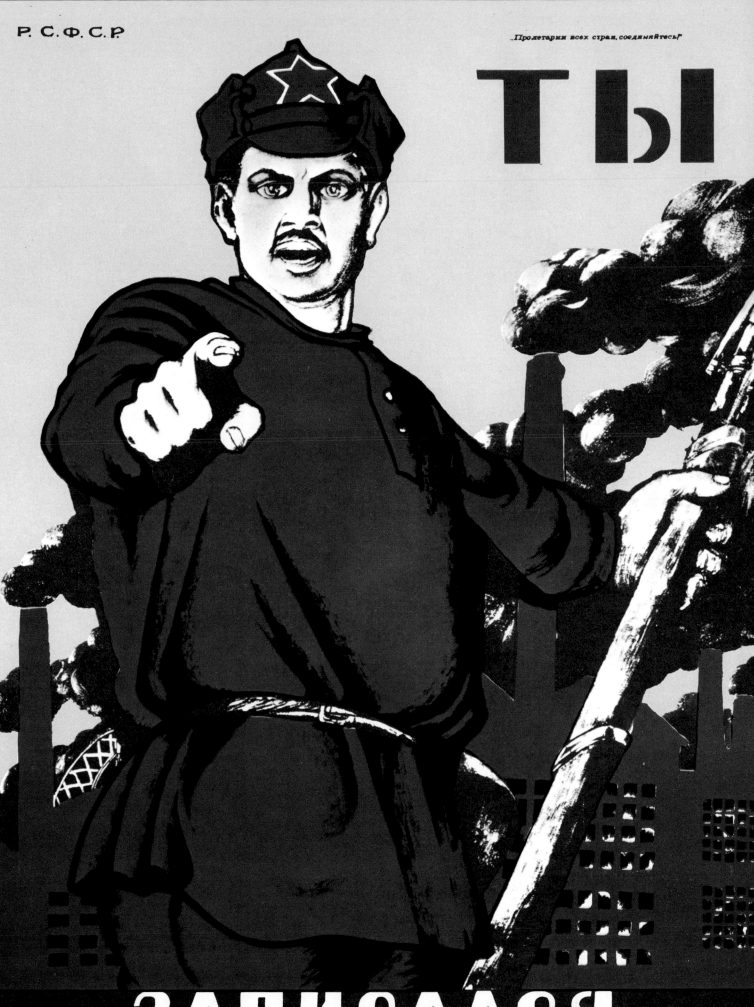

DMITRY MOOR

24 Have You Volunteered?
Poster. 1920

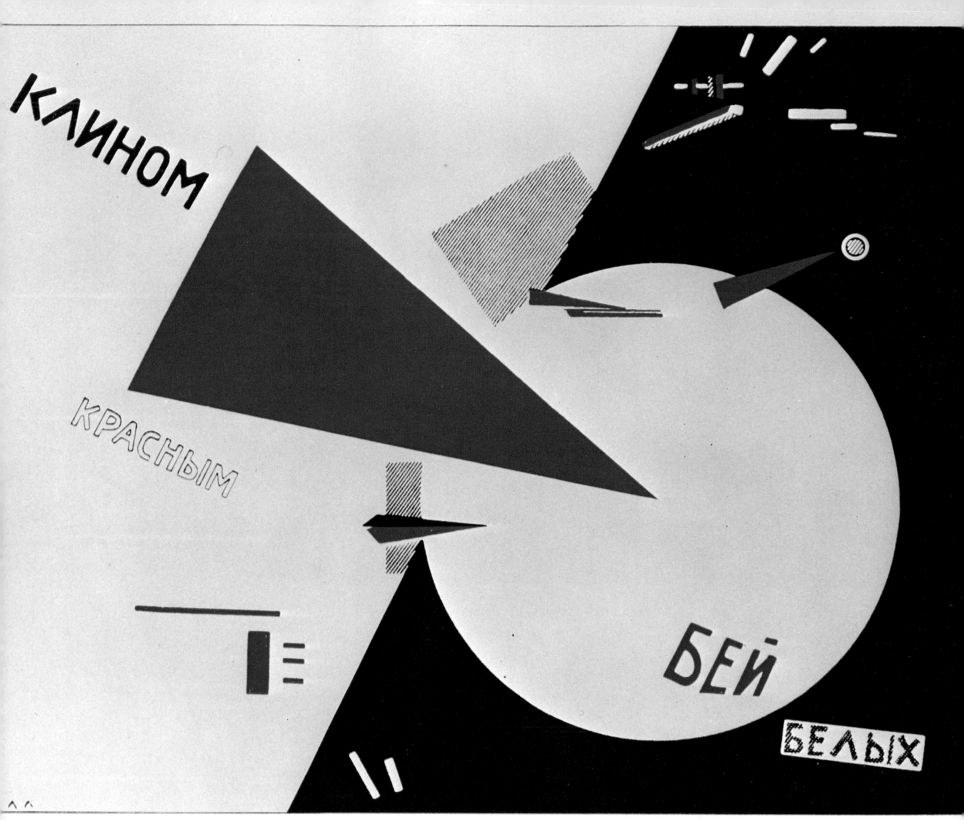

25

LAZAR (EL) LISSITZKY

25 Beat the Whites with the Red Wedge! Poster. 1920

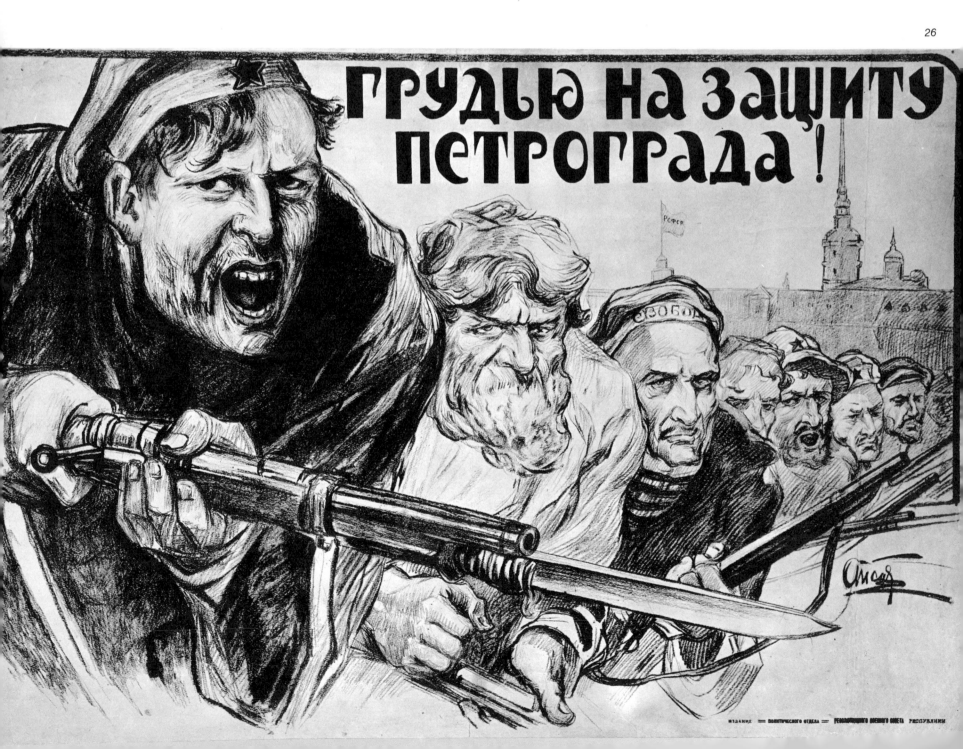

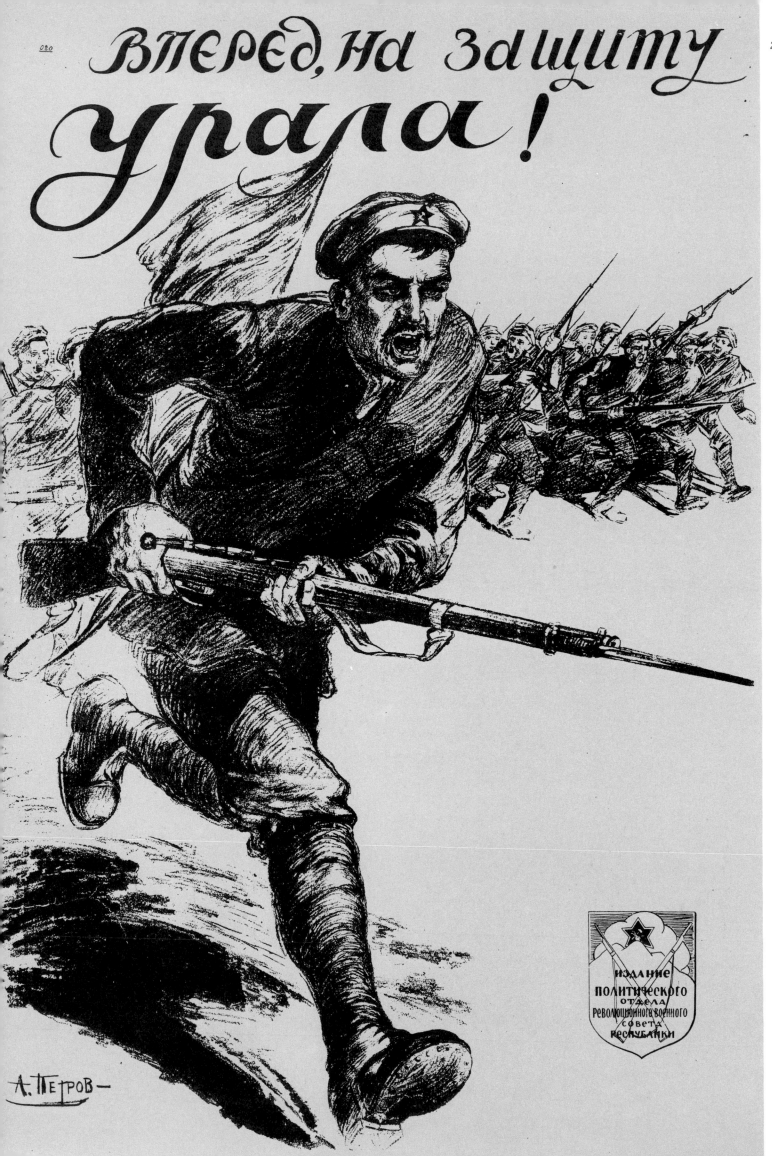

ALEXANDER APSIT
(PETROV)

27 Forward!
Defend the Urals!
Poster. 1919

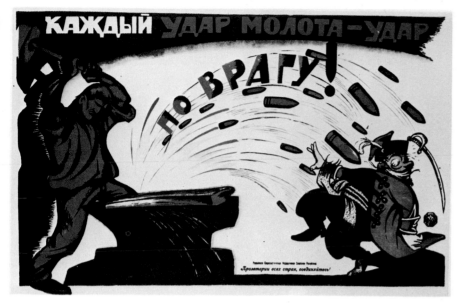

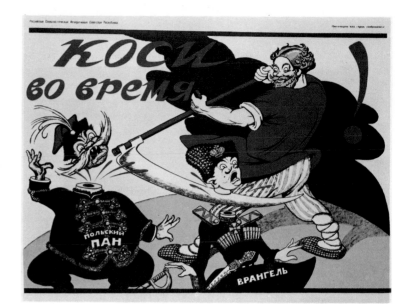

28

29

VICTOR DENI

28 *Every Blow of the Hammer Is a Blow at the Enemy!* Poster. 1920

29 *Start Mowing in Time!* Poster. 1920

UNKNOWN ARTIST

30 *Strike the Pole with All Your Strength
and Wrangel Too We'll Beat at Length!!!* Poster
Wrangel, general of the tsarist army, was one of the leaders of the counterrevolution
during the Civil War of 1918–20.

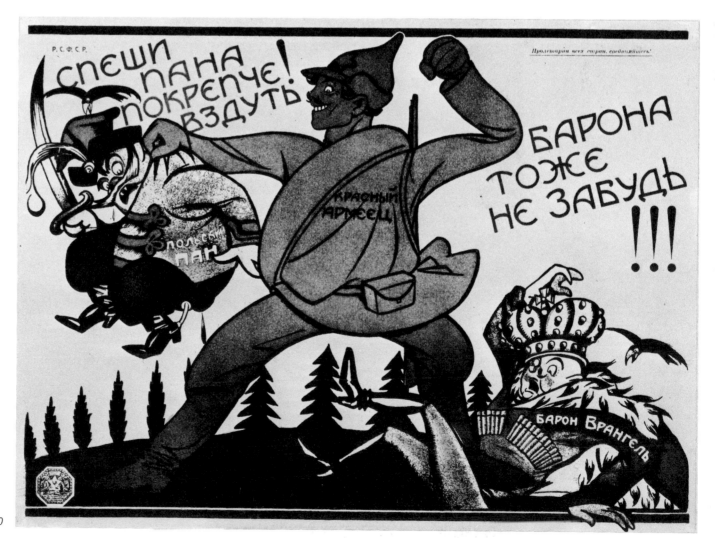

30

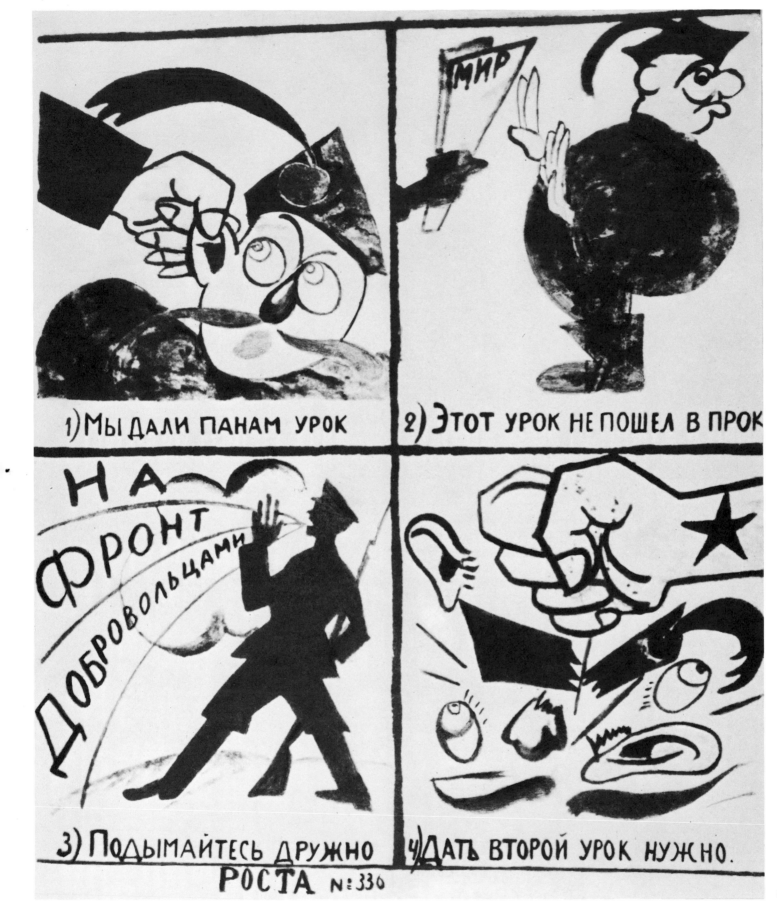

VLADIMIR MAYAKOVSKY

31 ROSTA window No 336. 1920

1. THE LESSON WE TAUGHT THE POLISH GENTS

2. IT DIDN'T TEACH THEM ANY SENSE

3. SO UP ON YOUR FEET ALL YOU MEN

4. WE'LL HAVE TO GO TEACH THEM AGAIN

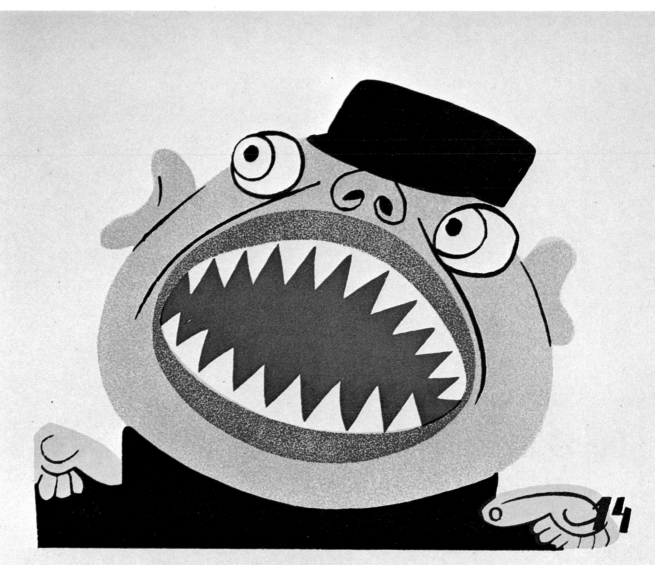

14) Товарищи ! бойтесь попасть
в такую пасть
что-бы с нами никогда
не случилось это
Сплотимся
Власть укрепим советов !

ГЛАВПОЛИТПРОСВЕТ № 146.

32

VLADIMIR MAYAKOVSKY

32 Glavpolitprosvet window No 146. 1921.
(Glavpolitprosvet: Chief Political Education Department)
BEWARE, COMRADES! PLEASE
DON'T YOU FALL
INTO JAWS LIKE THESE!
TO US MAY THIS NEVER,
NEVER BEFALL!
SO LET'S RALLY TOGETHER,
LET'S STRENGTHEN SOVIET POWER!

The first ROSTA windows came out singly, were done in one copy only;
the later ones were stenciled and appeared in dozens or hundreds of copies.
These windows give a picture-book history of the Soviet Union's three most
tense years of struggle. They are the forerunners of all Soviet satirical
magazines.

VLADIMIR MAYAKOVSKY. FROM THE ARTICLE
"ROSTA SATIRICAL WINDOWS." 1930

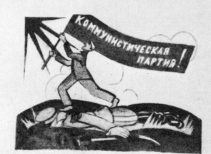

33

34

VLADIMIR MAYAKOVSKY

33 *Remember Red Army Barracks Day.*
ROSTA window No 729. 1920

1. WE'VE FINISHED OFF RUSSIA'S WHITE GUARDS.
 THAT'S NOT ENOUGH:
2. THE OGRE OF WORLD CAPITALISM IS STILL ALIVE,
3. THAT MEANS WE STILL NEED THE RED ARMY,
4. AND THAT MEANS WE'VE GOT TO HELP IT OUT –
 THE TASK IS CLEAR.

34 ROSTA window No 5. 1919

WORKERS!
FORGET NEUTRALITY – A FOOLISH THOUGHT!
IF YOU WANT TO LIVE AT ODDS WITH ONE ANOTHER,
DENIKIN WILL CATCH YOU ALL DISTRAUGHT,
THE GENERAL WILL GOBBLE YOU ALL UP.

BUT IF MILLIONS RESPOND TO THE CALL FOR A PARTY WEEK,
FROM FACTORY AND FIELD,
THE WORKER WILL BE GIVING REAL, LIVING PROOF
THAT COMMUNISTS ARE AFRAID OF NO ONE.

Denikin, general of the tsarist army, was one of the leaders of
the counterrevolution during the Civil War of 1918–20.

As soon as telegrams came in (for newspapers waiting to go to press), poets and journalists would immediately give out "themes" – a biting piece of satire, a line of verse. Throughout the night artists would mess about on the floor over huge sheets of paper, and in the morning, often before the newspapers appeared, posters – satirical windows – would be hung up in the places where people most often gathered: agit-centers, stations, markets, etc. The posters were enormous, 3 meters square, many-colored, and always attracted even someone running past. The first "poster department," with Cheremnykh as its head, opened branches in Petersburg, Kharkov, Rostov-on-Don, Baku, right down to the smallest towns . . .

VLADIMIR MAYAKOVSKY. FROM THE ARTICLE
"THE REVOLUTIONARY POSTER." 1923

MIKHAIL CHEREMNYKH

35 ROSTA window No 580. 1920

1. THE ENTENTE IS ENRAGED BY WRANGEL'S DEFEAT:

2. HE DIDN'T HOLD ON!

3. NOW WHO IS THERE TO HIRE?

4. PETLIURA IS FEEBLE,

5. THE SRs ARE FEEBLE;

6. POOR ENTENTE! HASN'T GOT THE BRAINS TO THINK UP
SOMEONE TO SMASH THE RED ARMY.

Simon Petliura was one of the ringleaders of the counterrevolutionary bourgeois-nationalist movement in the years 1918–20.

SRs (Social-Revolutionaries): a petit-bourgeois party which after 1917 came out openly against Soviet power.

VLADIMIR MAYAKOVSKY

36 ROSTA window No 867. 1921

IF YOU WANT SOMETHING – JOIN UP

1. WANT TO CONQUER COLD?

2. WANT TO CONQUER HUNGER?

3. WANT TO EAT?

4. WANT TO DRINK?

HURRY UP AND JOIN THE SHOCK BRIGADE OF THE MODEL WORKERS.

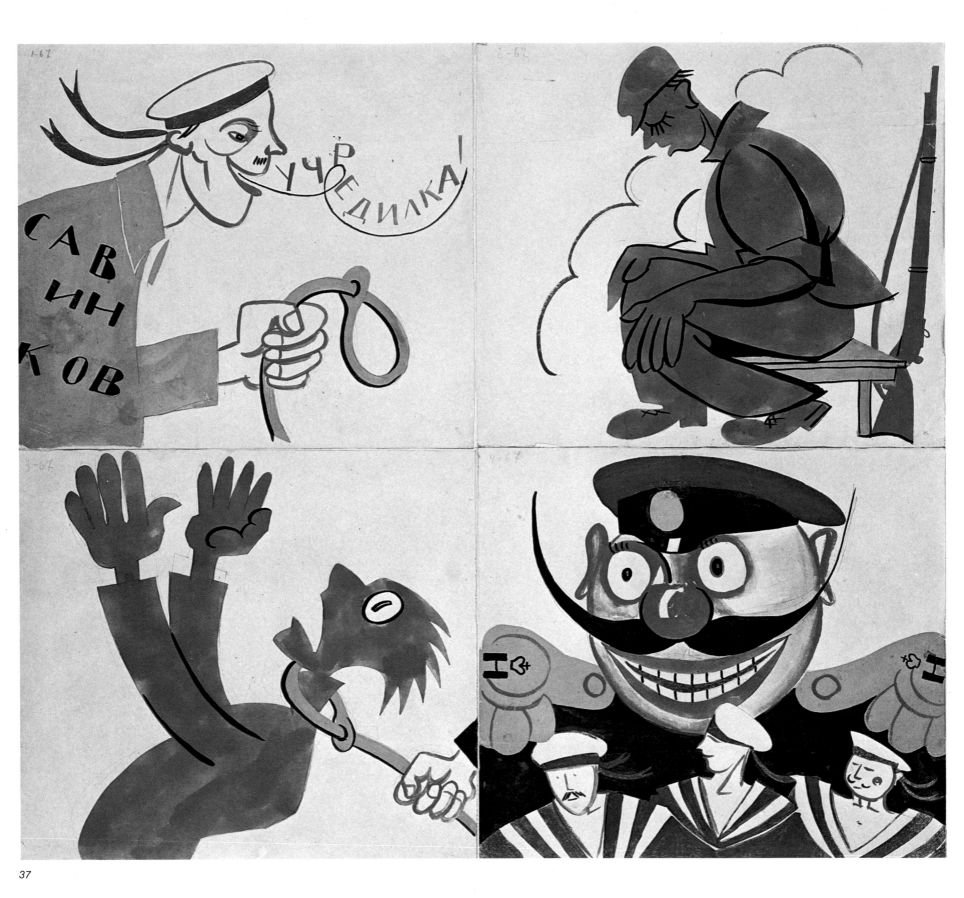

37

VLADIMIR MAYAKOVSKY

37 Uchredilka. Poster. 1921

Uchredilka is a contemptuous name for the Constituent Assembly,
which during the 1917 October Revolution showed its hostility
to the program of the Bolshevik Party and to the true
interests of the people.

Boris Savinkov, a counterrevolutionary, several times headed
conspiracies against Soviet Russia.

38

39

40

VLADIMIR MAYAKOVSKY

38 ROSTA window No 132. 1920

 1. THE ENTENTE'S WEAPON IS MONEY

 2. THE WHITE GUARDS' WEAPON IS LYING

 3. THE MENSHEVIKS' WEAPON – THE KNIFE IN THE BACK

 4. *PRAVDA* (TRUTH)

 5. OPEN EYES

 6. AND RIFLES – THOSE ARE THE COMMUNISTS' WEAPONS.

 Mensheviks, menshevism: a petit-bourgeois opportunist movement
 in the Russian Social Democratic Party which was hostile
 to Marxism-Leninism.

39 Glavpolitprosvet window No 141. 1921. Detail

40 ROSTA window No 337. 1920. Detail

A STORY OF BUBLIKS*
FOR SALE TO THE PUBLIC
AND OF A WOMAN WHO
DENIED THE REPUBLIC

1. THIS STORY TOOK PLACE ONE DAY
 IN SOME REPUBLIC OR OTHER;
 A WOMAN WENT DOWN TO THE MARKET,
 CARRYING BUBLIKS WITH HER.

2. SHE HEARS THE TRAMP OF FEET NEARBY.
 MUSIC WHISTLES DOWN THE WIND –
 SOLDIERS OF THE RED ARMY ARE SPEEDING
 TO SMASH THE POLES AT THE FRONT.

3. ONE OF THE SOLDIERS FELT LIKE EATING.
 SO HE SAYS TO HER: ''MA,
 GIVE A HUNGRY MAN A BUBLIK!
 YOU'RE NOT GOING TO THE FRONT.

4. IF MY JAWS DON'T GET TO WORK,
 I'LL BE AS FEEBLE AS DEAD MAN'S BONES.

5. THE POLES WILL DEVOUR THE REPUBLIC,
 IF WE'RE UNDERFED.''

6. THE WOMAN SAID, ''NOT ON YOUR LIFE!
 I'M NOT GIVING UP MY BUBLIKS!
 BE OFF WITH YOU, SOLDIER, LEAVE ME ALONE!
 I DON'T GIVE A TINKER'S FOR THE REPUBLIC!''

7. SO OFF WENT OUR REGIMENT, SKINNY AND THIN,
 BUT THE POLES ARE ALL GIGANTIC;
 THE POLES' MIGHT DOES US IN
 AT THE FIRST ENCOUNTER.

8. THE POLE RACES BY, FEROCIOUS, FURIOUS,
 BRINGING DEATH TO THE WORKING MAN.
 ON THE WAY HE COMES UPON
 THE STUPID WOMAN AT THE MARKET.

9. THE POLE SEES THE FAT, WHITE
 WOMAN IN THE CROWD.
 IN A FLASH SHE'S EATEN UP,
 SHE AND HER BUBLIKS.

10. TAKE A LOOK, COME OUT ON THE SQUARE!
 NO PEASANTS, NO SITNIKS** THERE.
 YOU'VE GOT TO FEED IN GOOD TIME
 THE MAN OF THE RED ARMY!

11. SO FEED THE RED MEN THEN!
 BRING YOUR BREAD AND DON'T COMPLAIN,
 OTHERWISE YOU'LL LOSE YOUR BREAD
 AND YOUR HEAD TOGETHER!

*Bubliks: Bread-rings.

**Sitniks: White bread made of sifted flour.

MIKHAIL CHEREMNYKH and VLADIMIR MAYAKOVSKY

41–43 ROSTA window No 241. 1920

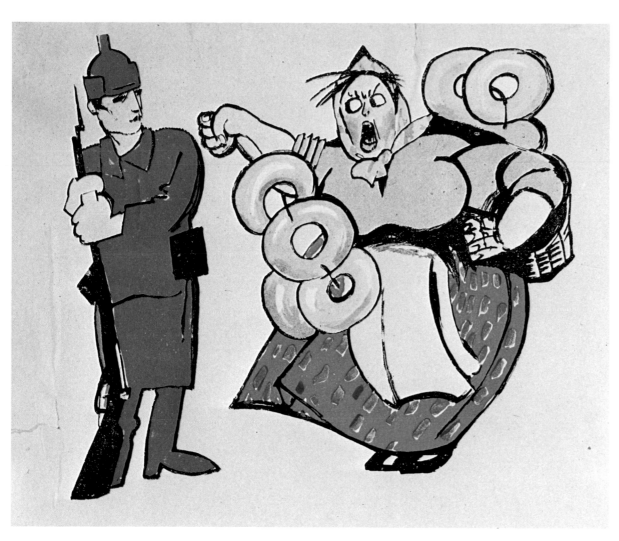

42

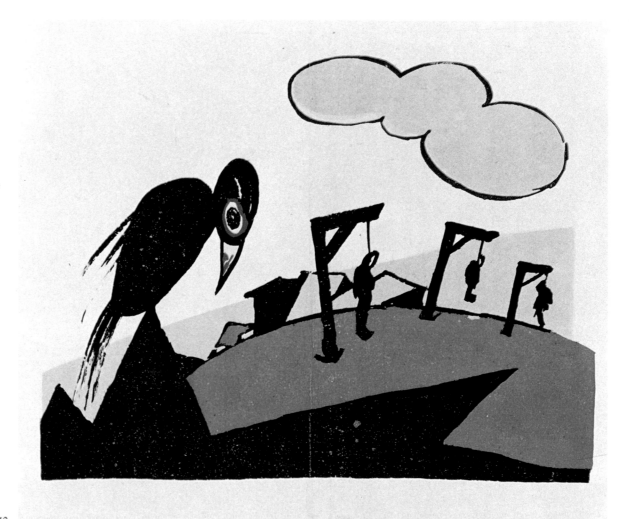

43

VLADIMIR LEBEDEV

44 ROSTA window. 1920
PEASANTS,
IF YOU DON'T WANT
TO FEED THE LANDLORDS,
FEED THE MEN AT THE FRONT INSTEAD,
WHO ARE DEFENDING
YOUR LAND AND
YOUR FREEDOM.

45

NIKOLAI KOGOUT

45 *Budionnovets* (one of Budionny's men). 1921.
Watercolor and India ink on paper, 18 × 14.7 cm.
Private collection, Moscow

Semion Budionny (1883–1973), a hero of the Civil War of 1918–20,
was a commander of the First Cavalry Army which operated
against enemies of the Soviet Republic in the Ukraine,
northern Caucasus, and the Crimea. He subsequently became
Marshal of the Soviet Union.

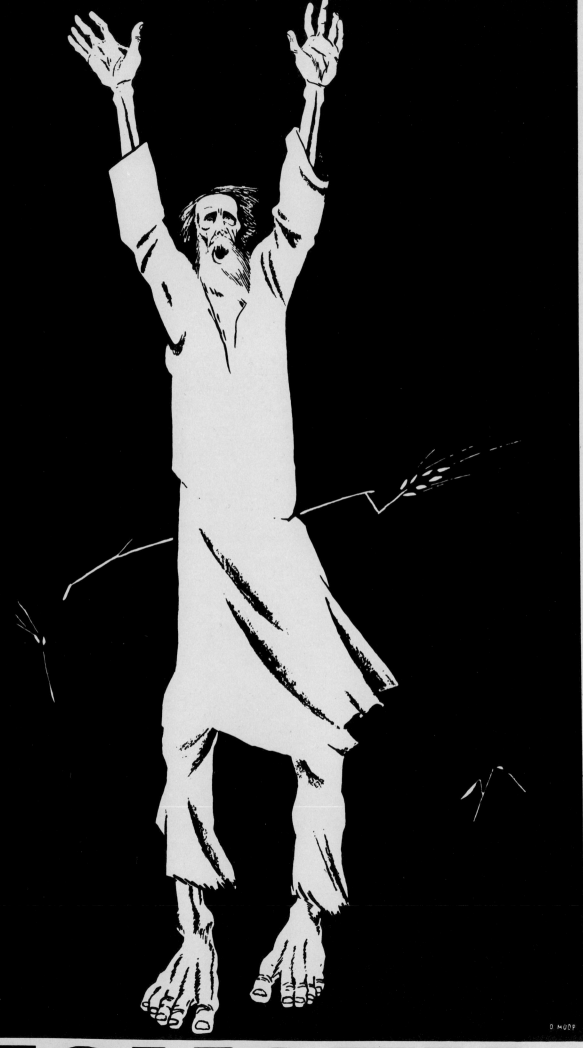

ПОМОГИ

DMITRY MOOR
46 *Help!* Poster. 1921

Хлѣба!
Защитникам земли, взятой крестьянами у помѣщиков.

Для успѣшной борьбы с надвигающеюся опасностью нѣмецкаго рабства и буржуазной кабалы необходимо весь сѣверь Россіи НЕМЕДЛЕННО обезпечить хлѣбом!

Хлѣба!
борцам за власть Крестьян, рабочих и солдат.

Ко всему крестьянству хлѣбородных областей и губерній
БРАТЬЯ КРЕСТЬЯНЕ!

Дорогіе братья! Крикомъ души мы, боевые революціонеры, обращаемся к Вам с этим призывом.

Откликнитесь! Отзовитесь! Бьет послѣдній час нашей рѣшительной битвы. Окончательно рѣшается вопрос: **о закрѣпленіи передачи трудящимся земли без выкупа, фабрик, заводов и банков.**

Шлите нам хлѣба, чтобы мы не были изнурены голодом и имѣли бы возможность крѣпко держать в своих руках винтовку против разбойников міра.

СОЦІАЛИСТИЧЕСКОЕ ОТЕЧЕСТВО В ОПАСНОСТИ!

Хлѣба! Хлѣба! Хлѣба!

Ссыпайте хлѣб в пустующіе элеваторы, в амбары и ссыпные пункты близ станцій желѣзных дорог и пристаней судоходных рѣк!

Наши желѣзныя дороги разрушены благодаря происходящим на них невѣроятным и сказочным безпорядкам. Трусы, мародеры и спекулянты, натянувши на плечи солдатскія шинели, чинят насилія на станціях желѣзных дорог и останавливают правильное движеніе поѣздов.

Сознательные и вѣрные революціи солдаты, крестьяне, и рабочіе! Мы призываем вас, оказывать содѣйствіе всѣм тѣм, кто охраняет наши желѣзныя дороги и препятствует хулиганам вмѣшиваться во внутренній распорядок их. Разрушеніем желѣзных дорог всѣ эти отбросы помогают нашему заклятому врагу — нѣмецкой буржуазіи и поэтому они — внѣ закона.

Хлѣба! Хлѣба! Хлѣба! Хлѣба!

Извѣщеніе от Совѣта Народных Комиссаров.
По техническим условіям хлѣбный паек может быть увеличен до полфунта только с 21-го января. 19 и 20 января будет выдано по старому, т. е. по четверть фунта.
Предсѣд. Сов. Нар. Комиссаров **В. Ульянов (Ленин).**
Народный Комиссар по Продовольствію **Шлихтер.**
Управляющій дѣлам Сов. Нар. Ком. **Влад. Бонч-Бруевич.**
Секретарь **Н. Горбунов.**
Петроградская Центральная Продовольственная Управа.
18 января 1918 г.

47 Appeal to the peasants to give bread to the State. 1918
Notice of the Soviet of People's Commissars on the bread ration. 1918

48

Stamps issued in aid of
the famine-stricken population. 1921–22

48 In aid of the famine-stricken population of
the Volga Region

49, 50, 52 Steamer, Train, Aeroplane

51 The Ukraine's aid to the starving

53 South-East's aid to the starving

SERGEI CHEKHONIN

54 *The Union of Art Workers Aids the Starving.*
Poster. 1921

In 1921 the Volga Region was hit by a terrible famine – the
result of an unprecedented drought. Posters, slogans, and
newspaper articles called on people to help the starving
and to share their last crust of bread with them.
People did everything they could and more.

49

50

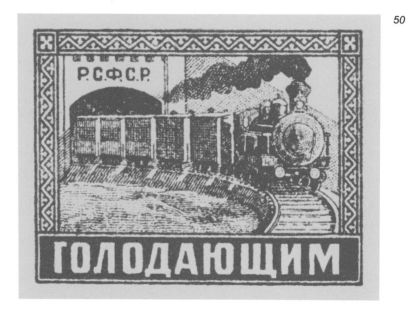

51

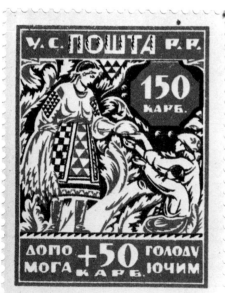

52

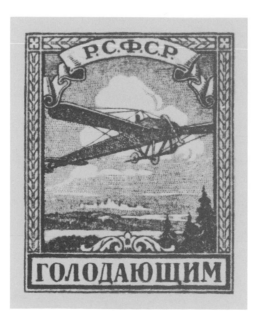

53

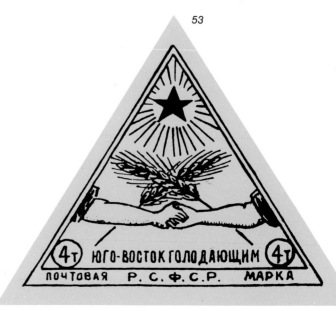

54

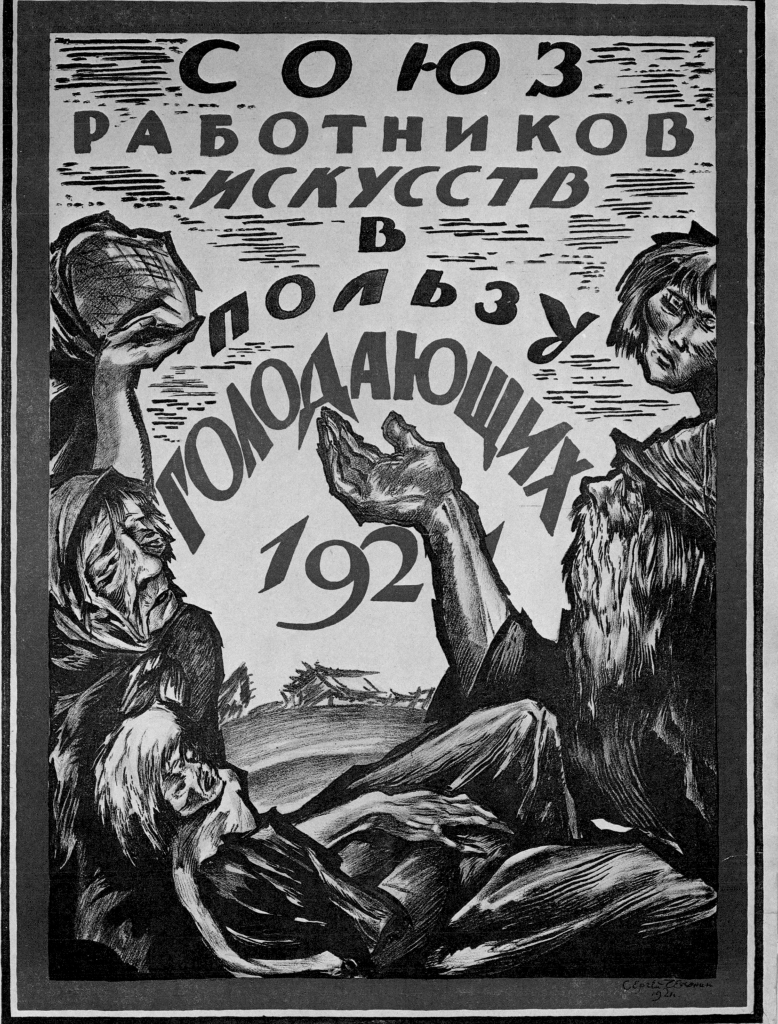

MIKHAIL CHEREMNYKH

55 ROSTA window. 1920
 1. YOU'LL BE BOLD,
 2. THE WHITES COLD.

56 ROSTA window. 1920
 1. THE ENTENTE'S A GLUTTON,
 2. THE ENTENTE WILL BURST ITS BUTTONS.

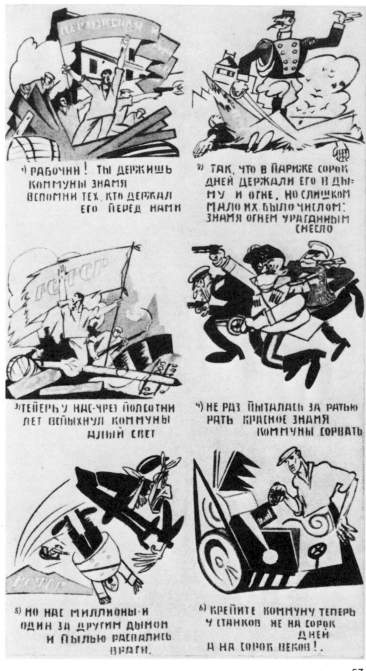

57

56

55

MIKHAIL CHEREMNYKH

57 ROSTA window. 1921
 1. WORKERS! YOU'RE BEARING THE BANNER OF THE COMMUNE;
 REMEMBER THOSE WHO BORE IT BEFORE US:
 2. BEAR IT AS IT WAS BORNE IN PARIS FORTY DAYS
 AMID SMOKE AND FIRE.
 BUT THERE WERE TOO FEW OF THEM:
 THE BANNER CAME DOWN IN A WHIRLWIND OF FLAME.
 3. NOW WITH US, FIFTY YEARS ON,
 THE SCARLET COLOR OF THE COMMUNE HAS BLAZED OUT AGAIN.
 4. TIME AFTER TIME, ONE ARMY AFTER ANOTHER HAS TRIED
 TO TEAR DOWN THE RED BANNER OF THE COMMUNE.
 5. BUT THERE ARE MILLIONS OF US, AND ONE AFTER ANOTHER
 OUR ENEMIES HAVE FALLEN APART IN SMOKE AND DUST.
 6. STRENGTHEN THE COMMUNE NOW, AT THE WORKBENCH,
 TO LAST NOT JUST FOR FORTY DAYS, BUT FORTY CENTURIES!

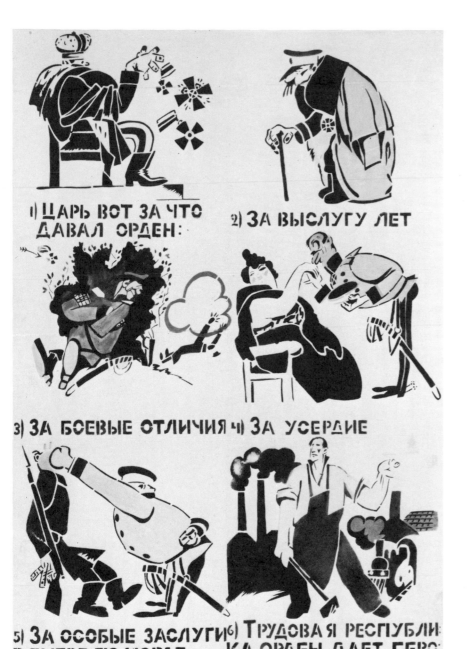

WE'VE TAUGHT A NUMBER OF MIGHTY POWERS NOT TO MAKE WAR ON US, BUT WE'VE STILL GOT TO BE PREPARED.

1. WE SUCCEEDED IN TEACHING A LOT OF THEM,

2. BUT THERE ARE STILL A LOT SHARPENING THEIR KNIVES;

3. WHILE ENTERING UPON YEARS OF WORK,

4. BE READY FOR THIS TOO, COMRADE!

59

МЫ ОТУЧИЛИ РЯД МОГУЧИХ ДЕРЖАВ ОТ ВОЙНЫ С НАМИ НО НАДО БЫТЬ ГОТОВЫМ.

1. МНОГИХ НАМ УДАЛОСЬ ОТУЧИТЬ,

2. НО И МНОГИЕ НЕ ПЕРЕСТАНУТ НОЖИ ТОЧИТЬ,

3. ПЕРЕЙДЯ НА ПУТЬ ТРУДОВЫХ ГОДОВ,

4. ТОВАРИЩ, И К ЭТОМУ БУДЬ ГОТОВ!

РОСТА N 744

58

MIKHAIL CHEREMNYKH

58 ROSTA window No 780. 1920

1. THIS IS WHAT THE TSAR GAVE MEDALS FOR:

2. YEARS OF SERVICE

3. DISTINCTION IN BATTLE

4. ZEAL

5. SPECIAL MERIT IN PUSHING IN FACES

6. THE REPUBLIC OF LABOR GIVES MEDALS TO HEROES OF WORK.

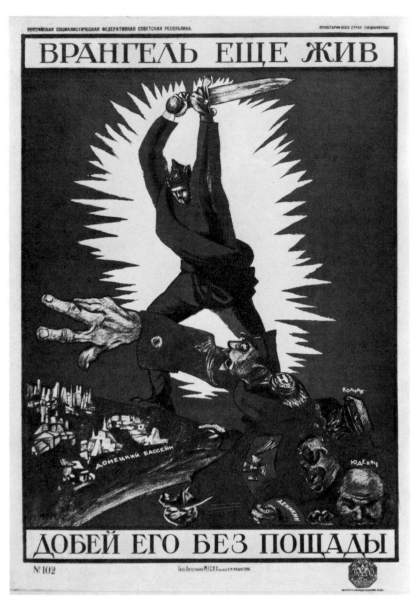

60

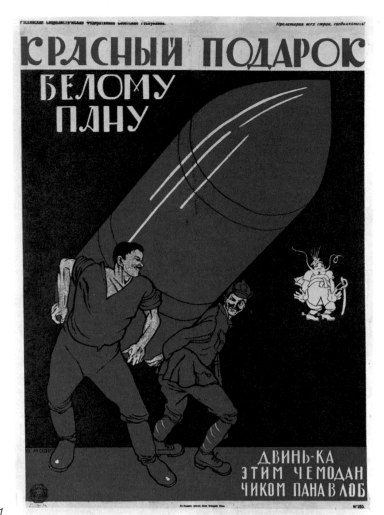

61

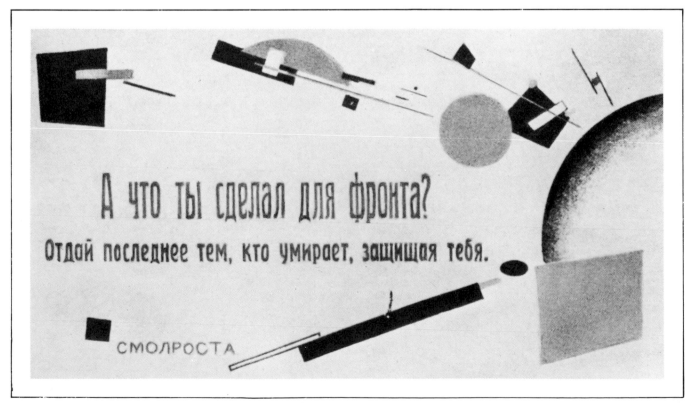

62

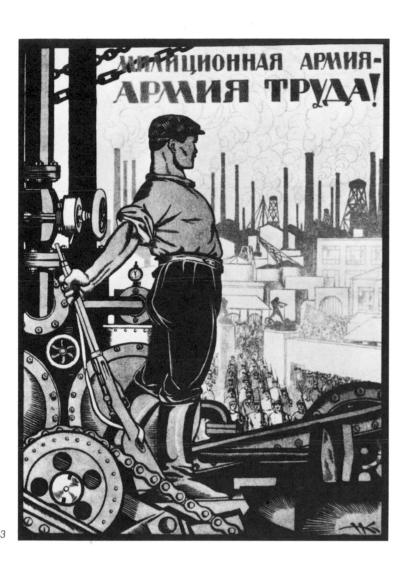

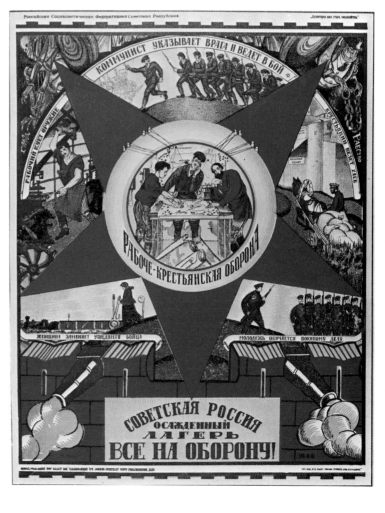

DMITRY MOOR

60 *Wrangel Is Still Alive, Smash Him without Mercy!* Poster. 1920

61 *A Red Gift for the White Pole.* Poster. 1920

UNKNOWN ARTIST

62 ROSTA window. 1920. Smolensk
WHAT HAVE YOU DONE TO HELP THE FRONT?
GIVE ALL YOU HAVE TO THOSE WHO GIVE THEIR LIVES FOR YOU.

NIKOLAI KOCHERGIN

63 *The Home Guard Is the Army of Labor!* Poster. 1920

NIKOLAI KOGOUT

64 *By Force of Arms We Have Smashed the Enemy,*
with Our Hands We Will Get Bread.
Comrades, Get Down to Work! Poster. 1921

DMITRY MOOR

65 *Soviet Russia Is a Camp under Siege. Defend It!* Poster. 1919

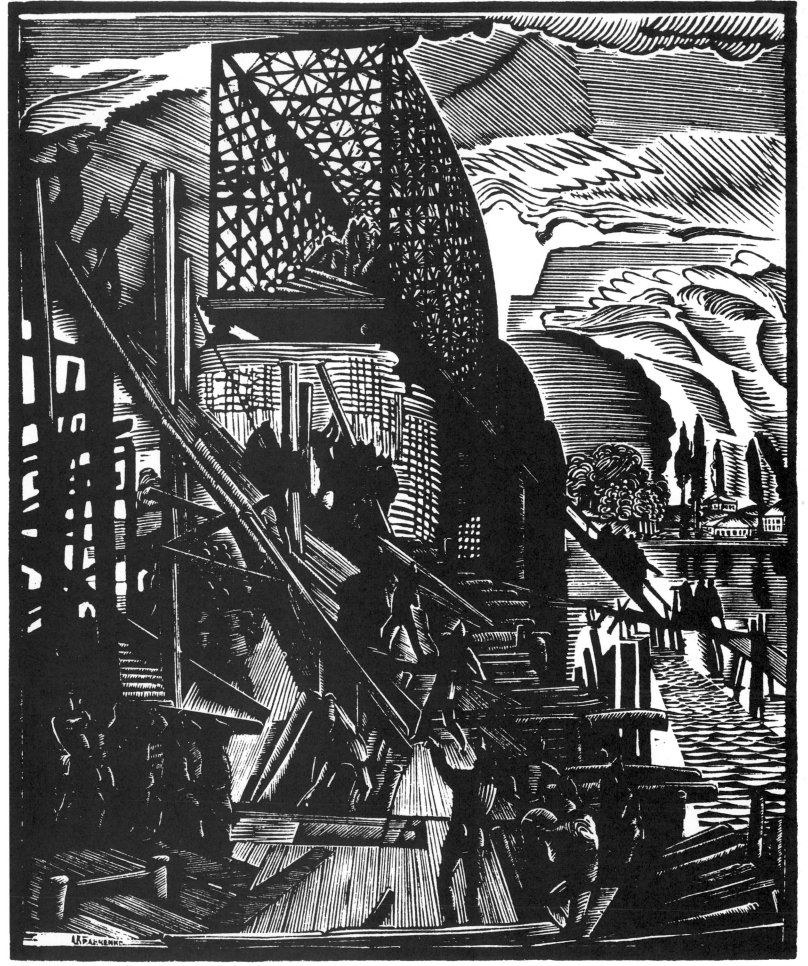

ALEXEI KRAVCHENKO

66 Red Army Men Reconstruct a Blown-up Bridge. 1923.
Xylograph, 18.1 × 14.6 cm.

67

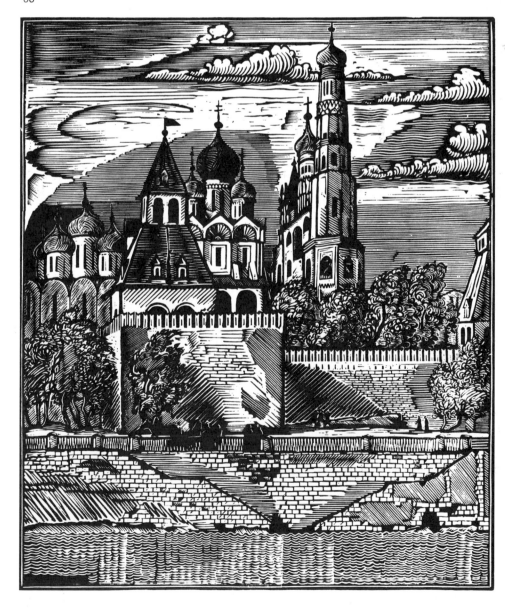

68

VADIM FALILEYEV

67 *The Troops of the Revolution*. 1919. Linocut, 6 × 18 cm.

ALEXEI KRAVCHENKO

68 *The Moscow Kremlin*. 1923. Xylograph, 16.4 × 13.2 cm.

РЕВОЛЮЦИОННАЯ

МОСКВА

—

ТРЕТЬЕМУ

КОНГРЕССУ

КОММУНИСТИЧЕСКОГО

ИНТЕР-
НАЦИО
НАЛА

ИЗДАНИЕ
МОСКОВСКОГО СОВЕТА MCMXXI

69 Cover of the album *Revolutionary Moscow
to the Third Congress of the Communist International*. 1921

DMITRY MOOR

70 *Long Live the 3rd International!* Poster. 1921

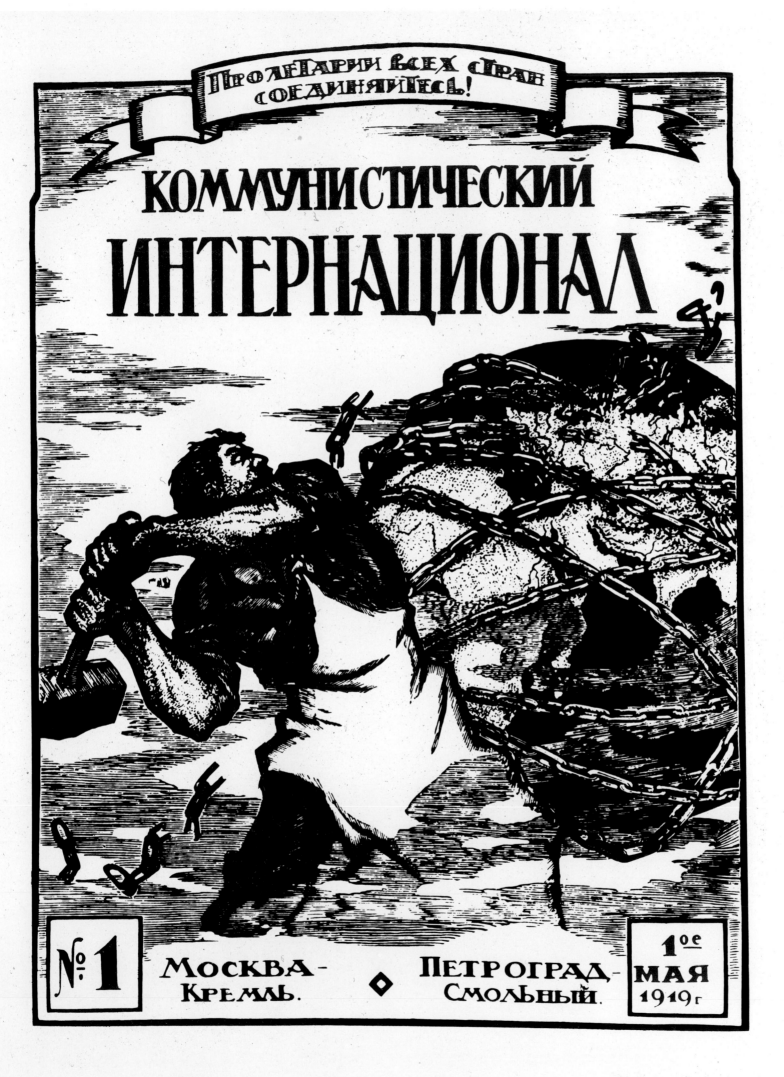

71 Cover of the journal *The Communist International,* 1919, No 1

GEORGY NARBUT
72 Cover of the journal *Mistetstvo* (Art), 1920, Kiev

BORIS GRIGORYEV
73 Cover of the journal *Plamia* (The Flame), 1918, No 33

ISAAC BRODSKY
74 Cover of the journal *Plamia* (The Flame), 1918, No 27

ADOLF STRAKHOV

75 *March 8 –*
Women's Emancipation
Day. Poster. 1920

IVAN SIMAKOV

76 *Long Live the Fifth Anniversary of the Great Proletarian Revolution!* Poster. 1922

It may well be said that in the first years after the Revolution the poster was the main or at least the most necessary art form. It was journalism in pictures, the *bon mot* brought to life.

The poster stimulated thought, expressed indignation, bubbled over with enthusiasm, provoked laughter, responded to events on the instant, and communicated news without delay. Posters were drawn at night, to be pasted up on the streets in the morning. Although the sheets were devised with the knowledge that their life was but a day, in the history of art they have lasted down the years. They have lasted not merely as witnesses of great events, but also because of their great and rigorous perfection.

Maximum information with the least means: this was impossible without penetrating insight and true craftsmanship, without a profound belief in the cause of the Revolution.

СЕВЕРНОЕ БЮРО
Центрального Агентства Всеросс. Центральн. Исполнительн. Комитета
„СЕВЦЕНТРОПЕЧАТЬ"

РАБОЧИЕ! Читайте свою печать и сейте слово правды!

WORKERS! READ YOUR PRESS
AND SPREAD THE WORD OF TRUTH!

Северное Бюро Центральн. Агентства В. Ц. И. К.
„СЕВЦЕНТРОПЕЧАТЬ"

РАБОЧАЯ ПЕЧАТЬ — факел, освещающий путь к новой жизни.

THE WORKERS' PRESS IS A TORCH
WHICH LIGHTS THE WAY TO A NEW LIFE.

Северное Бюро Центральн. Агентства В. Ц. И. К.
„СЕВЦЕНТРОПЕЧАТЬ"

РАБОЧИЙ! Если ты грамотен, собери неграмотных и читай им газету — ЭТО ТВОЙ ДОЛГ.

WORKER! IF YOU ARE LITERATE, BRING TOGETHER A GROUP OF ILLITERATES
AND READ THEM A NEWSPAPER – IT IS YOUR DUTY.

Северное Бюро Центральн. Агентства В. Ц. И. К.
„СЕВЦЕНТРОПЕЧАТЬ"

Печать—могучее оружие— ИСПОЛЬЗУЙТЕ ЕГО ПРОЛЕТАРИИ!

THE PRESS IS A POWERFUL WEAPON –
USE IT, PROLETARIANS!

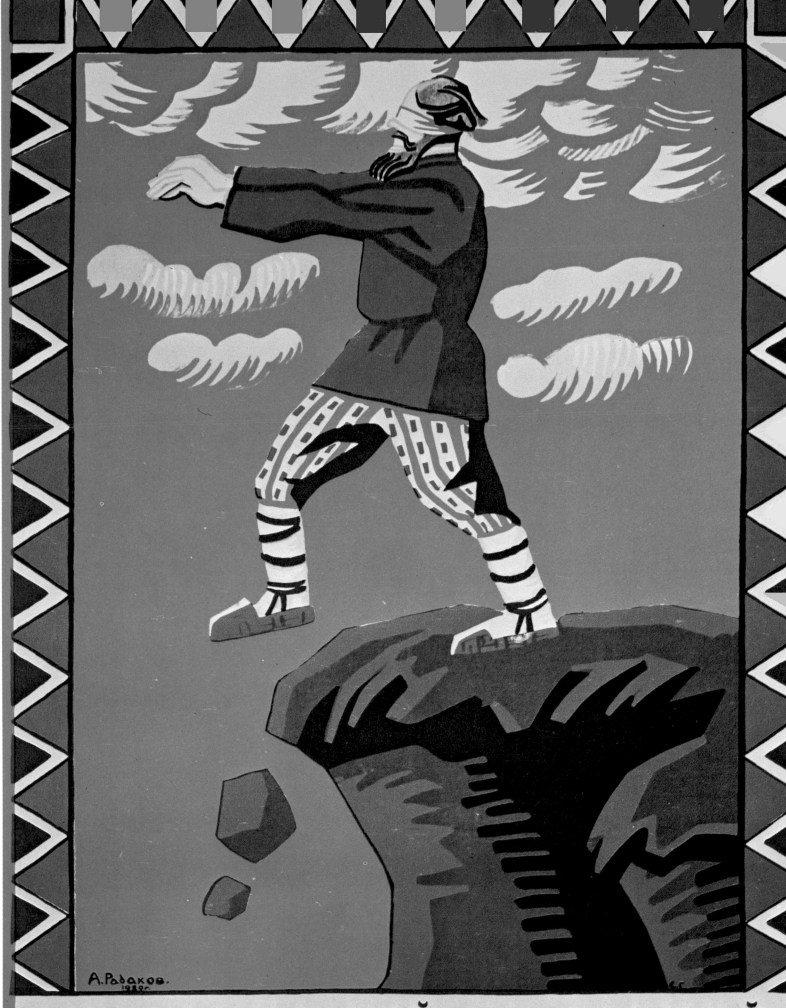

ALEXEI RADAKOV

81 *He Who Is Illiterate*
Is Like a Blind Man.
Failure
and Misfortune
Lie in Wait for Him
on All Sides.
Poster. 1920

YELIZAVETA KRUGLIKOVA

82 Women! Learn Your Letters!
Poster. 1923

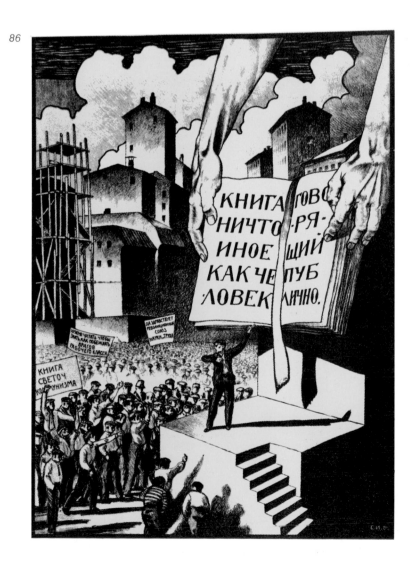

ALEXANDER RODCHENKO

83 The Press Is Our Weapon. Poster

ALEXANDER APSIT (PETROV)

84 Fit Out Reading Rooms! Poster. 1919

VERA MUKHINA

85 The Masses Are Powerless If They Are Not United,
and Unity Is Useless without Knowledge. Poster. 1919

S. IVANOV

86 Books Are Nothing But Men Talking to Everyone. Poster. 1920

ТВОРЕСТВО

ЖУРНАЛ

ЛИТЕРАТУРЫ, ИСКУССТВА, НАУКИ И ЖИЗНИ

N 5-6 1920

ИЗДАНИЕ МОСК. СОВ. Р. и К. Д.

IGNATY NIVINSKY

87 Cover of
the journal
Tvorchestvo
(Creative Work),
1920, Nos 5–6

РУССКОЕ ИСКУССТВО

№ 1923 г. 1

МОСКВА ПЕТЕРБУРГ

SERGEI
CHEKHONIN
and PIOTR
KONCHALOVSKY

88 Cover of
the journal
Russkoye Iskusstvo
(Russian Art),
1923, No 1

89

90

VLADIMIR FAVORSKY

89 Cover of the journal *Pechat i revolutsiya*
(The Press and the Revolution), 1923, No 4

90 *Still Life with Books*. 1919. Xylograph, 14.1 × 18.2 cm.

91 *View of Moscow from the Vorobyov Hills*. From the series
Views of Moscow. 1918. Xylograph, 11.2 × 12.2 cm.

92 Cover of the magazine *Makovets*, 1923, No 3. Xylograph, 18.1 × 17.5 cm.

91

92

93

VLADIMIR FAVORSKY

93 *The Sverdlov Hall.* 1921. Xylograph, 21 × 17.2 cm.

Красноармеец.

Если красное знамя рдеется,
Если люди дорвались до света,
Это дело красноармейца
Первой опоры Совета.

94

Матрос.

Потрудился в октябре я
День и ночь буржуев брея.

95

100

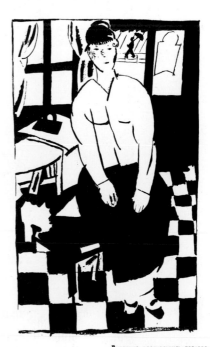

Прачка.

Довольно поотносились ласково,
Заждались Нева, Фонтанка и Мойка.
Прачка! Буржуя иди прополаскивать,
Чтоб был белее в Неве промой-ка.

96

Sheets from the album *October 1917–1918.*
Heroes and Victims of October. 1918.

Drawings by Xenia Boguslavskaya, Vladimir Kozlinsky,
Sergei Makletsov, and Ivan Puni;
text by Vladimir Mayakovsky

94–99 Heroes: soldier, sailor, laundress,
railwayman, seamstress, mechanic

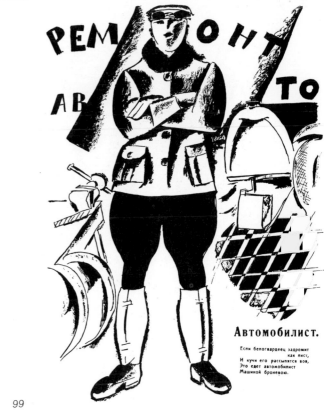

Автомобилист.

Если белогвардеец задрожит
как лист,
И кучи его рассыпятся вон,
Это едет автомобилист
Машиной броневою.

99

SEAMSTRESS

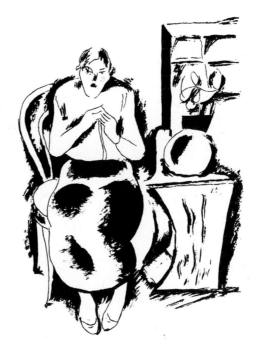

Довольно купчихам строчить тряпицы.
Золотом знамя теперь расшей-ка.
Октябрь идет, пора торопиться.
Вперед, швейка!

Швея.

98

101

RAILWAYMAN

Железнодорожник.

Ни сайки не достанется ни рожь никому,
Коли забудем железнодорожника мы.

VLADIMIR KOZLINSKY

Sheets from the unpublished album *Petersburg Today.* 1919

100 All Power to the Soviets! Linocut, 22.5 × 14.7 cm.

101 Street. Linocut, 31.6 × 21.6 cm.

97

Тов. Ленин ОЧИЩАЕТ землю от нечисти.

MIKHAIL CHEREMNYKH
and VICTOR DENI

102 Comrade Lenin
Sweeps the Globe Clean.
Poster. 1920

103

Банкир.

Все буржуи в панике
Отобрали банки.
Долю не найдешь другую
Тяжелей банкирочной,
Стал, селедками торгуя,
На углу у Кирочной.

BANKER

Sheets from the album *October 1917–1918.*
Heroes and Victims of October. 1918.

Drawings by Xenia Boguslavskaya, Vladimir Kozlinsky,
Sergei Makletsov, and Ivan Puni;
text by Vladimir Mayakovsky

103–6 Victims: banker, general, lady, factory-owner

105

Барыня.

Расстрелялись парни
Беспокойство барыне.
Надоел хозяйке пост
Самолично стала в хвост.

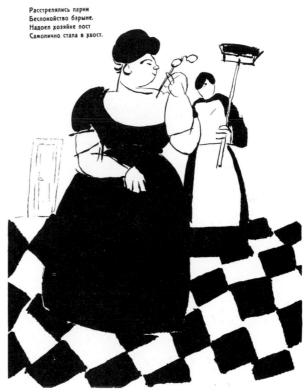

LADY

Генерал.

И честь никто не отдает,
И нет суконца алого,
Рабочему на флаг пошла
Подкладка генералова.

104

GENERAL

Заводчик.

Резвясь жила синица птица
За морем и за водами,
И день и ночь бедняге снится
Как он владел заводами.

106

FACTORY-OWNER

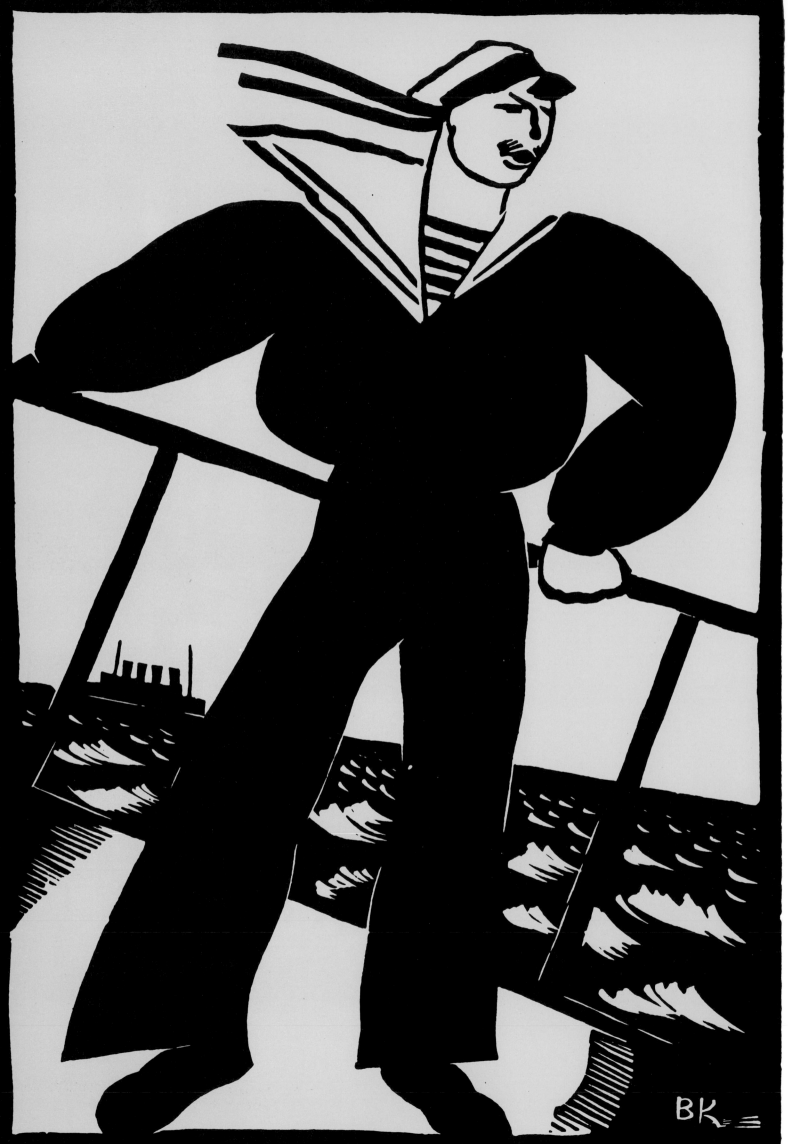

MSTISLAV DOBUZHINSKY

108 The Sts. Peter and Paul Fortress. From the album
Petersburg in 1921. 1921. Lithograph

VLADIMIR KOZLINSKY

107 Sailor. 1919. Linocut, 33.1 × 22.1 cm.

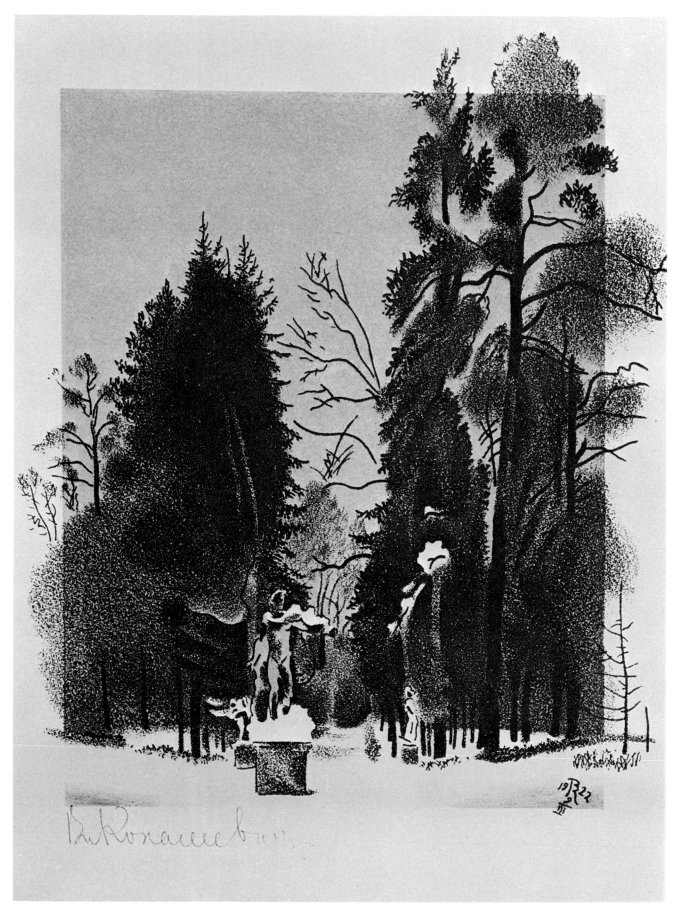

VLADIMIR KONASHEVICH

109 In the Old Sylvia. From the album
The Pavlovsk Park. 1922. Colored lithograph

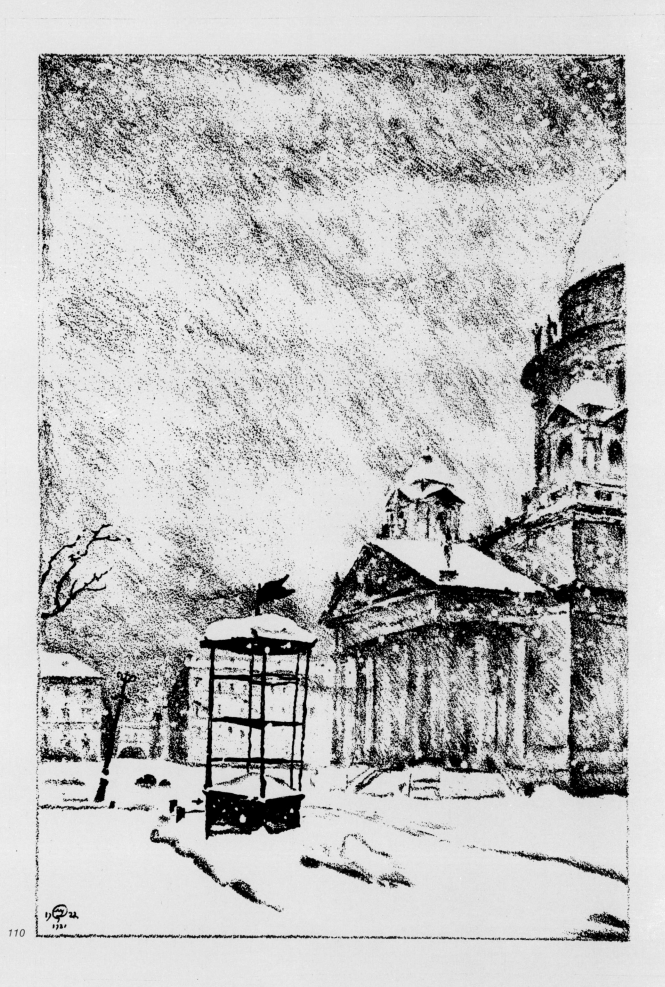

110

MSTISLAV DOBUZHINSKY

110 *St. Isaac's in a Snow Storm.* From the album
Petersburg in 1921. 1921. Lithograph

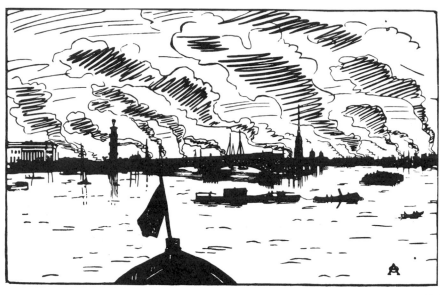

111

112

ANNA OSTROUMOVA-LEBEDEVA

111 *Petrograd. Construction of the Palace Bridge and Factory Smoke on the Vyborg Side.* 1919. Xylograph, 13.3 × 20.7 cm.

112 *The Moika near the Pevchesky Bridge.* 1919. Xylograph, 13.1 × 20.6 cm.

113 *Rigged for Fishing.* 1917. Colored xylograph, 27.1 × 38.8 cm.

113

Ростральная Колонна у Биржи. · Colonne Rostrale devant la Bourse.

PAVEL SHILLINGOVSKY

From the album *Petersburg.*
Ruins and Rebirth. 1923

114 *Barge.* Xylograph

115 *The Rostral Column near the Exchange.*
Xylograph

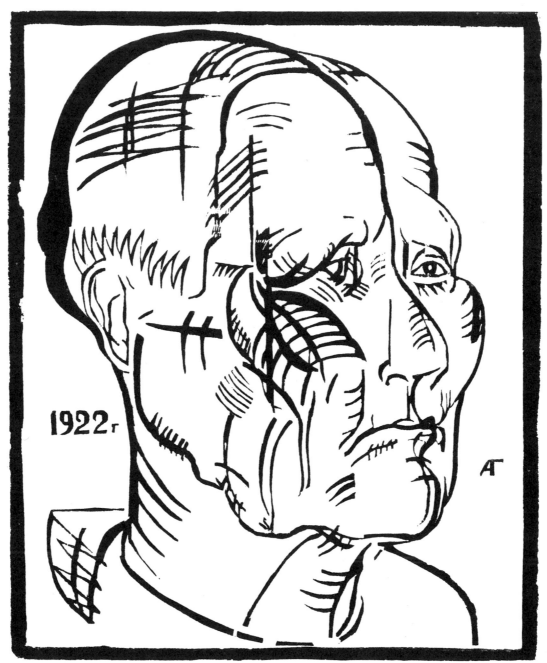

ANDREI GONCHAROV

116 Head of an Old Woman. 1922. Woodcut, 17 × 14.6 cm.

. . . We must have a swan's mighty wings to take flight on them, hang long in the air, and descend to earth unscorched, unharmed by that worldover conflagration of which we are all witnesses and contemporaries, which is flaming out and will go on flaming out, long, irresistible, shifting its centers from east to west and west to east until all the world bursts into flame and is consumed to ashes.

ALEXANDER BLOK. FROM THE ARTICLE "CATILINE." 1918

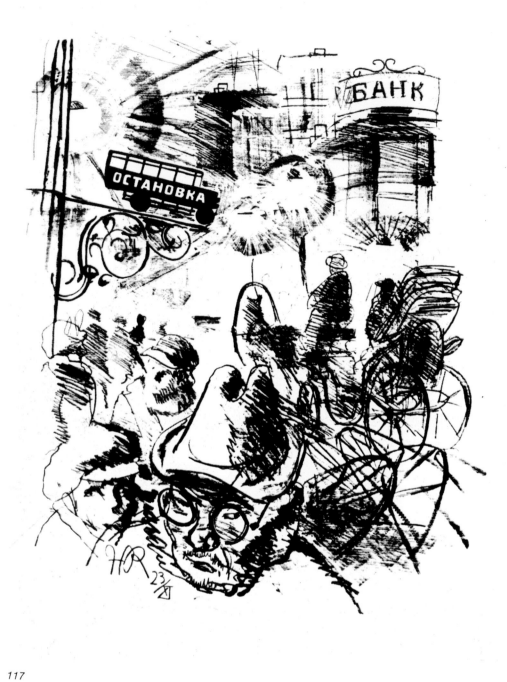

117

118

DMITRY KARDOVSKY

118 Bourgeois of the NEP (New Economic Policy). 1920s.
Watercolor, 34.5 × 20 cm.
The Russian Museum, Leningrad

119 Street. From the cycle *The City.* 1919. Pen and India ink

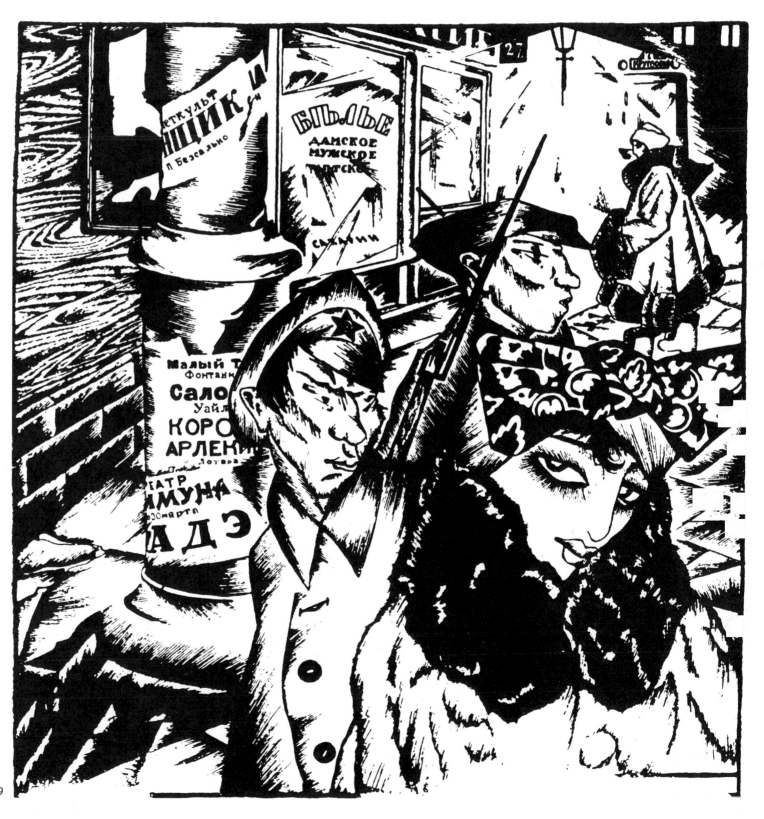

НАРОДНАЯ БИБЛИОТЕКА

А.С.ПУШКИН

КАПИТАНСКАЯ ДОЧКА

ГОСУДАРСТВЕННОЕ
ИЗДАТЕЛЬСТВО
ПЕТЕРБУРГ
1919

120

122

121

ALEXANDER BENOIS

120 Cover of Pushkin's novel *The Captain's Daughter*.
People's Library. 1919

121 Headpiece for Pushkin's poem ''The Bronze Horseman.'' 1921

VLADIMIR KONASHEVICH

122 Illustration for Fet's *Anthology of Verse*. 1921

MSTISLAV DOBUZHINSKY

123 Headpiece for Dostoyevsky's story *White Nights*. 1922

124 Illustration for Dostoyevsky's story *White Nights*. 1922

VENIAMIN BELKIN

125 Cover of Lermontov's story *Princess Mary*. People's Library. 1920

DMITRY MITROKHIN

126 Cover of Afanasyev's *Anthology of Russian Folk Tales*.
People's Library. 1919

123

124

125

НАРОДНАЯ БИБЛИОТЕКА

М. Ю. ЛЕРМОНТОВ
КНЯЖНА
МЕРИ

ГОСУДАРСТВЕННОЕ ИЗДАТЕЛЬСТВО
ПЕТЕРБУРГ * 1920

126

НАРОДНАЯ БИБЛИОТЕКА

А. Н. АФАНАСЬЕВ
РУССКИЕ
НАРОДНЫЕ
СКАЗКИ

ЛИТ.-ИЗД. ОТД. НАР КОМ. ПО ПРОСВ.
ПЕТЕРБУРГ
1919

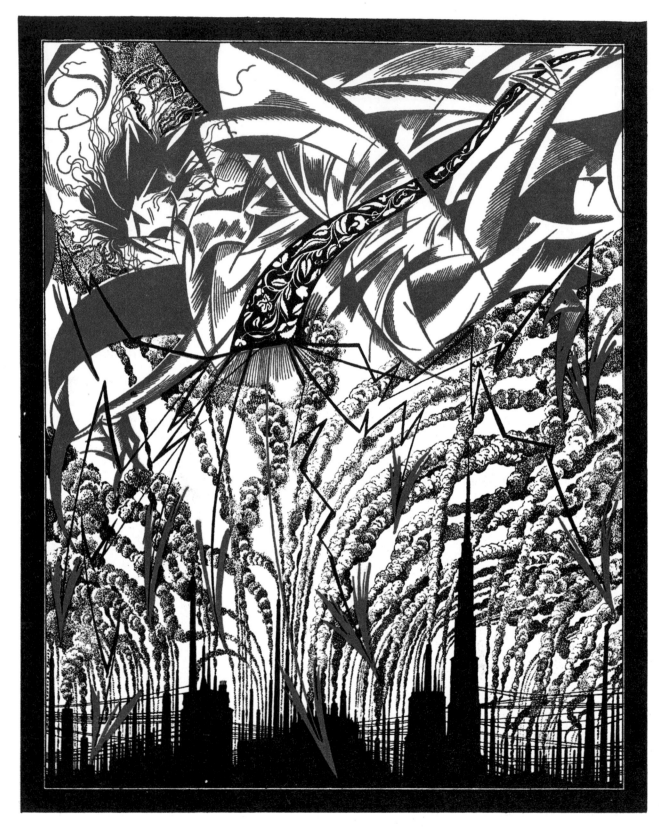

127

SERGEI CHEKHONIN

127 Illustration for Lunacharsky's play *Faust and the City*. 1919.
Watercolor (?), India ink, and pen on paper, 20.5 × 16.2 cm.

128

YURY ANNENKOV

128 Portrait of Maxim Gorky. 1920.
Watercolor, India ink, and pen on paper, 21 × 16.9 cm

129

130

131

132

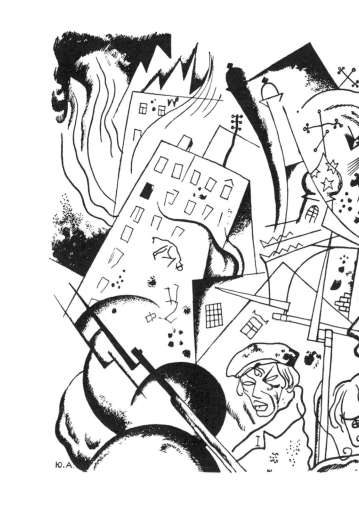

Black evening.
White snow.
The wind! The wind!
No one can keep upon his feet.
The wind! The wind!
Through all God's earth!

The wind ruffles
The white snow.
Under the snow is ice.
It is slippery, beastly . . .
Every walker
Slips. Ah, poor things!

. .

The wind is like a whip,
Just as fierce as the frost,
And the bourgeois at the crossroads
Buries his nose in his collar.

But who's this? with long hair
And speaking low:
"Traitors!
Russia is ruined!"
A writer, no doubt,
A phrase-maker . . .

. .

And there's a man in a long coat,
Passing by over there, beyond the snow-drift . . .
Why aren't you gay nowadays,
Comrade priest?
Do you remember the old days:
How you strutted belly foremost,
And how your belly with the cross upon it
Shone upon the people? . . .

. .

The tempest roves; the snow flies.
Twelve men march along.
Their rifle-slings are black . . .
All round are fires, fires, fires . . .

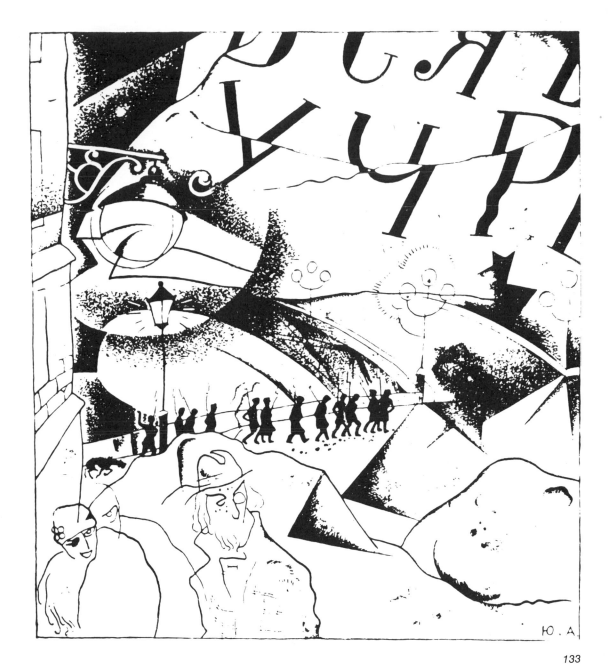

133

ALEXANDER BLOK. FROM THE POEM
"THE TWELVE." 1918

YURY ANNENKOV

129–133 Illustrations for Blok's poem "The Twelve." 1918

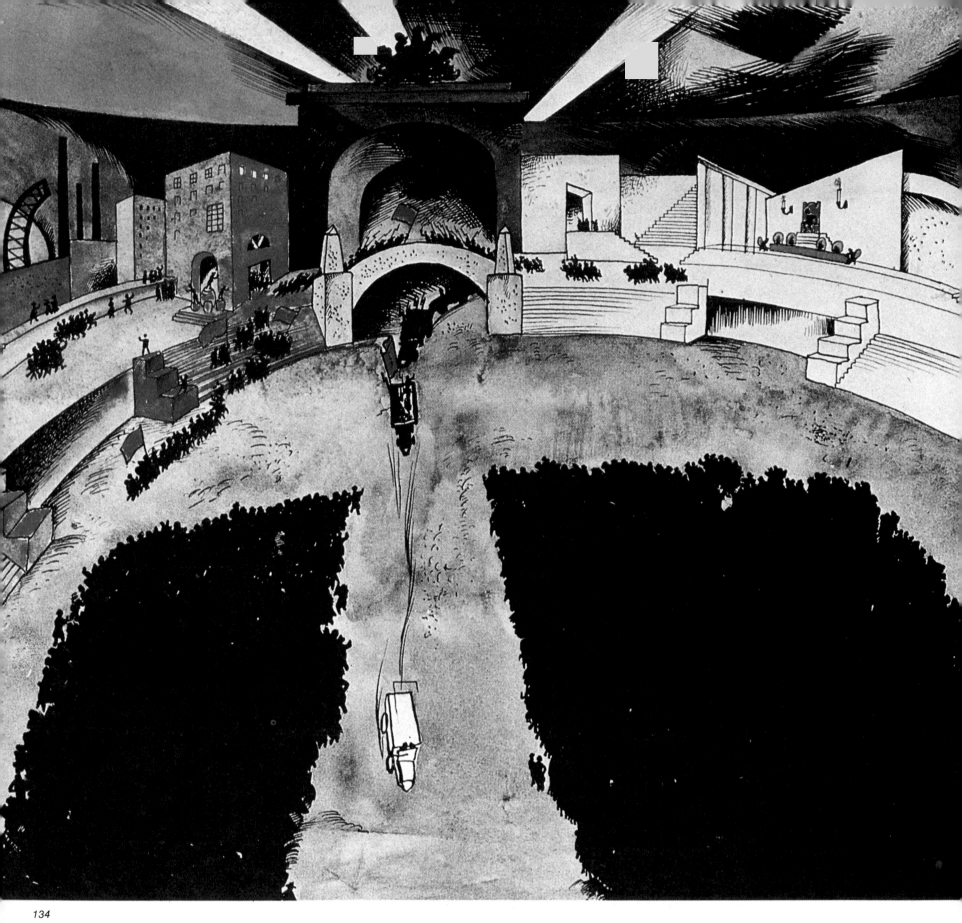

134

YURY ANNENKOV

134 *The Storming of the Winter Palace.*
Decor design for a mass performance on Palace Square
in Petrograd. 1920. Watercolor on paper.
Bakhrushin Theatre Museum, Moscow

VLADIMIR LEBEDEV

135 *Two Sailors with Rifles.*
From the series *Sidewalks of the Revolution.* 1922.
India ink and lead pencil on paper, 31.5 × 22 cm.
Private collection, Leningrad

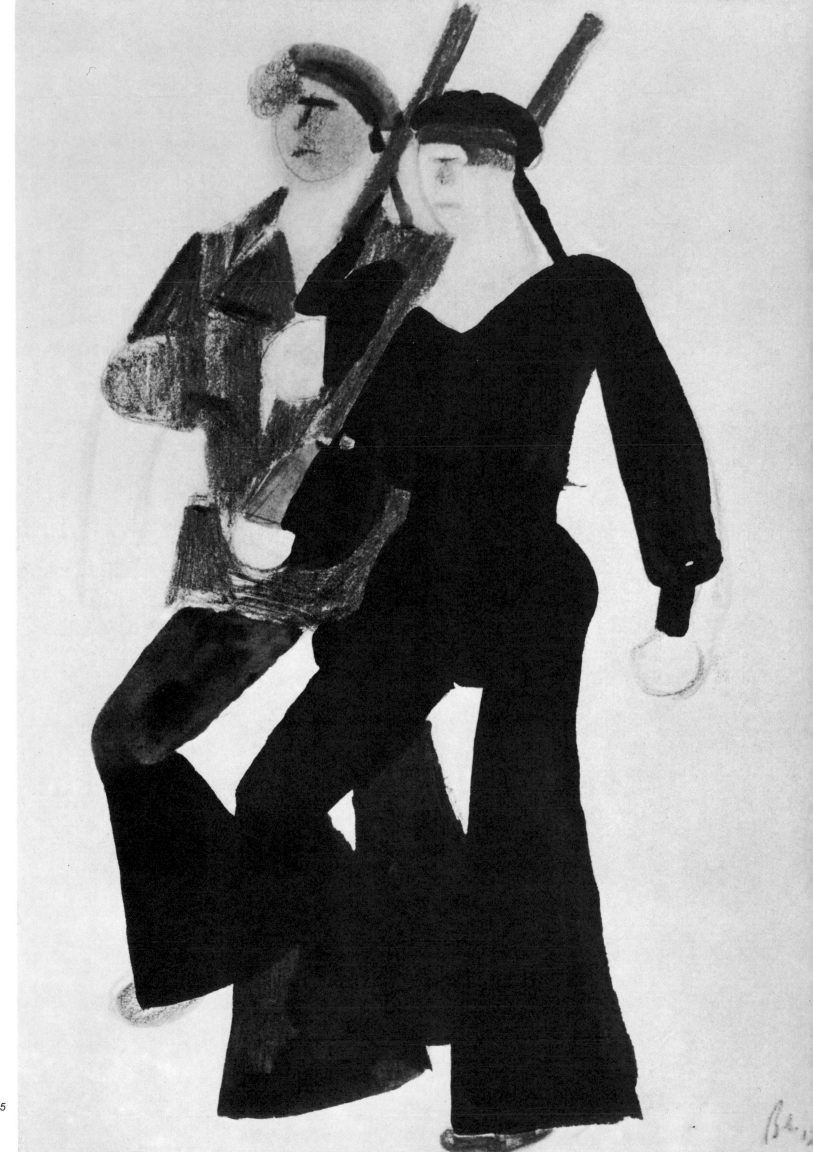

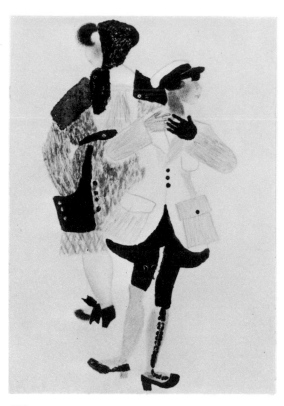

136

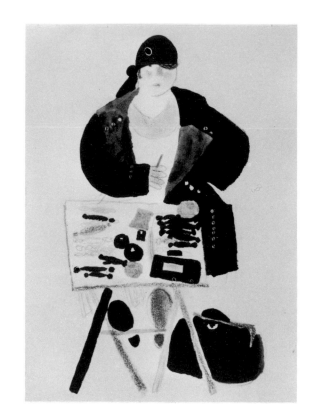

137

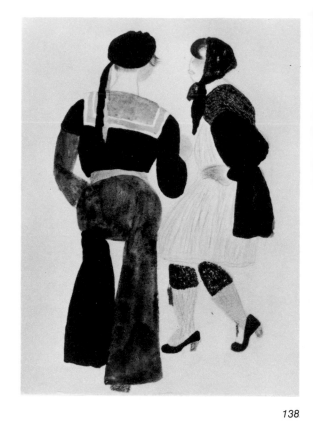

138

139

140

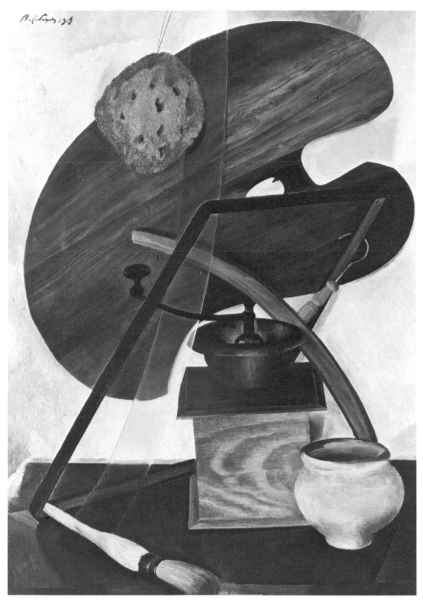

141

142

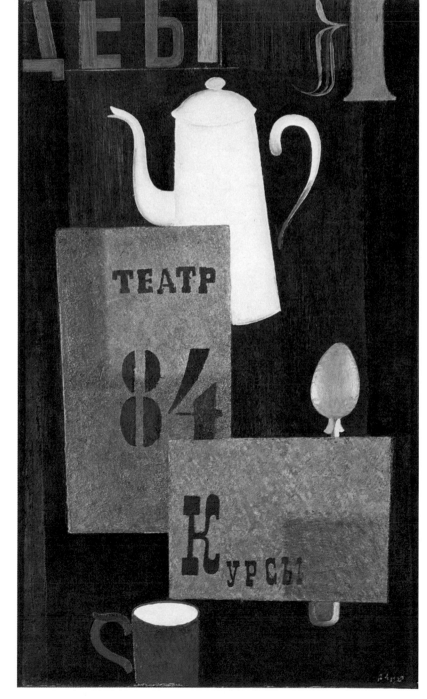

VLADIMIR LEBEDEV

Drawings from the series *Sidewalks of the Revolution.* 1922.
Private collection, Leningrad

136 *Girl and Dandy.*
 India ink, gouache, and lead pencil on paper, 30.5 × 23.7 cm.

137 *Market Woman.*
 India ink, gouache, and lead pencil on paper, 27.8 × 20 cm.

138 *Sailor and Girl.*
 India ink, gouache, and lead pencil on paper, 29 × 22 cm.

139 *Sailor and Girl.*
 India ink, gouache, and lead pencil on paper, 32.5 × 21.2 cm.

140 *Shoeblack.*
 India ink, gouache, and lead pencil on paper, 32.2 × 24.2 cm.

143

144

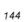

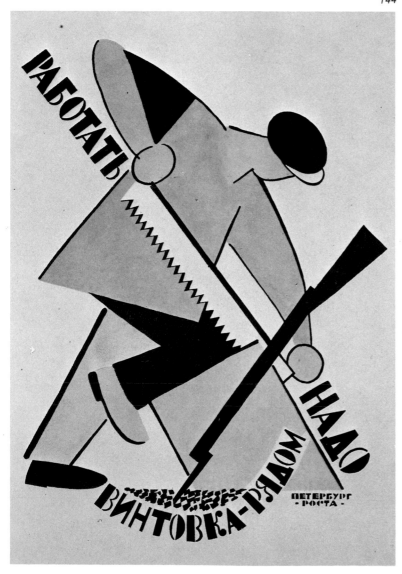

РАБОТАТЬ

НАДО

ВИНТОВКА-РЯДОМ

ПЕТЕРБУРГ
·РОСТА·

146

145

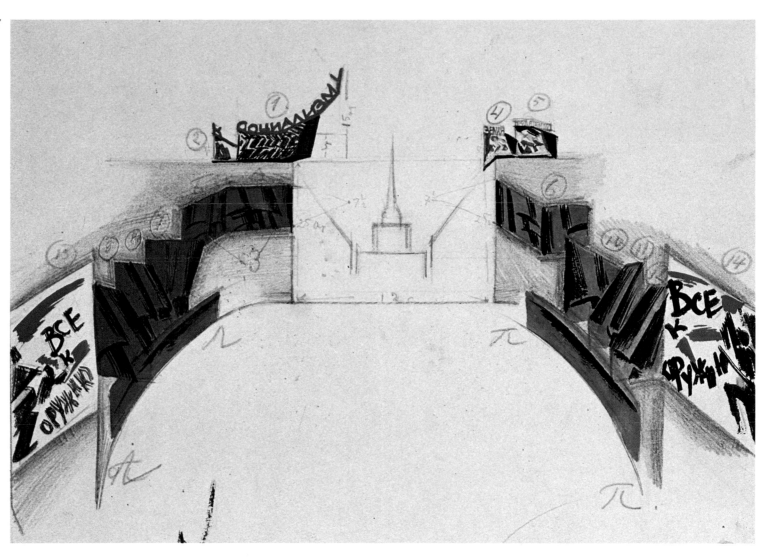

147

148

VLADIMIR LEBEDEV

143 *Apotheosis of a Worker.* Poster. 1920

144 *Setting to Work, Keep Your Rifle at Hand.* ROSTA window. 1921
Petrograd

145 *Iron-cutter.* Poster. 1920–21

146 *Demonstration.* Poster

147 Design for the decoration of the Police Bridge. 1918. Petrograd.
Mixed mediums on paper, 22.7 × 25.7 cm.
The Russian Museum, Leningrad

148 *Earth.* Panel design for the decoration of
the Police Bridge. 1918. Petrograd. Gouache on paper, 19.8 × 18 cm.
The Russian Museum, Leningrad

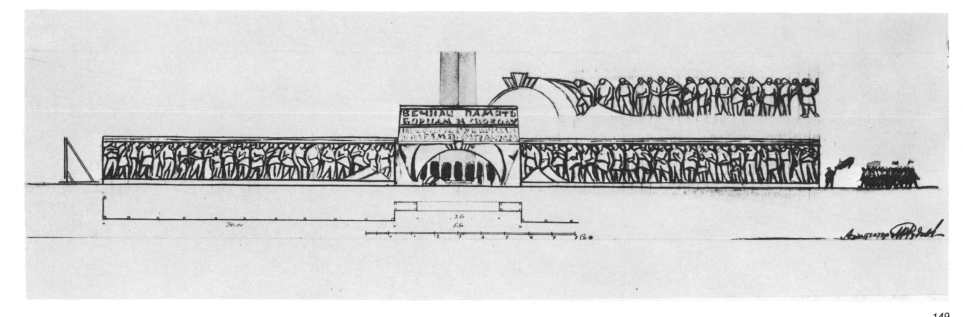

149

LEV RUDNEV

149 *Procession of Mourners*. Design for the decoration of
the Field of Mars. 1918. Petrograd. India ink and pen on paper.

150 Design for the festive decoration of the Field of Mars at night. 1918. Petrograd.
Watercolor and India ink on paper mounted on cardboard, 31 × 45 cm.
Museum of the Great October Socialist Revolution, Leningrad

150

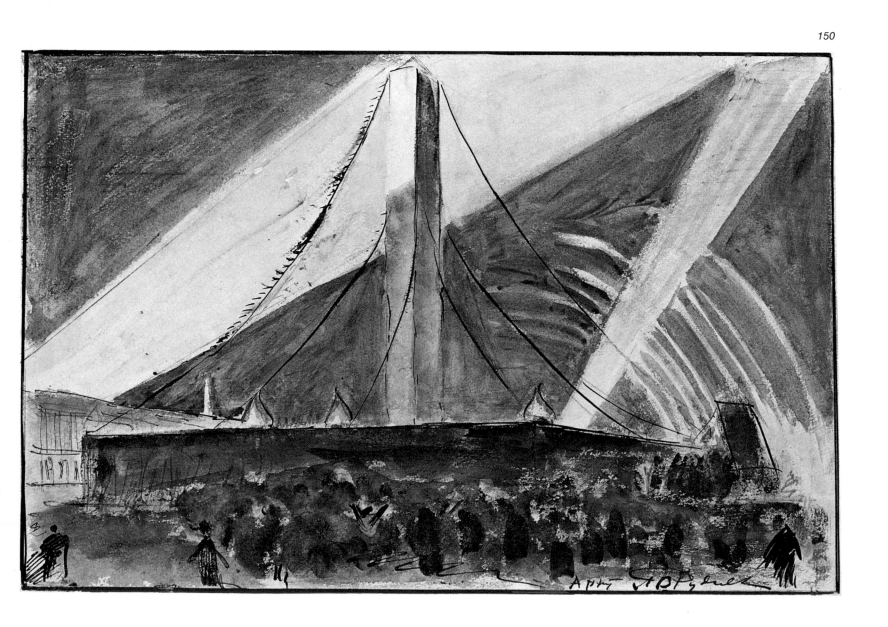

151

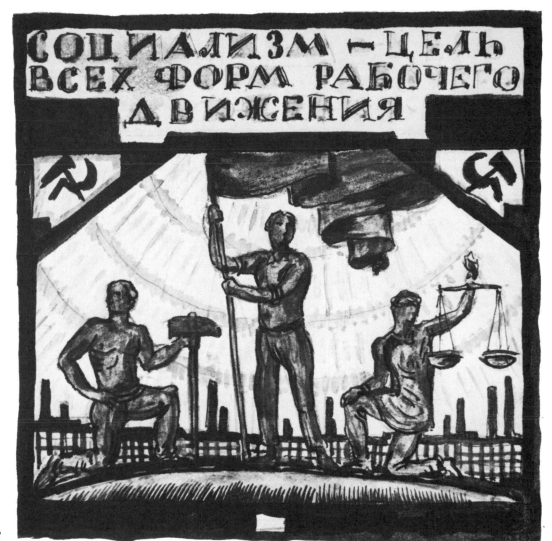

152

153

MSTISLAV DOBUZHINSKY

Designs for the festive decoration of
the Admiralty Building. 1918. Petrograd

151 *Flag.* Watercolor and black lead on paper, 31.2 × 17 cm.
The Russian Museum, Leningrad

152 *Socialism Is the Goal of All Working Movements.*
Panel. Watercolor, India ink, and black lead
on paper, 17.2 × 16.8 cm.
The Russian Museum, Leningrad

153 *Frontage.* Watercolor, India ink, black lead,
and crayons on paper mounted on cardboard,
54.5 × 63 cm.
Museum of the Great October Socialist Revolution,
Leningrad

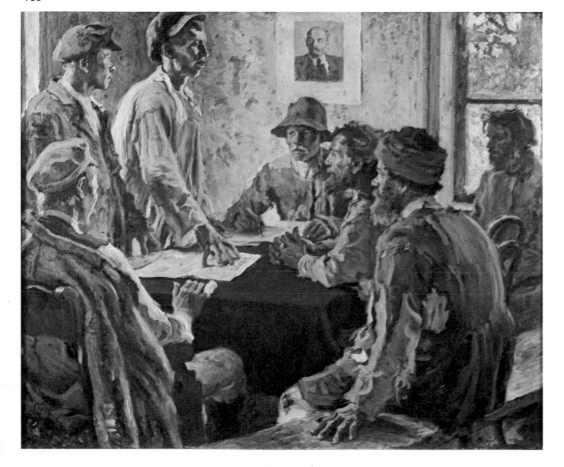

155

YEFIM CHEPTSOV

154 *Meeting of a Village Party Cell.* 1924.
Oil on canvas, 59 × 77 cm.
The Tretyakov Gallery, Moscow

ALEXANDER MORAVOV

155 *Meeting of a Committee of Poor Peasants.* 1920.
Oil on canvas, 103 × 125 cm.
The USSR Museum of the Revolution, Moscow

156

156 *Portrait of the Writer Dmitry Furmanov.* 1922.
Oil on canvas, 82 × 71 cm.
The Tretyakov Gallery, Moscow

Dmitry Furmanov (1891–1926), commissar of the celebrated Chapayev division during the Civil War of 1918–20, wrote the novel *Chapayev*.

157

MITROFAN GREKOV

157 *Off to Join Budionny's Army.* 1923.
Oil on canvas, 37 × 52 cm.
The Tretyakov Gallery, Moscow

KASIMIR MALEVICH

158 *The Red Cavalry*. 1918.
Oil on canvas, 90 × 140 cm.
The Russian Museum, Leningrad

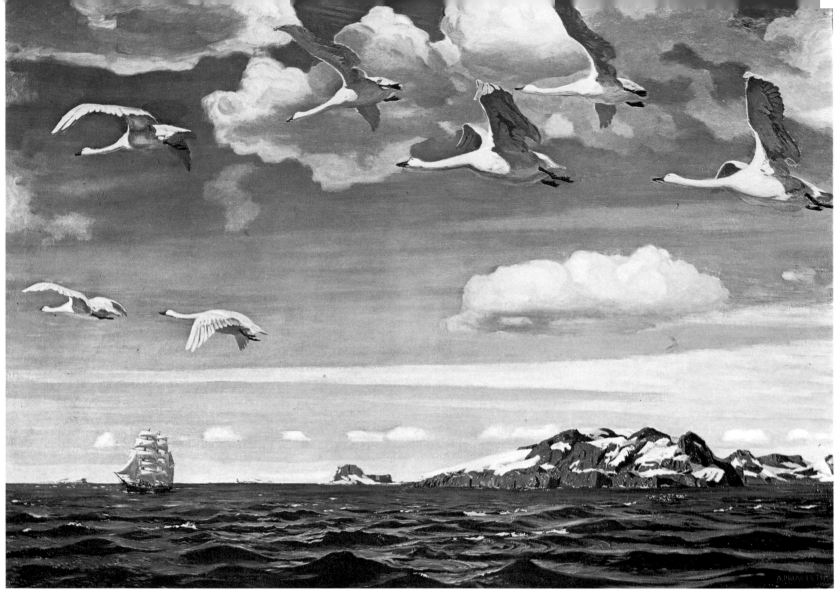

159

ARKADY RYLOV

159 The Blue Expanse. 1918.
Oil on canvas, 109 × 152 cm.
The Tretyakov Gallery, Moscow

160 Sunset. 1917.
Oil on canvas, 100 × 129 cm.
Museum of Fine and Applied Arts,
Smolensk

160

KONSTANTIN YUON

161 *Symphony of Action.* 1920.
Oil on canvas, 80 × 93 cm.
Private collection, Moscow

162 *A New Planet.* 1921.
Tempera on cardboard, 71 × 101 cm.
The Tretyakov Gallery, Moscow

161

162

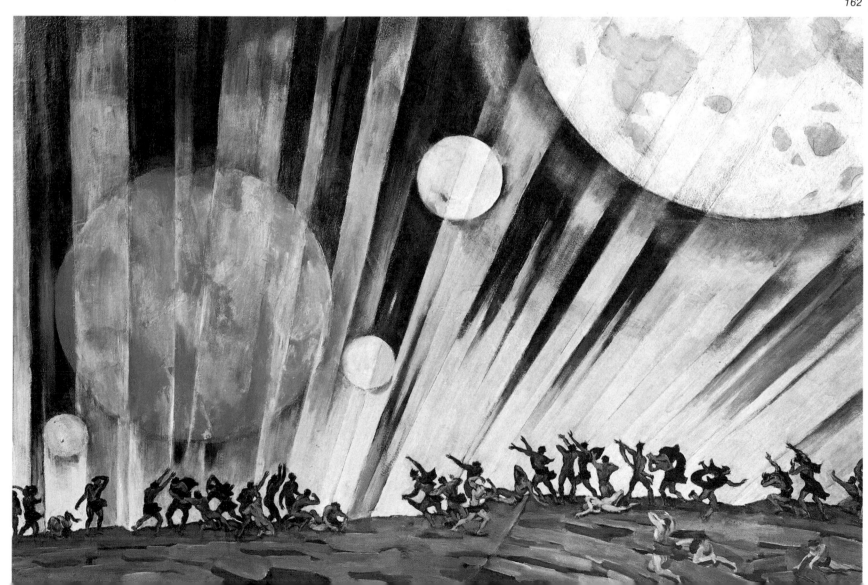

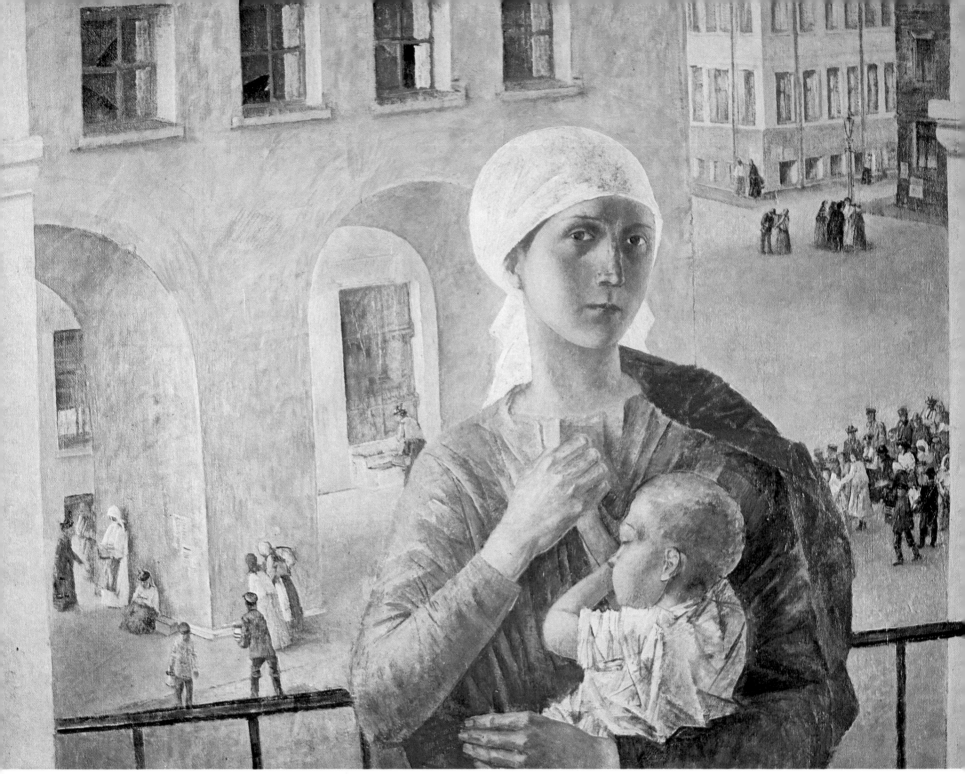

163

KUZMA PETROV-VODKIN

163 *The Year 1918 in Petrograd.* 1920.
Oil on canvas, 73 × 92 cm.
The Tretyakov Gallery, Moscow

KUZMA PETROV-VODKIN

164 *After the Battle.* 1923.
Oil on canvas, 154 × 121.5 cm.
Museum of the USSR Armed Forces, Moscow

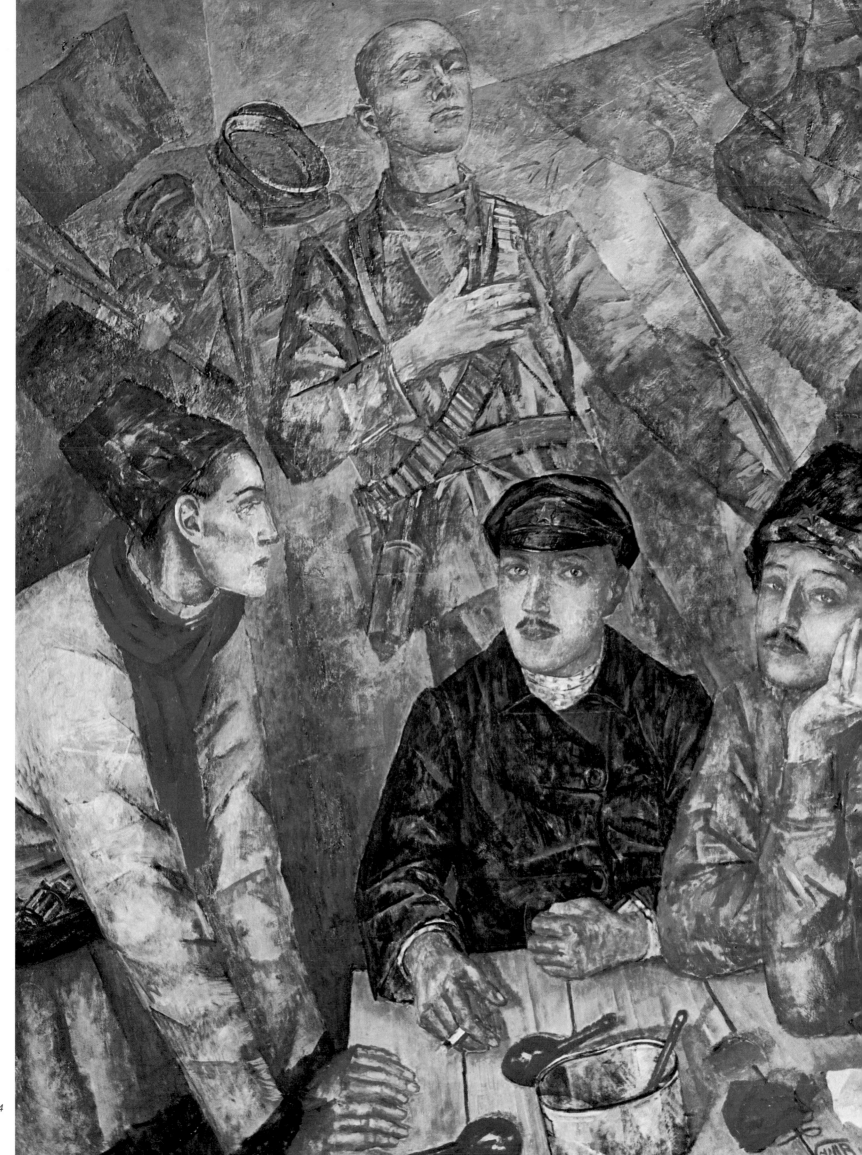

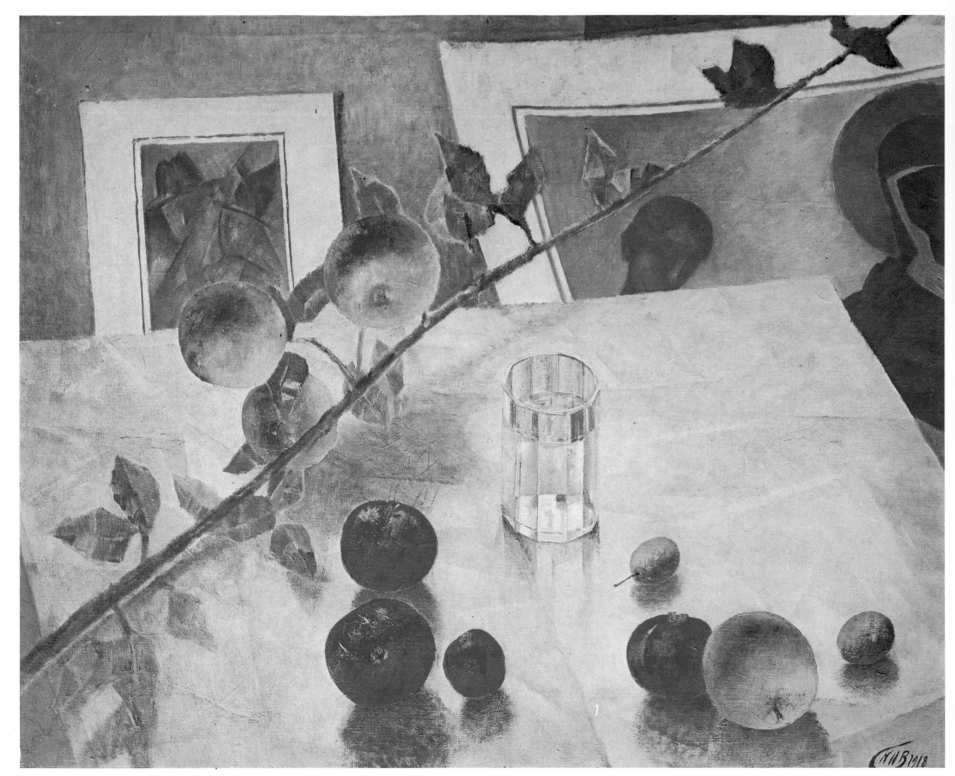

165

KUZMA PETROV-VODKIN

165 *Pink Still Life. Twig of an Apple Tree.* 1918.
Oil on canvas, 58 × 71 cm.
The Tretyakov Gallery, Moscow

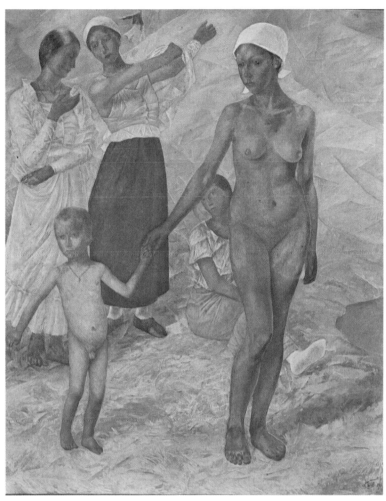

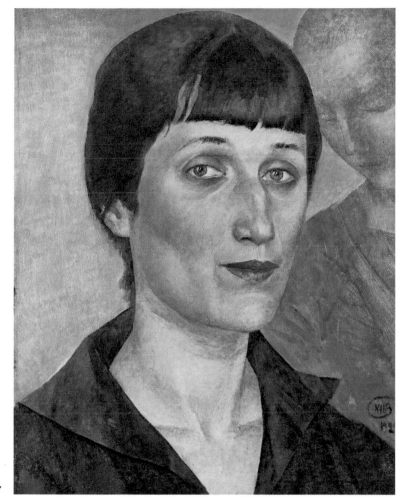

166

167

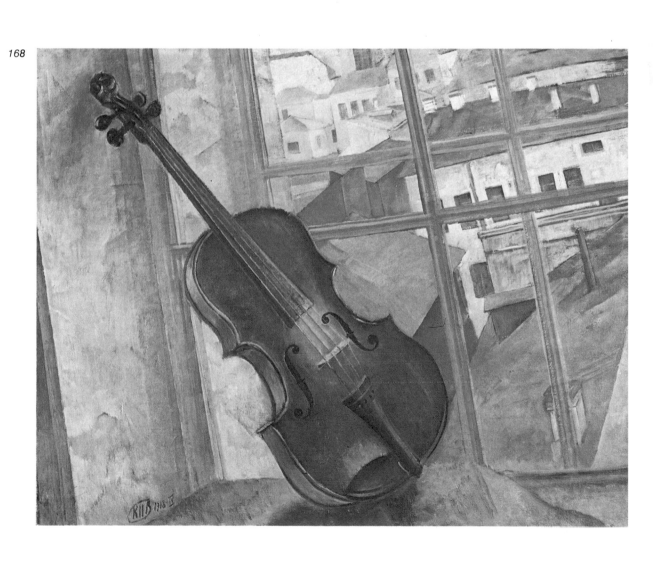

168

KUZMA PETROV-VODKIN

166 *Morning.* 1917.
Oil on canvas, 160 × 129 cm.
The Russian Museum, Leningrad

167 *Portrait of Anna Akhmatova.* 1922.
Oil on canvas, 54.5 × 43.5 cm.
The Russian Museum, Leningrad

168 *Violin.* 1918.
Oil on canvas, 65 × 80 cm.
The Russian Museum, Leningrad

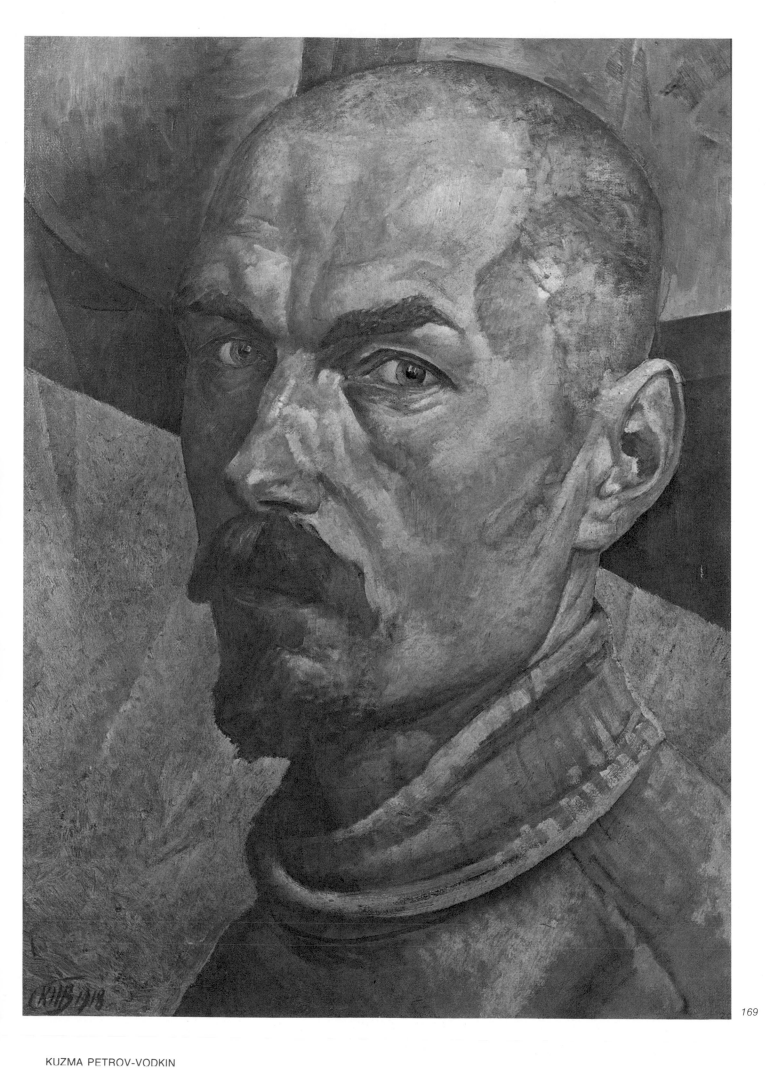

169

KUZMA PETROV-VODKIN

169 Self-Portrait. 1918. Oil on canvas, 73 × 53 cm.
The Russian Museum, Leningrad

170

KUZMA PETROV-VODKIN

170 Herring. 1918. Oil on oil-cloth, 58 × 88.5 cm.
The Russian Museum, Leningrad

Painting requires of the artist exceptional powers of concentration: a picture takes months to paint, sometimes even years.

At the time of the Revolution the world was changing before the artists' eyes, and they found it difficult to express in painting the headlong changes of the day. The exact representation of events, the philosophical still life, the bold allegory, the portrait of a man of the new world: underlying all this was the untiring quest for that new language of painting which could convey the throbbing pulse of the Revolution, the decisive step forward of the revolutionary age.

With these creative quests for something new were intertwined traditions: the inspiration of artists working at that time derived from the best in Russian democratic painting. It is to be marveled at that so many splendid canvases were produced in a period when there was so little time for quiet work in a studio, and when life was so difficult. This proves once again that art – if it is indeed art – cannot remain indifferent to the current affairs of the real world.

KUZMA PETROV-VODKIN

171 Design for a festive poster. 1918.
Watercolor on paper, 24.8 × 17.7 cm.
The Russian Museum, Leningrad

Panel designs for the festive decoration of
Theatre Square. 1918. Petrograd

172 *Stepan Razin*.
Watercolor and black lead on paper, 36.8 × 63.5 cm.
The Russian Museum, Leningrad

173 *The Firebird*.
Watercolor on paper, 31.5 × 63 cm.
The Tretyakov Gallery, Moscow

174 *Mikula Selianinovich* (Russian epic hero).
Watercolor on paper, 37 × 64 cm.
History and Architecture Museum, Pskov

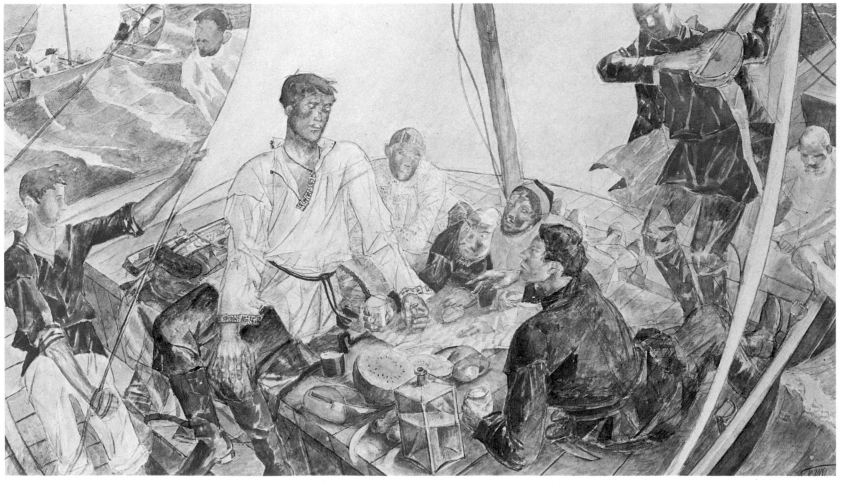

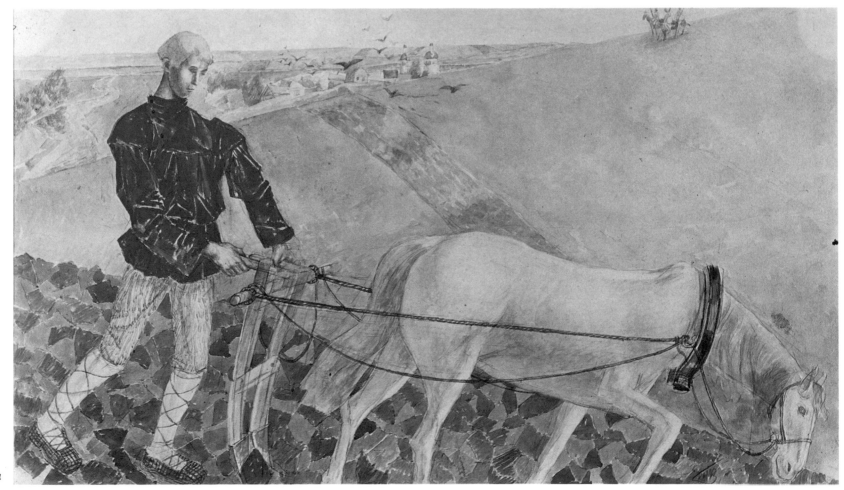

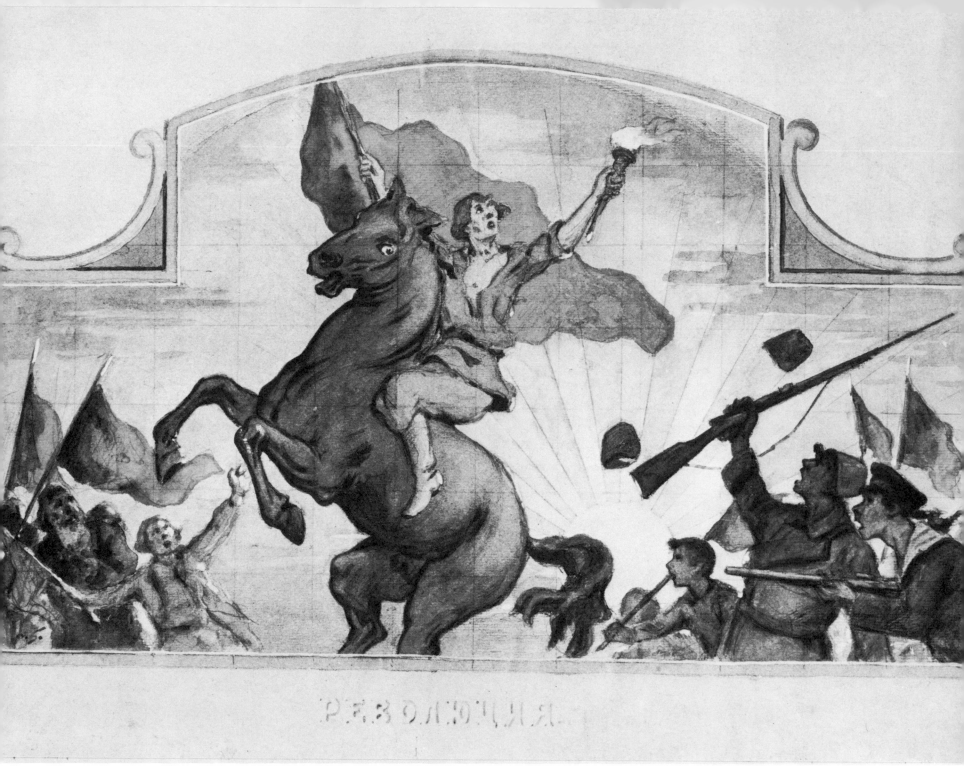

РЕВОЛЮЦИЯ

175

In the difficult days of the Civil War, the young Soviet Republic staged revolutionary celebrations as prototypes of the future. Art took to the streets: cities were decked out with picturesque panels, vivid montages of banners and flags, garlands of colored lamps.

There were no expensive materials, there was little time. Only the striking facility of the artists and their wonderful grasp of fantasy ensured that plywood and cloth would be enough to create magnificent and joyful spectacles.

Even the celebrated architectural complexes of Moscow and Petrograd were seen in a new light when decked in festive array. Artists seemed to be revealing anew the beautiful buildings to their onlookers, sometimes even arguing with the past. In this way the dialogue between past and present became part of the celebration.

FIODOR BUCHHOLZ

175 *The Revolution.*
Panel design for the festive decoration of
Bolshoi Prospekt on Vasilyevsky Island. 1918.
Petrograd.
Watercolor and lead white on paper,
44.5 × 64.3 cm.
The Russian Museum, Leningrad

ARNOLD LAKHOVSKY and YAKOV BUVSTEIN

176 *The Triumph of Labor.*
Arch design for the festive decoration of
Liteiny Prospekt. 1918. Petrograd.
Watercolor, India ink, and pen on paper,
29 × 39.2 cm.
The Russian Museum, Leningrad

176

VASILY SHUKHAYEV

177 Design for the festive decoration of the Lieutenant Schmidt Bridge. 1918. Petrograd.
Watercolor and gouache on paper mounted on cardboard, 66.5 × 89.5 cm.
Museum of the Great October Socialist Revolution, Leningrad

S. IVANOV

178 Design for the festive decoration of the former Duma Building. 1918. Petrograd.
Watercolor, India ink, and lead white on paper mounted on cardboard, 68 × 51.5 cm.
Museum of the Great October Socialist Revolution, Leningrad

177

178

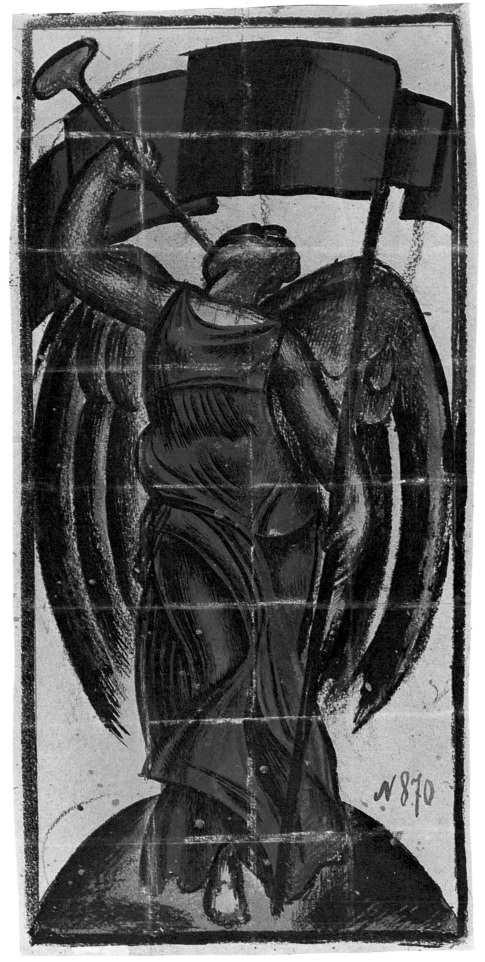

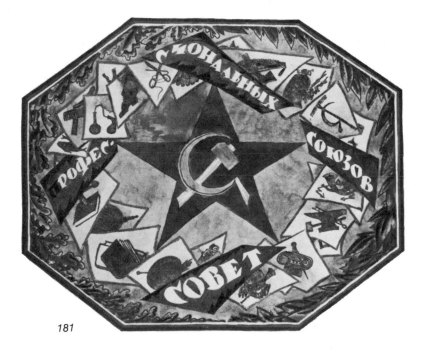

179

UNKNOWN ARTIST

180 *Revolutionary Procession.* Panel design.
Watercolor and India ink on paper, 37 × 59.5 cm.
Museum of the Great October Socialist Revolution,
Leningrad

UNKNOWN ARTIST

179, 182 Panel designs for the decoration of streets to celebrate
the First Anniversary of the October Revolution. 1918. Petrograd.
Watercolor and India ink on paper, 50.8 × 24 cm; 49.7 × 24 cm.
The Russian Museum, Leningrad

181

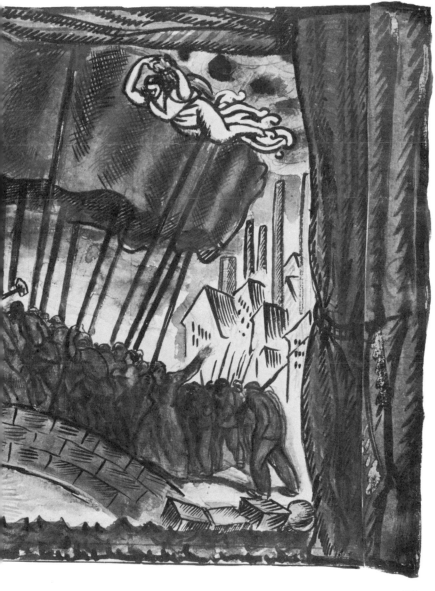

180

The revolutionary whirlwind has torn out of men's souls
the ugly roots of slavery. The soul of the people awaits
a mighty seed-time.

Perhaps artists will turn the gray dust of our cities into
rainbows of a hundred colors; perhaps a thunderous
music, volcanoes turned into pipes, will resound without
ceasing from the mountaintops; perhaps we will compel
the waves of the ocean to play upon the strings of the
networks stretching out from Europe to America.

Of one thing we are certain — we have turned over
the first page in the modern history of the arts.

VLADIMIR MAYAKOVSKY. "OPEN LETTER TO THE WORKERS." 1918

SIGISMUND VIDBERG

181 Trade Union emblem design.
Watercolor and India ink on paper, 23.5 × 27.5 cm.
The Russian Museum, Leningrad

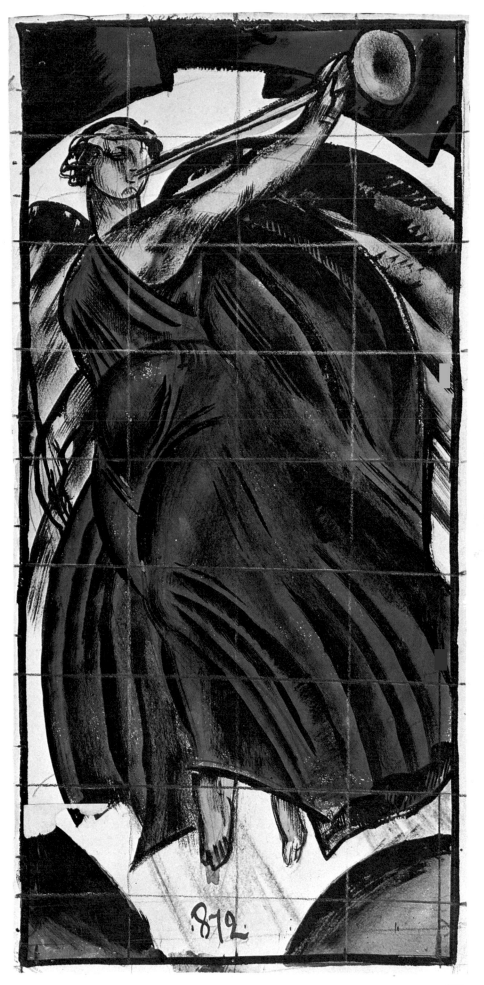

182

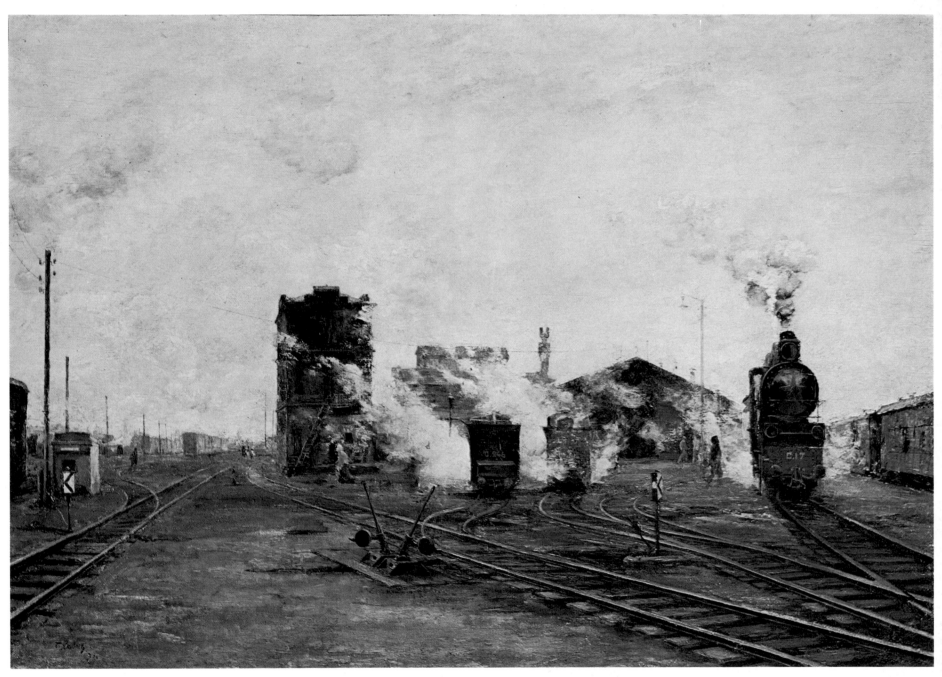

183

BORIS YAKOVLEV

183 Transport Returns to Normal. 1923.
Oil on canvas, 100 × 140 cm.
The Tretyakov Gallery, Moscow

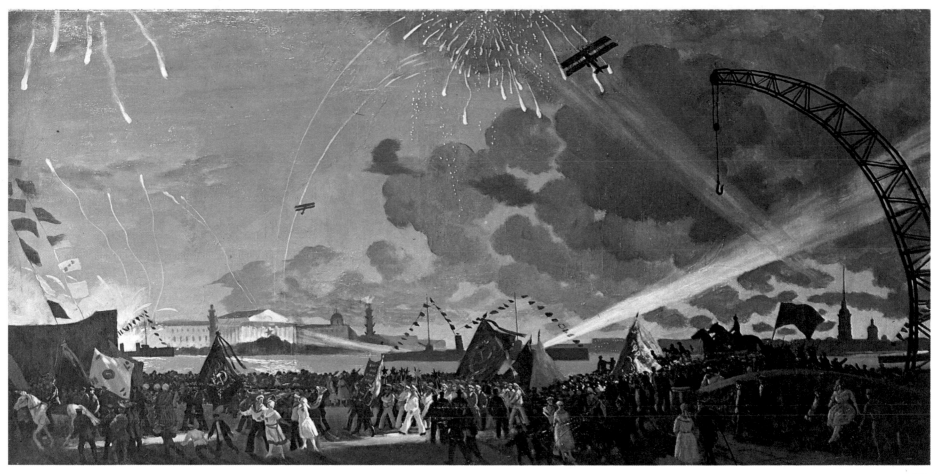

184

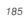185

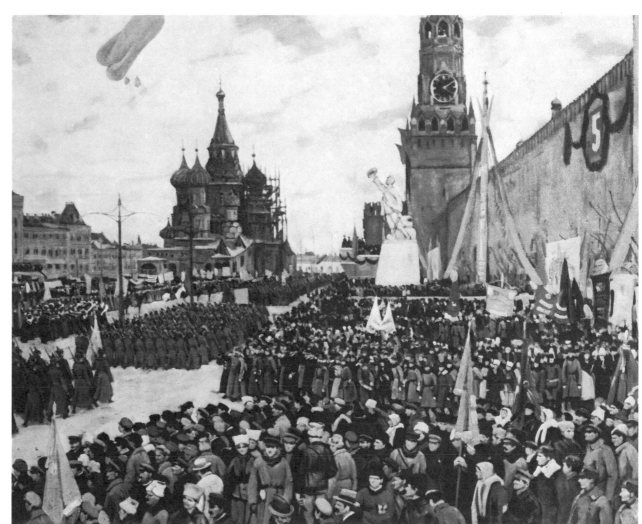

BORIS KUSTODIEV

184 *Night Celebration on the Neva.* 1923.
Oil on canvas, 107 × 216 cm.
The Russian Museum, Leningrad

KONSTANTIN YUON

185 *Parade in Red Square.* 1923.
Oil on canvas, 89.5 × 111.5 cm.
The Tretyakov Gallery, Moscow

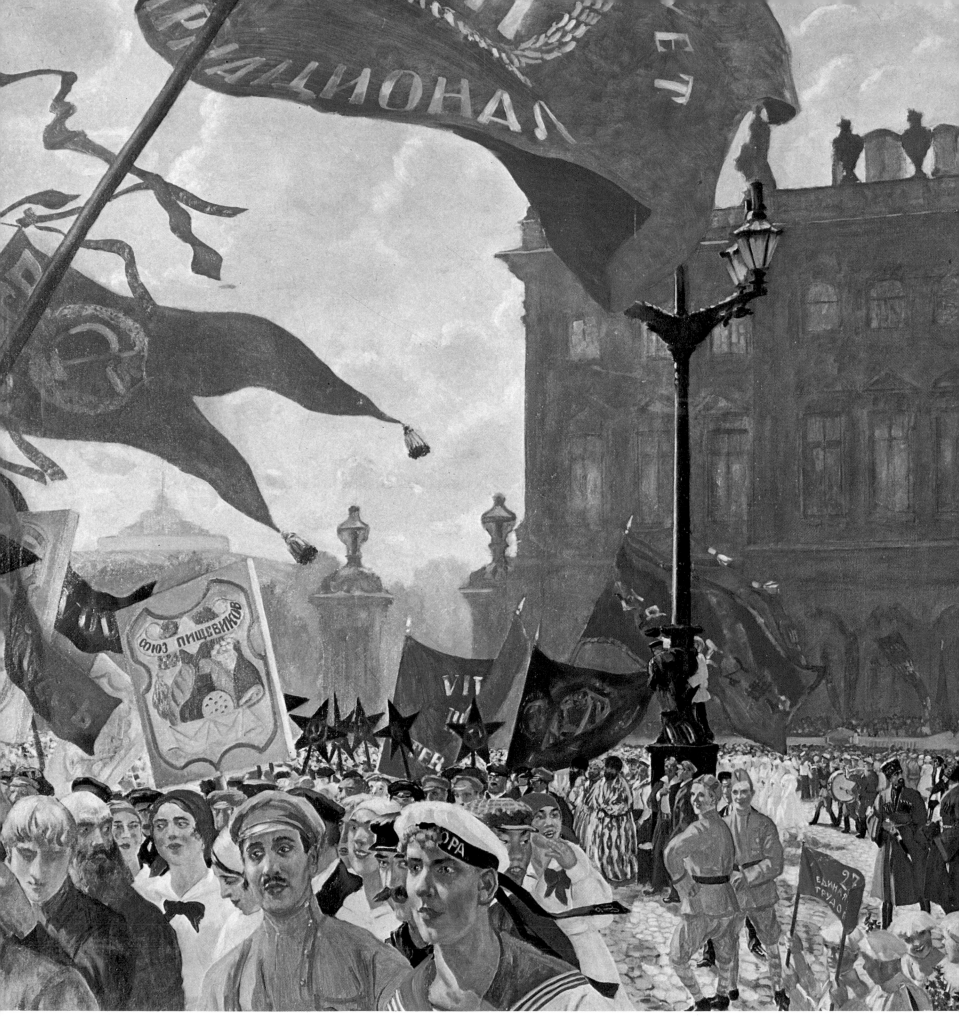

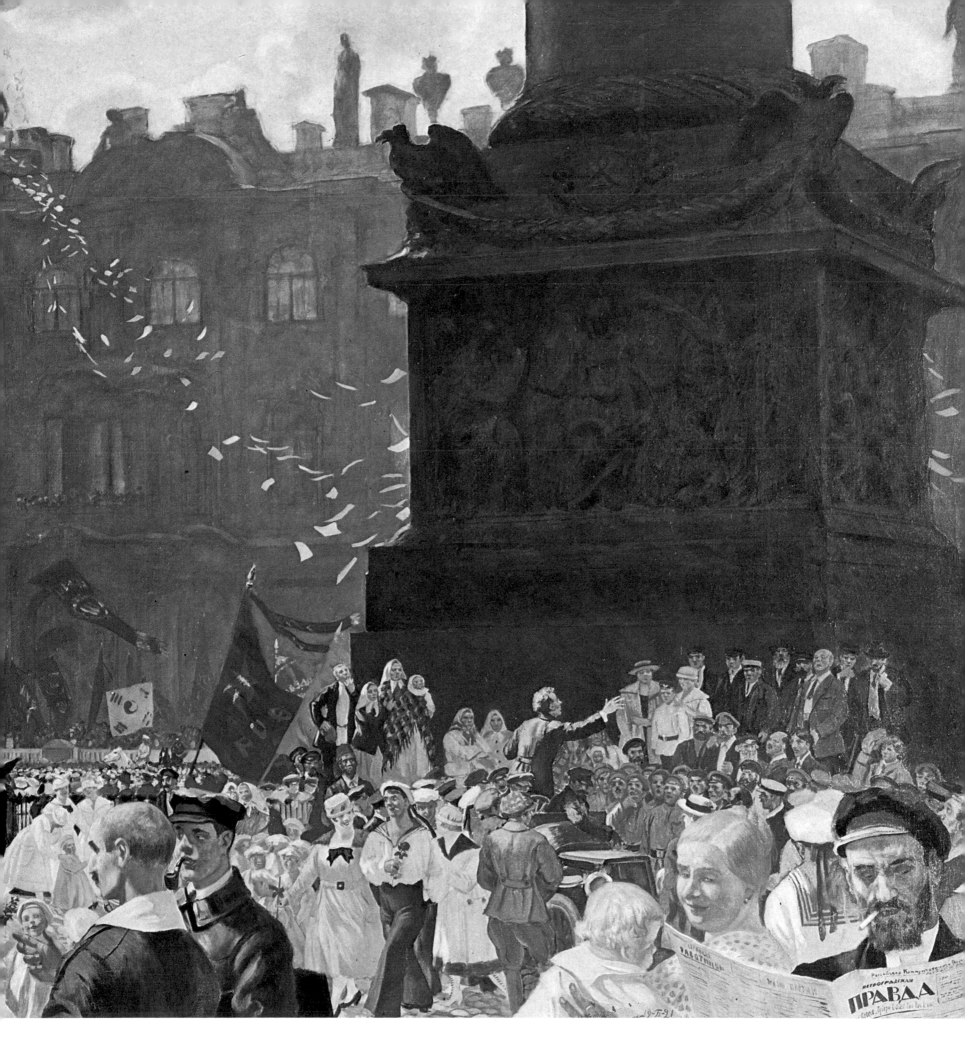

BORIS KUSTODIEV

*186 Festivities Marking the Opening of the 2nd Congress of
the Comintern in Uritsky (Palace) Square in Petrograd.* 1921.
Oil on canvas, 133 × 268 cm. The Russian Museum, Leningrad

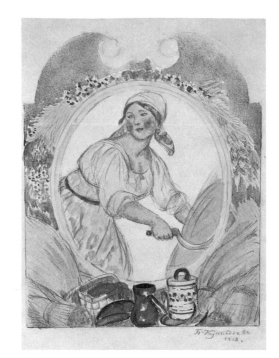

1918.

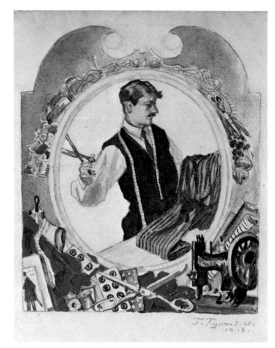

1918.

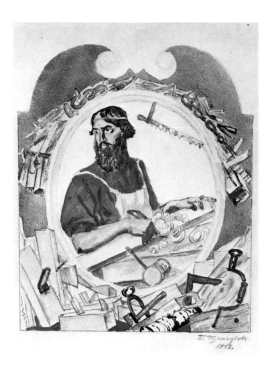

187 190 191

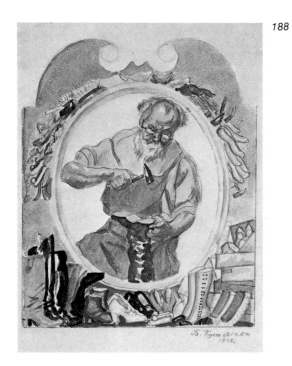

1918.

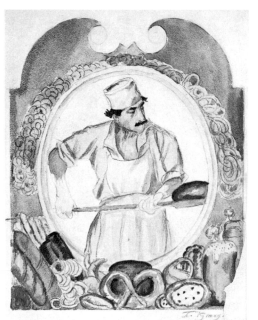

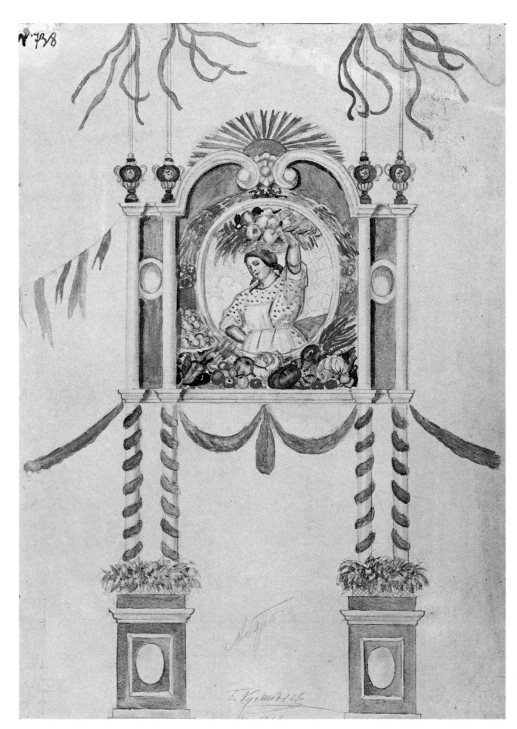

192

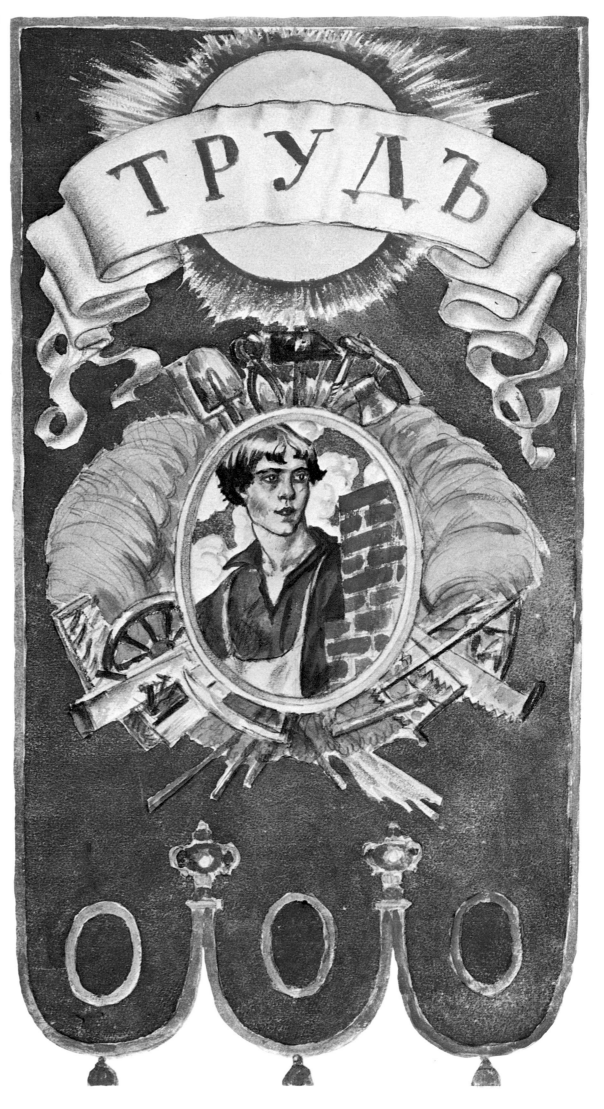

BORIS KUSTODIEV

Panel designs for the festive decoration of
Ruzheinaya Square. 1918. Petrograd

187 *Carpenter*.
 Watercolor and black lead on paper, 32.2 × 23.1 cm.
 The Tretyakov Gallery, Moscow

188 *Shoemaker*.
 Watercolor and black lead on paper, 32.2 × 23.5 cm.
 The Tretyakov Gallery, Moscow

189 *Baker*.
 Watercolor and black lead on paper, 28.1 × 20.1 cm.
 The Tretyakov Gallery, Moscow

190 *Reaper*.
 Watercolor and black lead on paper, 32.1 × 23.5 cm.
 The Tretyakov Gallery, Moscow

191 *Tailor*.
 Watercolor and black lead on paper, 31.2 × 23.5 cm.
 The Tretyakov Gallery, Moscow

192 *Abundance*.
 Watercolor and black lead on cardboard,
 78.5 × 55.5 cm.
 Museum of the Great October Socialist Revolution,
 Leningrad

193 *Labor*.
 Watercolor and black lead on cardboard,
 55.5 × 39.5 cm.
 Museum of the Great October Socialist Revolution,
 Leningrad

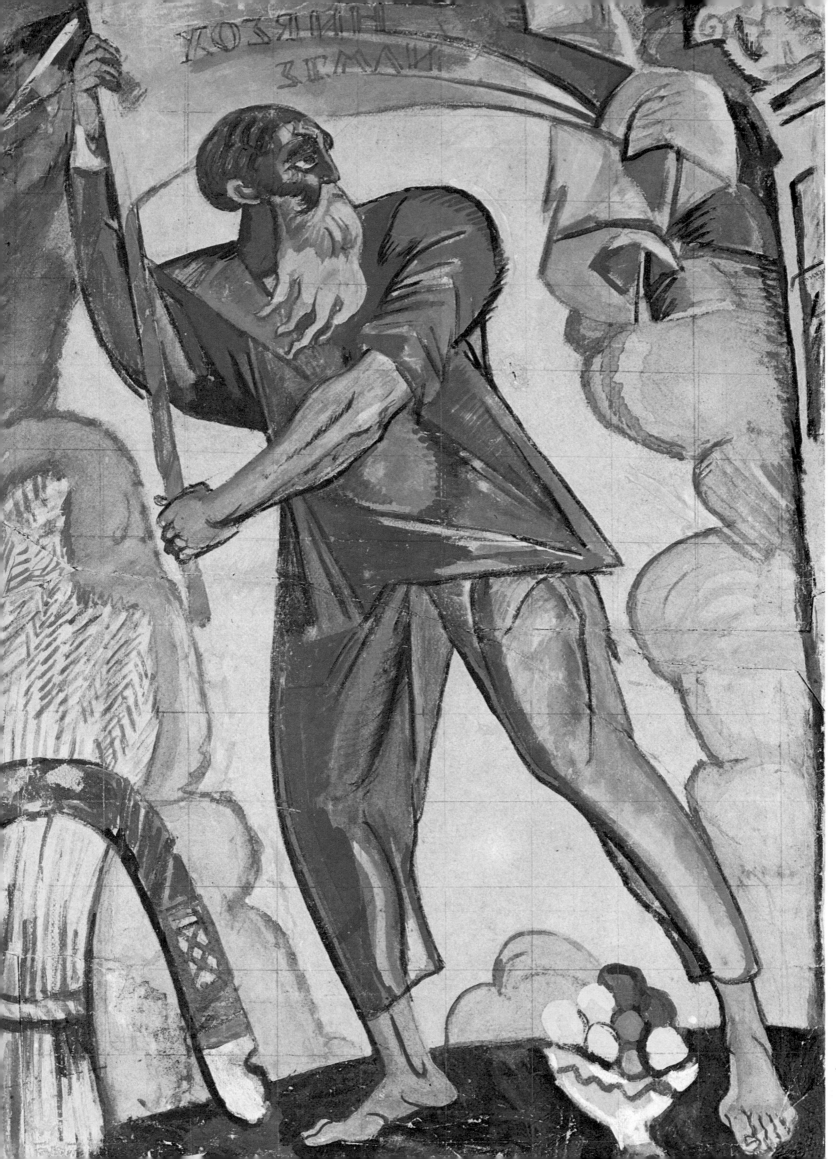

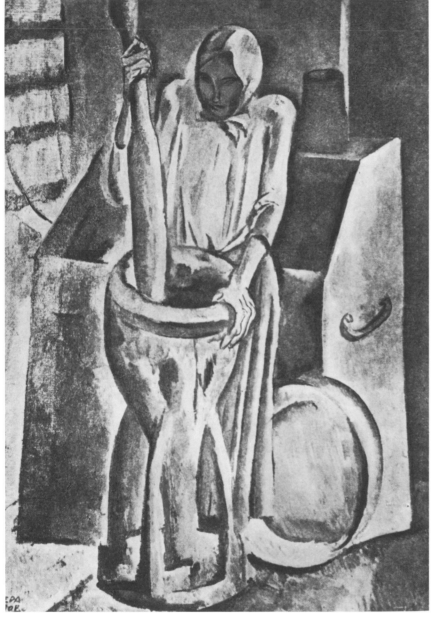

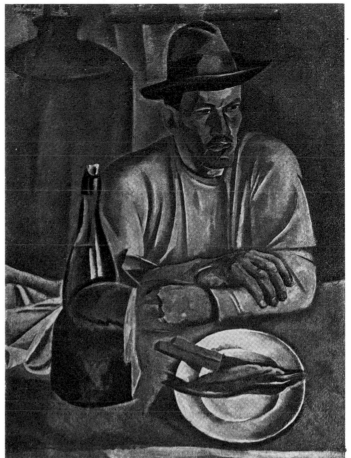

SERGEI GERASIMOV

194 *Master of the Land*. Panel design for the festive decoration of
the former Duma Building. 1918. Moscow.
Watercolor, gouache, and bronzing on cardboard, 83 × 64.3 cm.
The Tretyakov Gallery, Moscow

195 *Old Woman with Mortar*. 1922. Oil on canvas.
Present whereabouts unknown

196 *At the Table*. 1921. Oil on canvas.
Present whereabouts unknown

197 *Family of a Red Army Soldier*. 1922. Lithograph, 19.5 × 15.5 cm.
Private collection, Moscow

198

199

200

ABRAM ARKHIPOV

198 *Woman in Red*.1919.
Oil on canvas, 115.5 × 85.5 cm.
Art Museum, Gorky

ALEXANDER KUPRIN

199 *Spring Landscape. Apple Trees in Spring.* 1922.
Oil on canvas, 98 × 89.3 cm.
The Tretyakov Gallery, Moscow

NIKOLAI KRYMOV

200 *Autumn.* 1918.
Oil on canvas, 62 × 76 cm.
History and Architecture Museum, Pskov

ALEXANDER KUPRIN

201 *Moscow. Landscape with Church*. 1918.
Oil on canvas, 99 × 124 cm.
The Russian Museum, Leningrad

ISAAC BRODSKY

202 *Winter Landscape*. 1919–20.
Oil on canvas, 80.5 × 136 cm.
Brodsky Memorial Museum, Leningrad

201

202

203

PIOTR KONCHALOVSKY

203 *Trunk and Earthenware (Heroic Still Life).* 1919.
Oil on canvas, 143 × 174 cm.
The Russian Museum, Leningrad

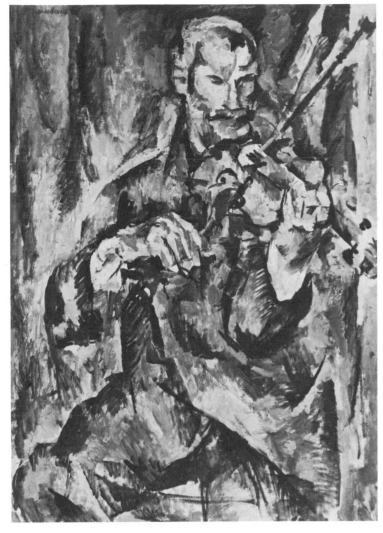

204

205

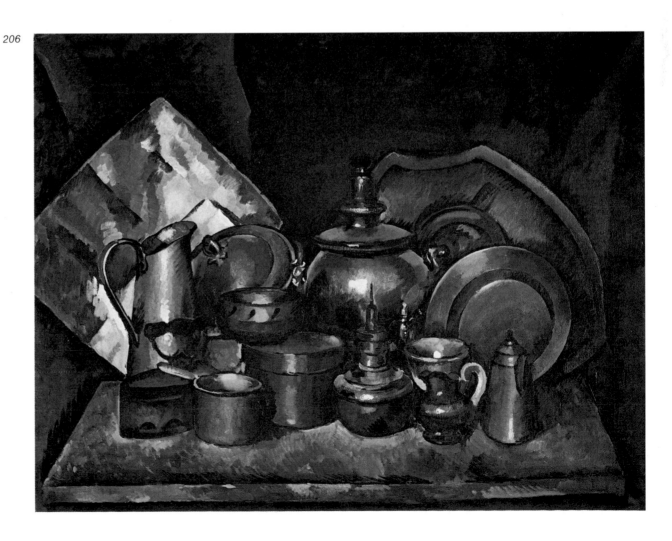

206

PIOTR KONCHALOVSKY

204 *Portrait of the Violinist G. Romashkov.* 1918.
Oil on canvas, 105 × 80 cm.
The Tretyakov Gallery, Moscow

ILYA MASHKOV

205 *Still Life with Fan.* 1922.
Oil on canvas, 145 × 127.5 cm.
The Russian Museum, Leningrad

206 *Still Life with Samovar (Copperware).* c. 1919.
Oil on canvas, 142 × 180 cm.
The Russian Museum, Leningrad

207

PAVEL KUZNETSOV

207 Still Life with Glassware. 1919. Oil on canvas, 98 × 71 cm.
The Russian Museum, Leningrad

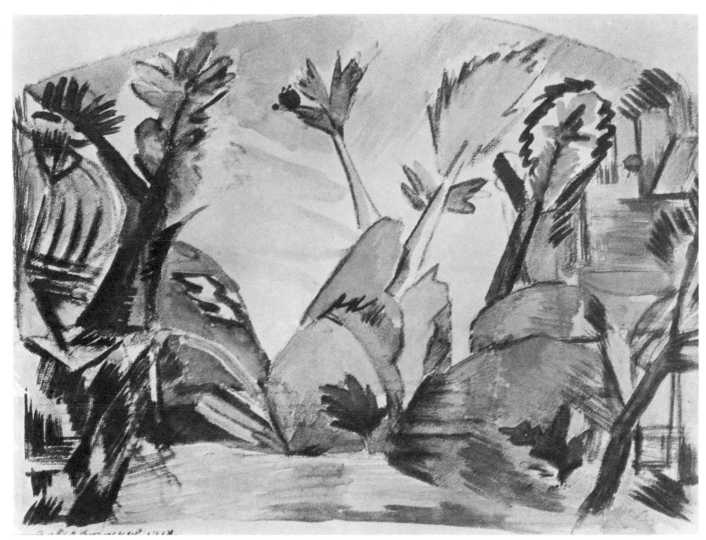

PAVEL KUZNETSOV

208 Decor design for Kamensky's play
Stepan Razin. 1918.
Watercolor on paper.
Bakhrushin Theatre Museum, Moscow
Stepan Razin was the leader of
the peasant uprising of the 1660s.

208

PAVEL KUZNETSOV

From the album *Turkestan.* 1923. Lithographs

209 Melon sellers

210 Town

211 Gathering Pears

209

210

211

RUDOLF FRENZ

212 Nevsky at Night. 1923. Oil on canvas, 65 × 82 cm.
The Russian Museum, Leningrad

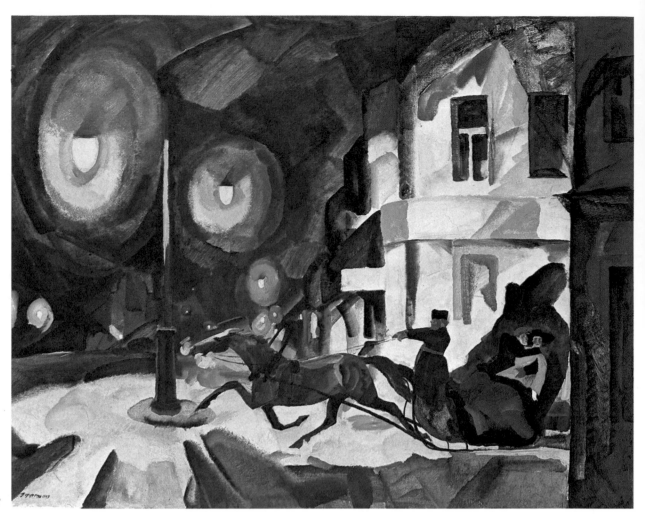

212

213

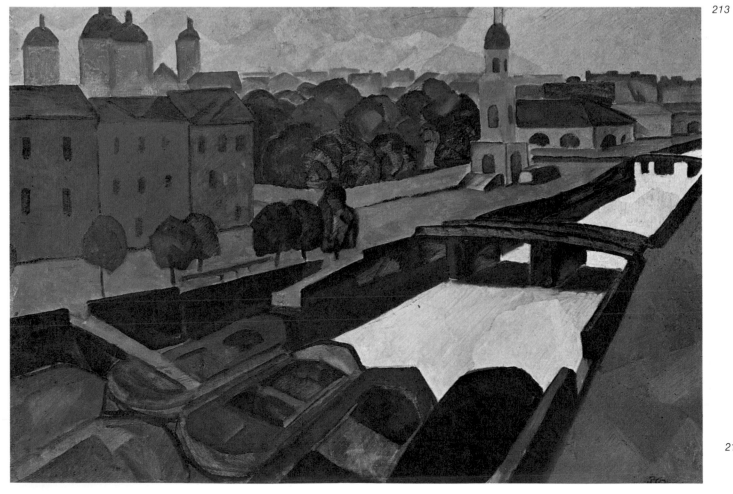

RUDOLF FRENZ

213 The Kriukov Canal. 1920.
Oil on canvas, 70 × 105 cm.
The Russian Museum, Leningrad

ALEXANDER OSMIORKIN

214 *Still Life with White Piala.* 1921. Oil on canvas, 84 × 68 cm.
The Russian Museum, Leningrad

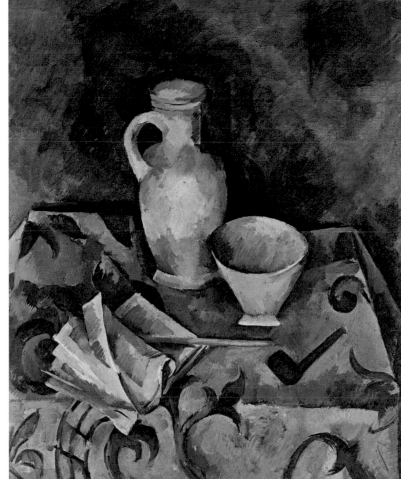

214

215

ALEXANDER OSMIORKIN

215 *Houses and City.* 1917. Oil on canvas, 89 × 52 cm.
Art Museum of the Uzbek SSR, Tashkent

216

MARTIROS SARYAN

216 *Mountains*. 1923.
Oil on canvas, 68 × 68 cm.
The Tretyakov Gallery, Moscow

ALEXANDER SHEVCHENKO

217 *Landscape with Washerwomen*. 1920.
Oil on cardboard, 58 × 59 cm.
The Russian Museum, Leningrad

218 *Still Life with Bottles*. 1922.
Oil on canvas, 84 × 85.5 cm.
The Russian Museum, Leningrad

217

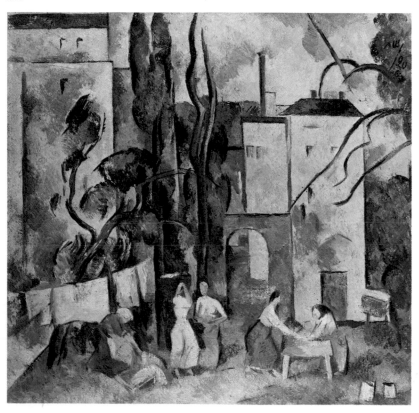

218

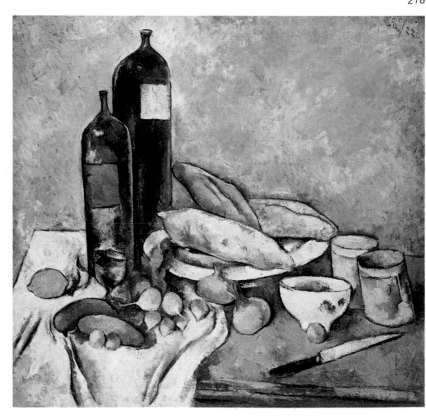

219

ARISTARKH LENTULOV

219 Townscape. 1920. Oil on canvas, 104 × 140 cm.
The Russian Museum, Leningrad

220

221

222

ALEXANDER KUPRIN

220 *Flowers*. Panel design. 1918.
Watercolor, India ink, black lead,
and lead white on cardboard, 50 × 30.7 cm.
The Tretyakov Gallery, Moscow

221 Design for the poster *Everyone Out
to the First Great May 1 Subbotnik*
(voluntary working Saturday). 1920.
Watercolor and black lead on paper, 30 × 23 cm.
The Tretyakov Gallery, Moscow

NATALYA AGAPYEVA

222 *Flowers and Ears*. Panel design. 1918.
Watercolor, India ink, crayons,
and lead white on paper, 29.1 × 47.1 cm.
The Tretyakov Gallery, Moscow

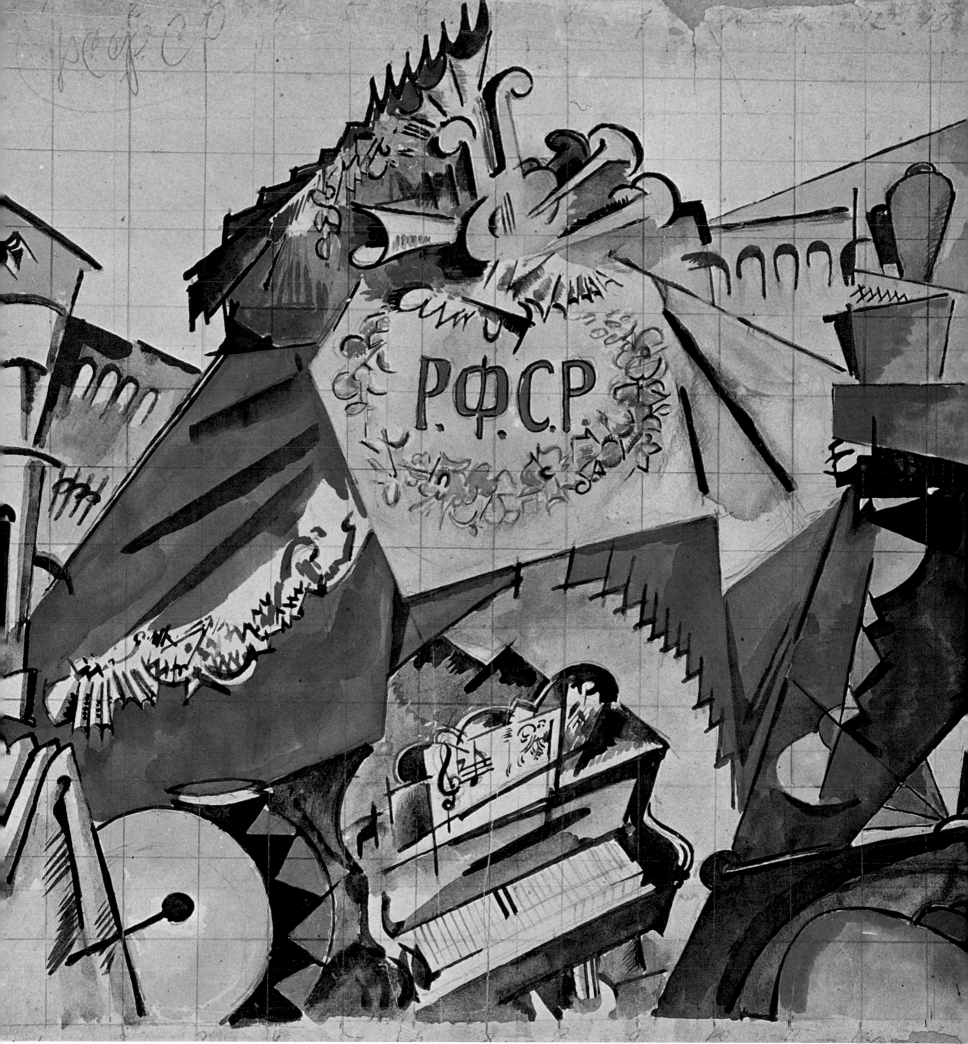

ALEXANDER KUPRIN

223 Art. Panel design. 1918. Watercolor, gouache, and black
lead on paper, 60 × 71 cm. The Tretyakov Gallery, Moscow

224 226

229

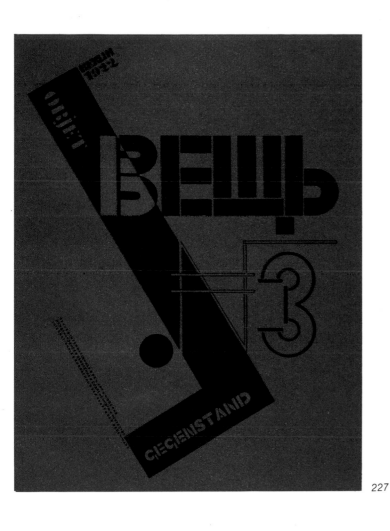

227

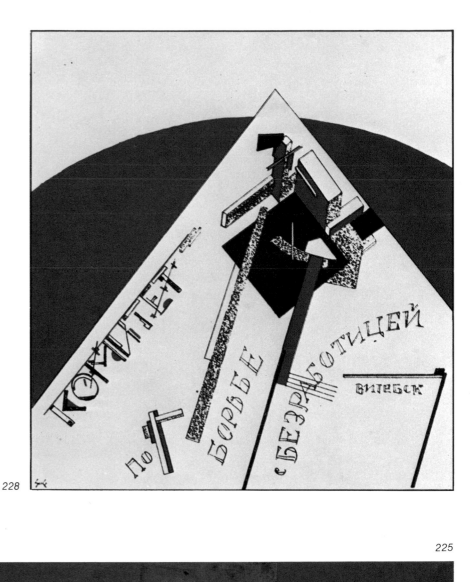

228

225

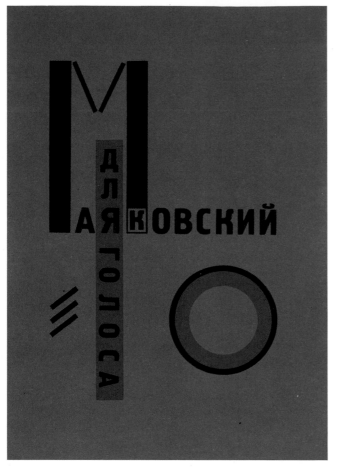

230

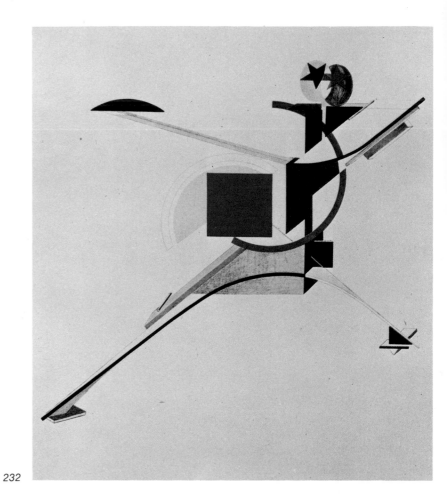

232

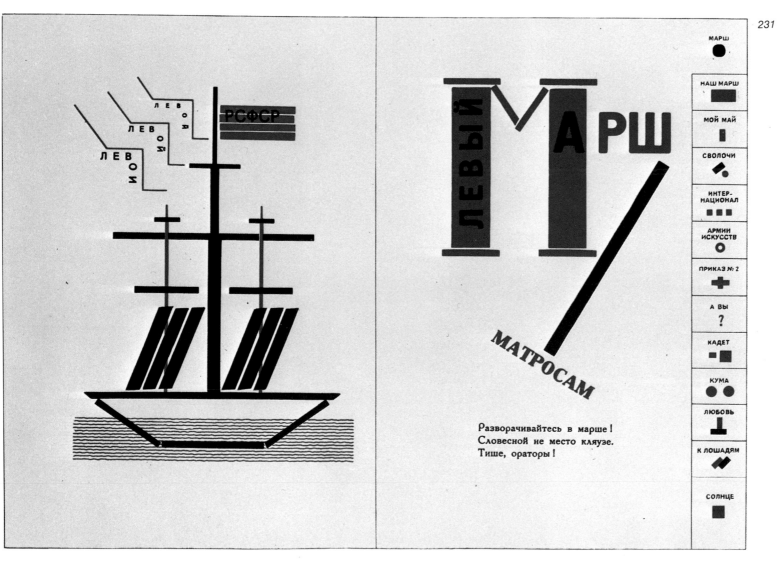

231

Graphic art, especially book design and illustration, was destined to become a truly mass art. Editions, accessible to the public, required a simple and attractive design. Both classical and contemporary literature were awaiting a presentation befitting them. The traditions of Russian graphic art were to dovetail with the search for a new style, thus preserving sensitivity to the spirit of the hour.

Daring photographic montages, bold typeface arrangements and, alongside them, the consummate, superb books and prints of the masters of the older generation. In all these the common feeling of the age and the distinctly palpable "graphic style" of the time found their expression.

234

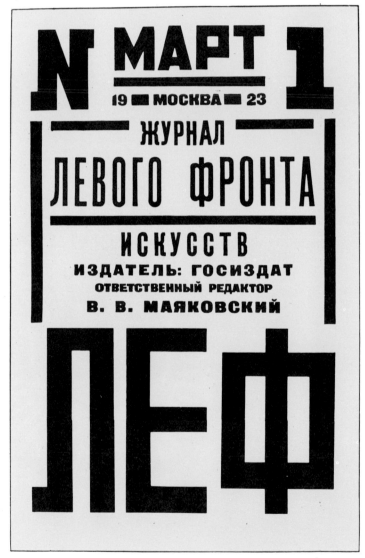

233

235

LAZAR (EL) LISSITZKY

230 Cover for Mayakovsky's book of poems *For Reading Out Loud.* 1923

231 Illustrations for "The Left March" in Mayakovsky's book *For Reading Out Loud.* 1923

232 From the series *Victory over the Sun.* 1923. Lithograph, 53 × 45.4 cm.

ALEXANDER RODCHENKO

233 Cover of the magazine *LEF*, 1923, No 1

234 Cover of the book *Mayakovsky Smiles, Mayakovsky Laughs, Mayakovsky Jeers.* 1923

235 Illustration for Mayakovsky's poem "Pro Eto." 1923

236

237

238

ALEXANDER RODCHENKO and VLADIMIR MAYAKOVSKY

Advertisements. 1923

236 "Give me the sun at night"

237 "The best nipple the world has yet to see,
you'll suck on it till you're well past ninety"

238 "Nowhere but at the Mosselprom"

ALEXANDER RODCHENKO and VLADIMIR MAYAKOVSKY

Advertisements. 1923

239 "The Rubber Trust is our protector in rain and slush. Without galoshes Europe sits and cries"

240 "The only survivors of days gone by are 'IRA' cigarettes"

241

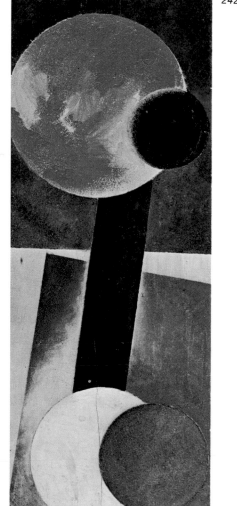

242

VASILY KANDINSKY

241 *White Background.* 1920. Oil on canvas, 95 × 138 cm. The Russian Museum, Leningrad

ALEXANDER RODCHENKO

242 *Nonobjective Composition.* 1918. Oil on panel, 53 × 21 cm. The Russian Museum, Leningrad

KLIMENT REDKO

243 *Factory.* 1922. Oil on canvas, 69.5 × 101 cm. Shevchenko Art Gallery, Alma-Ata

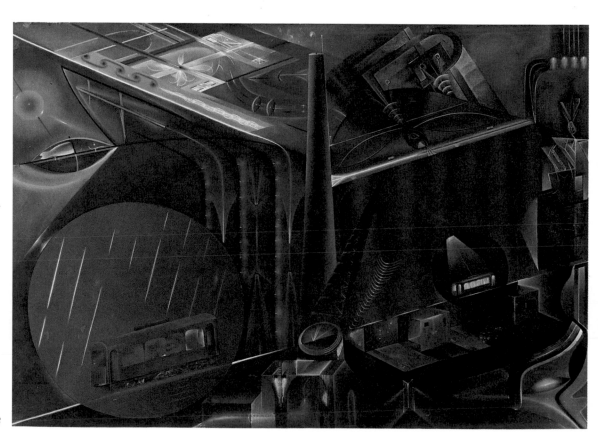

243

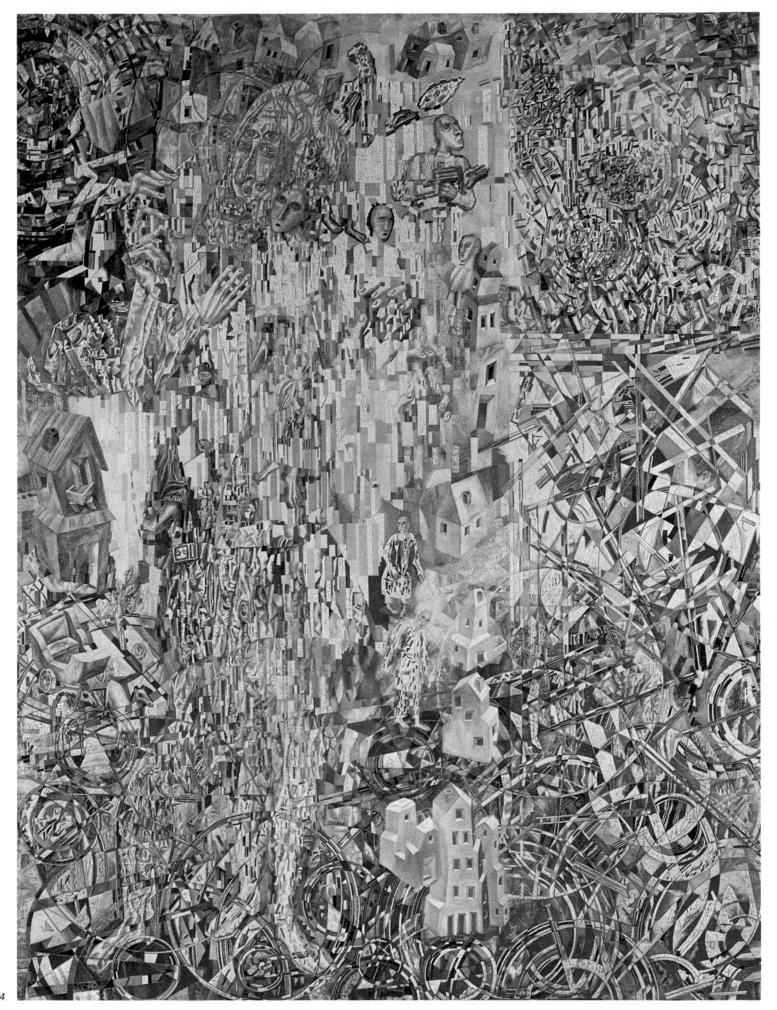

244

PAVEL FILONOV

244 Petrograd Proletariat Formula. 1920–21.
Oil on canvas, 154 × 118 cm.
The Russian Museum, Leningrad

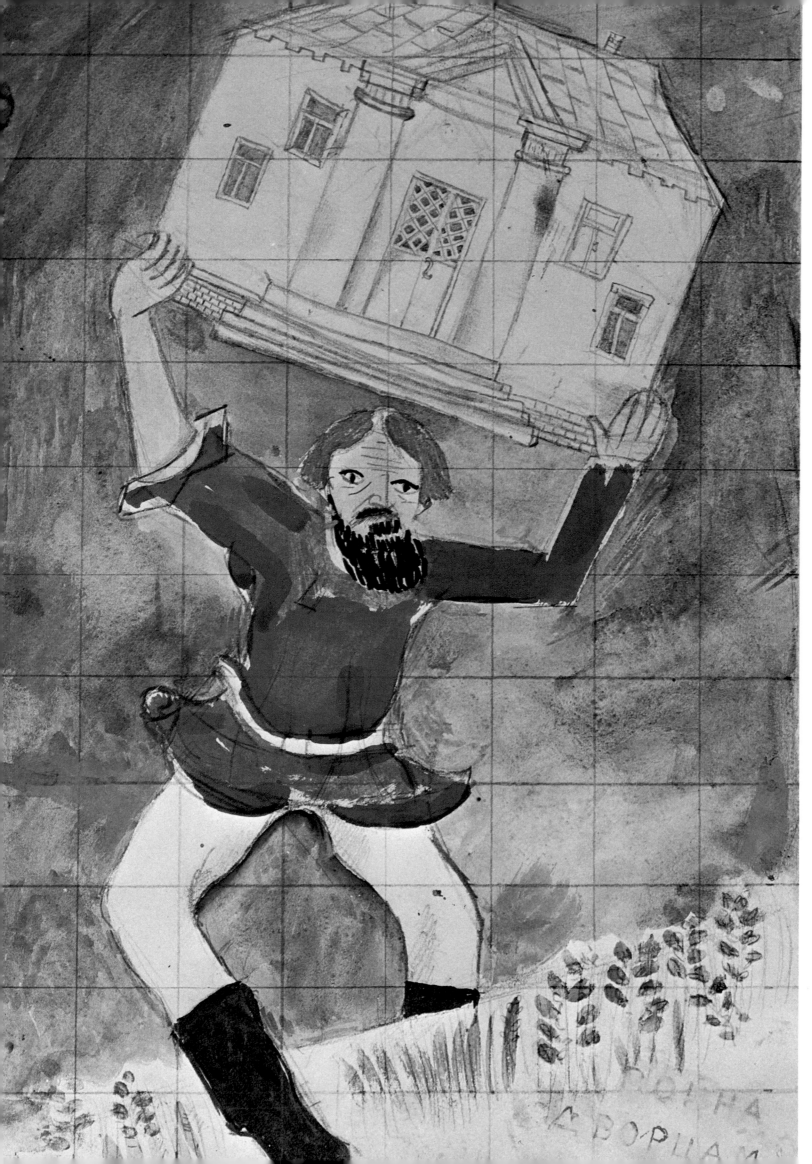

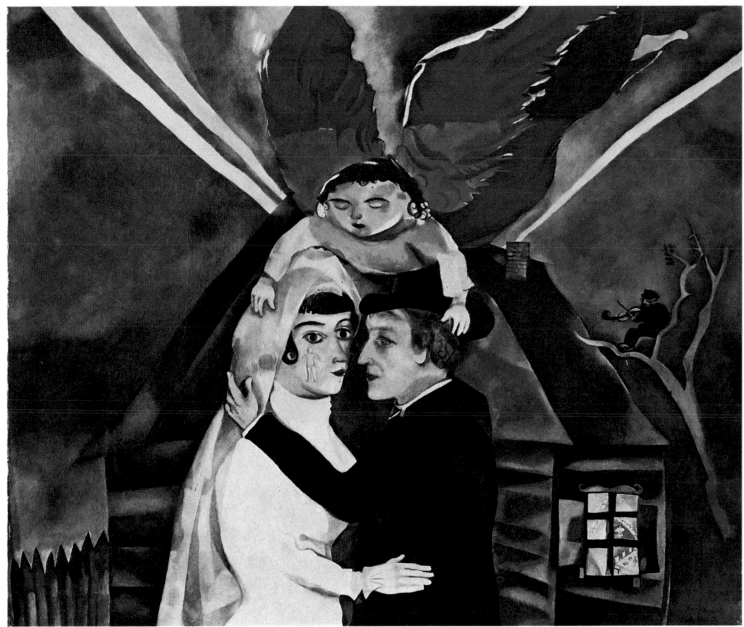

246

247

MARC CHAGALL

245 *Peace for the Huts, War on the Palaces . . .*
Panel design for the festive decoration of
Vitebsk. 1918–19.
Watercolor and black lead on paper, 33.7 × 23.2 cm.
The Tretyakov Gallery, Moscow

246 *Wedding.* 1918. Oil on canvas, 100 × 119 cm.
The Tretyakov Gallery, Moscow

247 Drawing from the series *My Life.* 1922

248

DAVID STERENBERG

248 Freedom Sun. Panel design for the festive
decoration of the Hermitage. 1918. Petrograd.
Watercolor, India ink, and pencil on paper mounted
on cardboard, 37.7 × 43.9 cm.
Museum of the Great October Socialist Revolution,
Leningrad

249

250

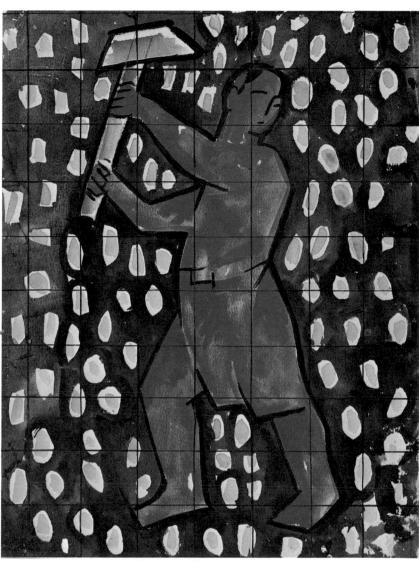

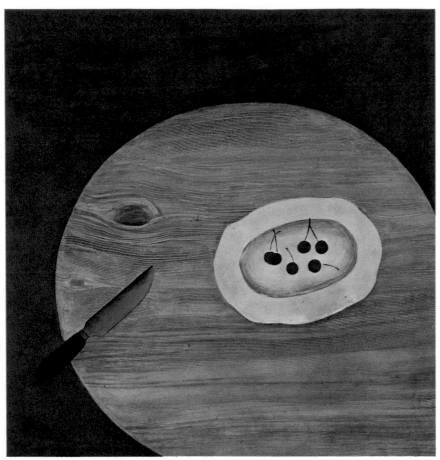

251

252

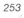
253

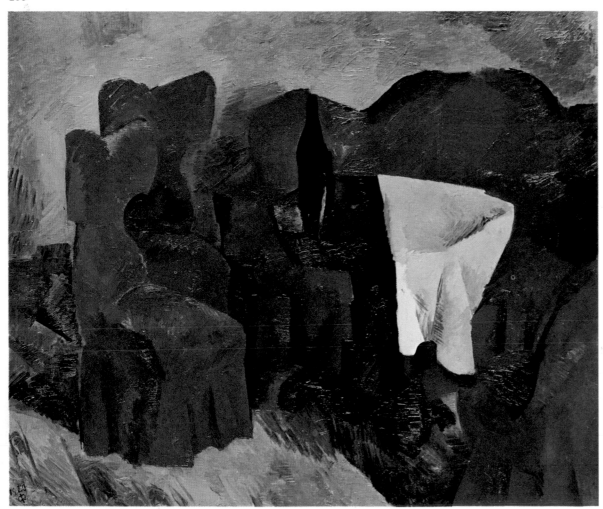

DAVID STERENBERG

251 Still Life with Cherries. 1919.
Oil on canvas, 68 × 67 cm.
The Russian Museum, Leningrad

252 Sour Milk. 1919.
Oil on canvas, 89 × 71.8 cm.
The Tretyakov Gallery, Moscow

ROBERT FALK

253 Red Furniture. 1920.
Oil on canvas, 105.6 × 122.8 cm.
The Tretyakov Gallery, Moscow

254 Working Woman. 1920.
Oil on canvas, 100 × 94 cm.
Art Gallery of Armenia, Yerevan

255 256

NATHAN ALTMAN

Designs for the festive decoration of Palace Square. 1918. Petrograd

255 *Land for the Workers*. Panel design. Gouache on paper, 92 × 83 cm.
Private collection, Leningrad

256 *Factories for the Workers*. Panel design. Gouache on paper, 92 × 83 cm.
Private collection, Leningrad

257 Design for the decoration of the façades of
the General Staff Building. Watercolor on paper, 27 × 97 cm.
Museum of the History of Leningrad

257

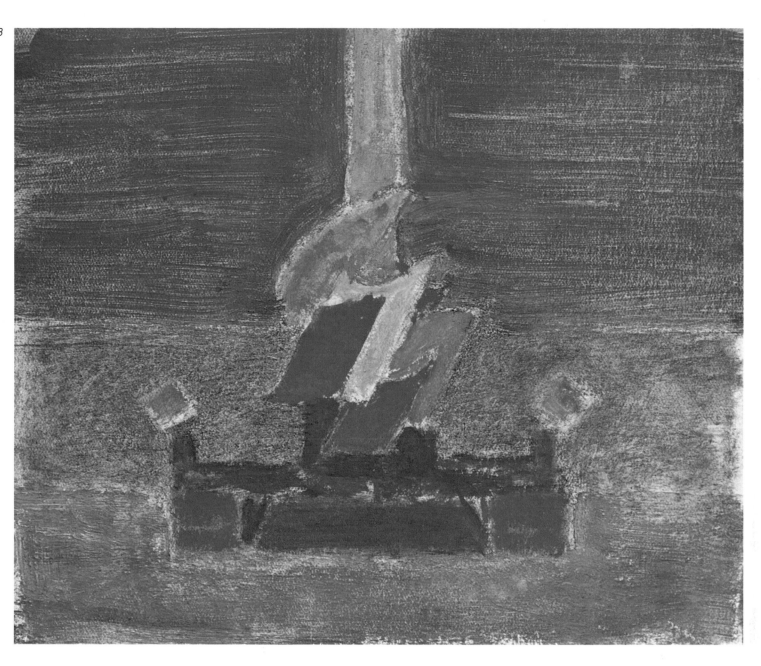

NATHAN ALTMAN

258 *The Alexander Column Lit Up at Night.*
Crayons and chalk on paper, 15.5 × 18.1 cm.
The Tretyakov Gallery, Moscow

259 Design for the decoration of the façades of the Winter Palace.
Watercolor on paper, 27 × 97 cm.
Museum of the History of Leningrad

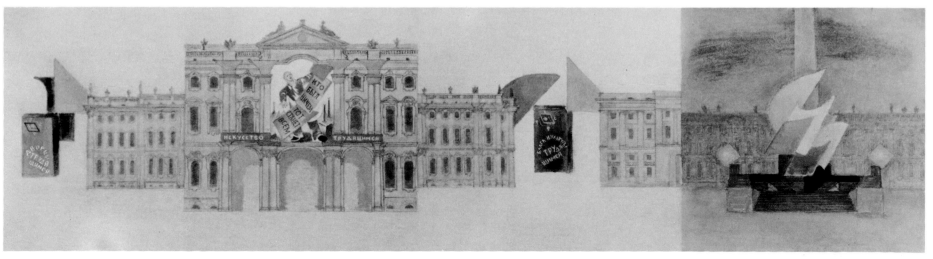

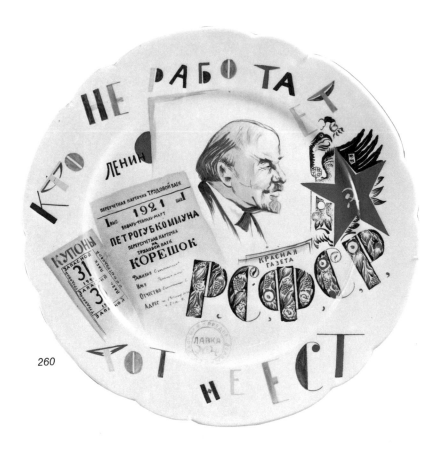

260

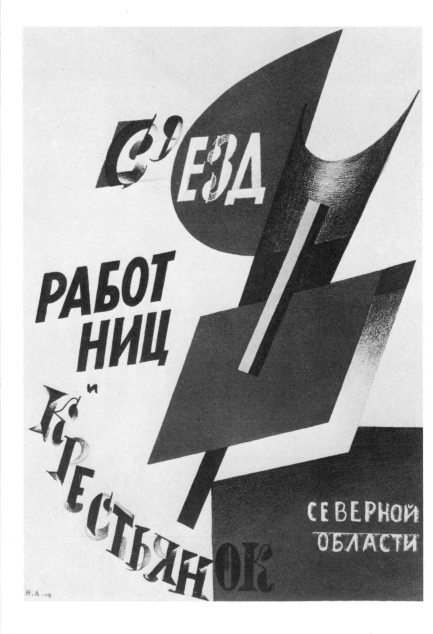

261

262

NATHAN ALTMAN

264 *Color Volumes and Planes.* 1918.
Oil and gypsum on canvas, 51 × 41 cm.
The Tretyakov Gallery, Moscow

265, 266 Early Soviet stamp designs. 1918.
Watercolor and India ink on paper, 20.5 × 19.4 cm.
Private collection, Leningrad

265

266

MIKHAIL ADAMOVICH

260 Plate with portrait of Lenin
(after Altman's drawing). 1922

NATHAN ALTMAN

261 Cover design for the pamphlet *Conference of Woman Workers and Peasants from the North.* 1919.
Colored lithograph, 47.5 × 31.8 cm.
Private collection, Leningrad

262 Emblem design.
India ink and appliqué on paper, 39.3 × 19.9 cm.
The Russian Museum, Leningrad

263 Design for the festive decoration of Palace Square. 1918. Petrograd.
Watercolor on paper, 27 × 111 cm.
Museum of the History of Leningrad

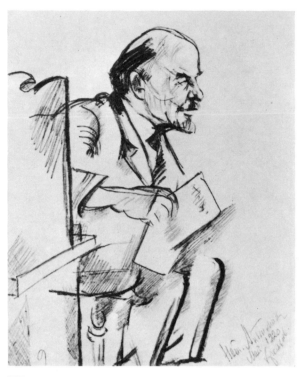

267

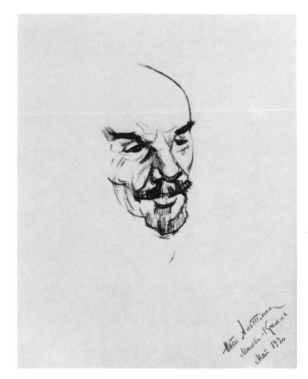

268

269

270

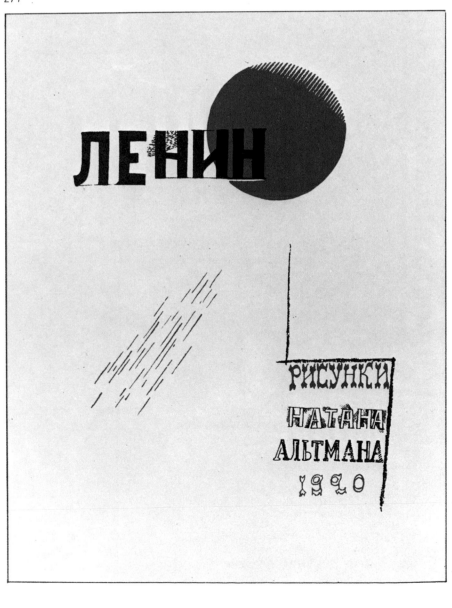

271

Drawings from life. 1920. The Central Lenin Museum, Moscow

NATHAN ALTMAN

267 *Lenin*. Pencil drawing, 22.5 × 17.8 cm.

268 *Lenin*. Pencil drawing, 21 × 18 cm.

269 *Lenin on the Phone*. Pencil drawing, 21 × 17 cm.

270 *Lenin Talking with Representatives of the British Trade Unions.*
 Pencil drawing, 17.5 × 21.5 cm.

271 Cover of the album *Lenin*. 1920

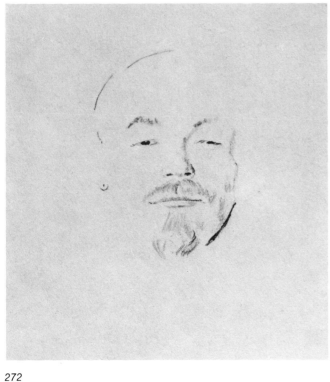

272

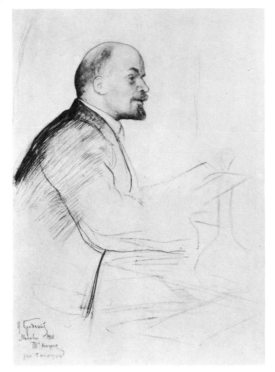

273

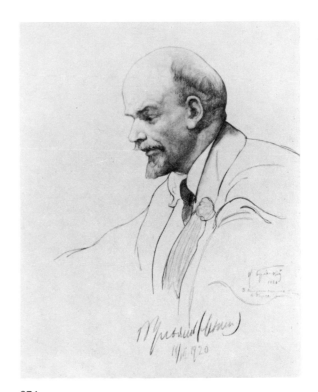

274

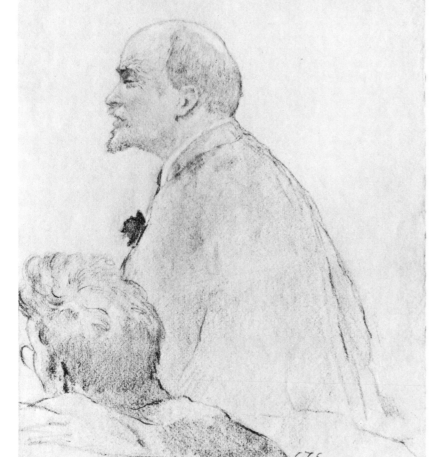

275

Drawings from life *(272–75)*. The Central Lenin Museum, Moscow

PHILIP MALIAVIN

272 *Lenin.* 1920. Pencil drawing, 17 × 14 cm.

ISAAC BRODSKY

273 *Lenin Speaking at the Opening of the 3rd Congress of the Comintern.* 1921. Pencil drawing, 14 × 10.2 cm.

274 *Lenin.* 1920. Pencil drawing, 49 × 35.2 cm. Autographed by Lenin

SERGEI CHEKHONIN

275 *Lenin at the Formal Opening of the 2nd Congress of the Comintern.* 1920. Pencil drawing, 13.5 × 9.5 cm.

NIKOLAI ANDREYEV

276 *Lenin.* 1920. Bronze, 30 × 39 × 38 cm. The Tretyakov Gallery, Moscow

276

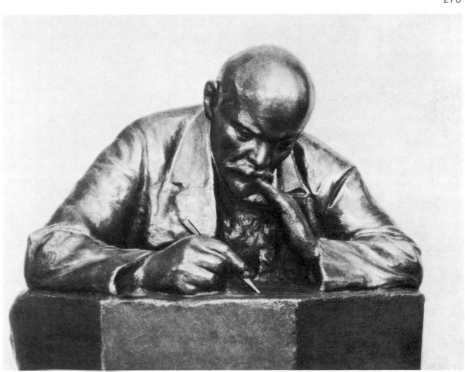

277 Memorial to Karl Marx. 1918. Gypsum. Photograph
Erected on November 4, 1918, in front of Smolny in Petrograd. Not extant

278

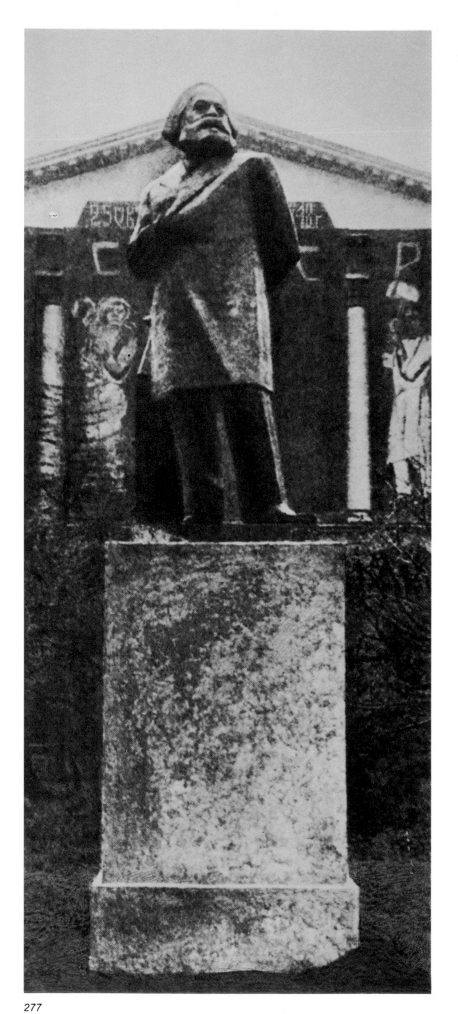

277

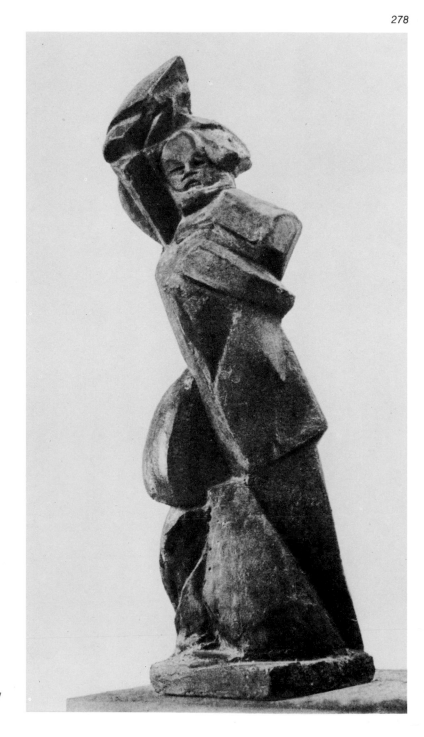

BORIS KOROLIOV

278 Model of the Memorial to Mikhail Bakunin. 1918.
Gypsum, 90 × 38 × 29 cm. Private collection, Moscow
Erected near the Miasnitskiye Gates in Moscow. Not extant

These memorials are the homage paid by a victorious
nation to those whose thoughts and deeds were at the roots
of the Great October Socialist Revolution.

Lenin believed that monumental propaganda, by
presenting the great revolutionaries of different countries,
taught the workers to understand the past. The memorials
produced during the monumental propaganda campaign
are essentially the sculptors' first addresses to the working
people. This is the prologue to the history of Soviet
plastic art.

VERA MUKHINA

279 The Torch of the Revolution.
Design for a memorial to Yakov Sverdlov. 1922–23.
Bronze, 104 × 60 × 60 cm. The Tretyakov Gallery, Moscow

Yakov Sverdlov (1885–1919) was a revolutionary, Bolshevik,
and first Chairman of the All-Russian Central Executive Committee (VTsIK)

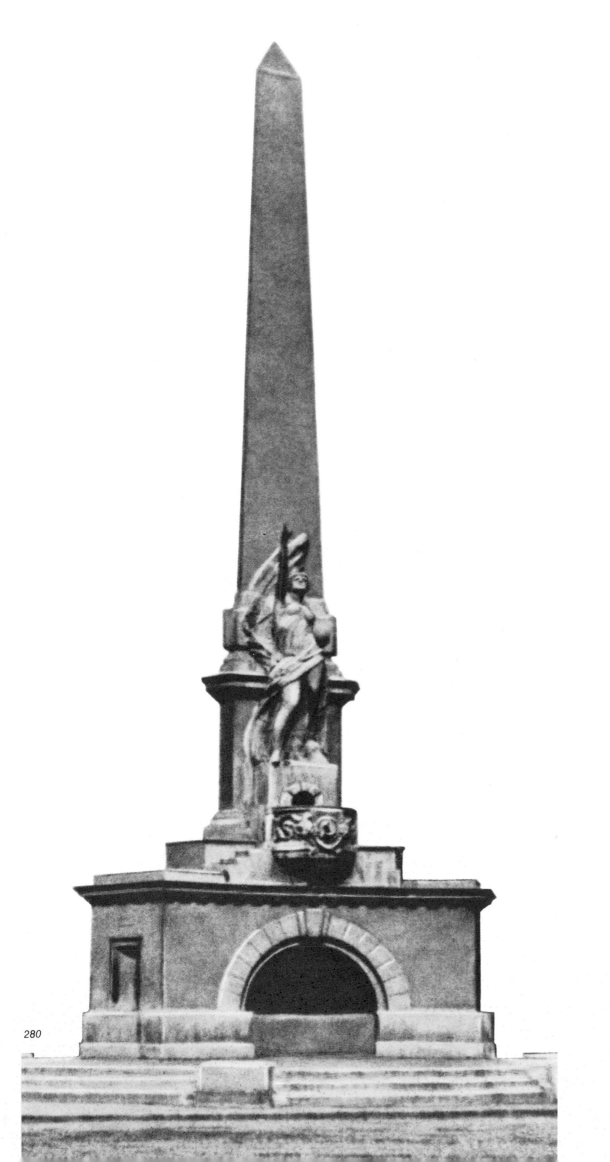

280

NIKOLAI ANDREYEV and D. OSIPOV (architect)

280 The Soviet Constitution. Obelisk. 1918–19. Concrete.
Photograph

Erected in Soviet Square in Moscow. Not extant

NIKOLAI ANDREYEV

281 Head of the *Statue of Freedom*
(The Soviet Constitution). 1919. Concrete, 97 × 57 × 50 cm.
The Tretyakov Gallery, Moscow

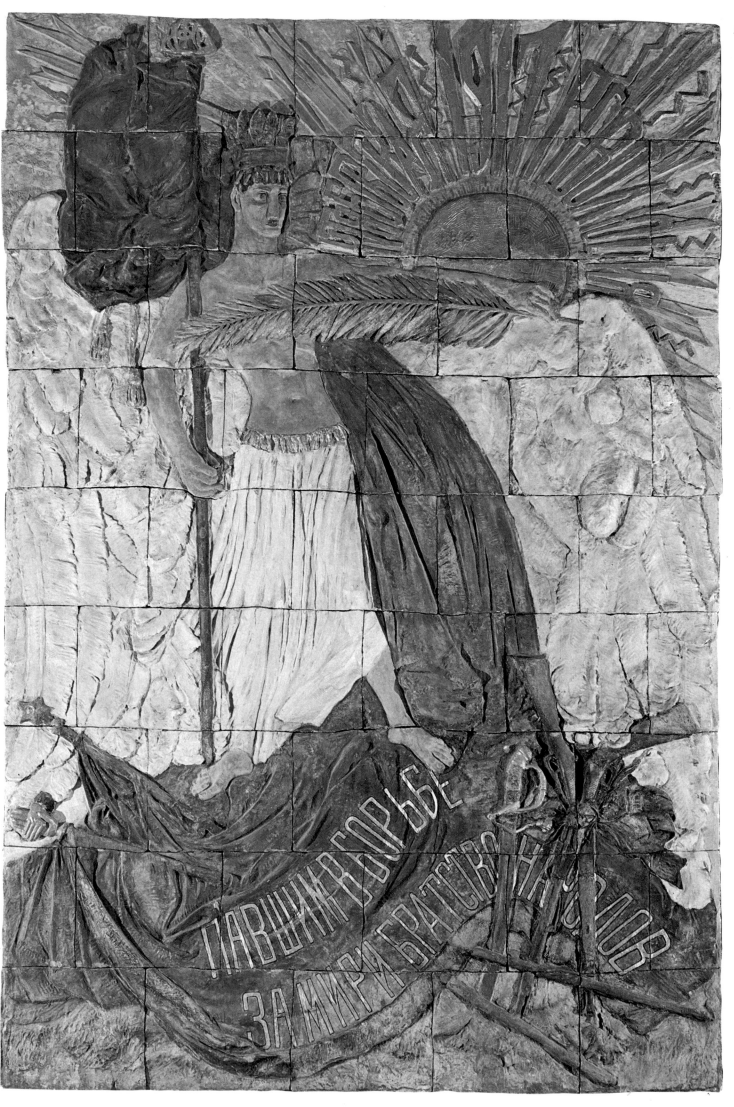

282

SERGEI KONIONKOV

282 *To Those Who Fell Fighting
for the Cause of Peace
and the Brotherhood of
Nations.*
Memorial plaque. 1918.
Bas-relief.
Tinted cement, 510 × 340 cm.
The Russian Museum,
Leningrad
Set up in 1918 on the wall of
the Senate Tower of
the Moscow Kremlin.

Sleep, dear brothers, sleep!

Once more your native land

sends to the Kremlin walls

fresh hosts of steadfast troops.

New ways are afoot in the world,

the red lightning is aglow . . .

Sleep, dear brothers, sleep,

in the light from immortal graves.

The sun like a golden seal

stands guard at the gates.

Sleep, dear brothers, sleep,

past you march the people's hosts

towards the universal dawn.

SERGEI ESENIN. FROM THE CANTATA
PERFORMED IN 1918 AT THE INAUGURATION
OF THE MEMORIAL PLAQUE
TO THOSE WHO FELL FIGHTING
FOR THE CAUSE OF PEACE
AND THE BROTHERHOOD OF NATIONS

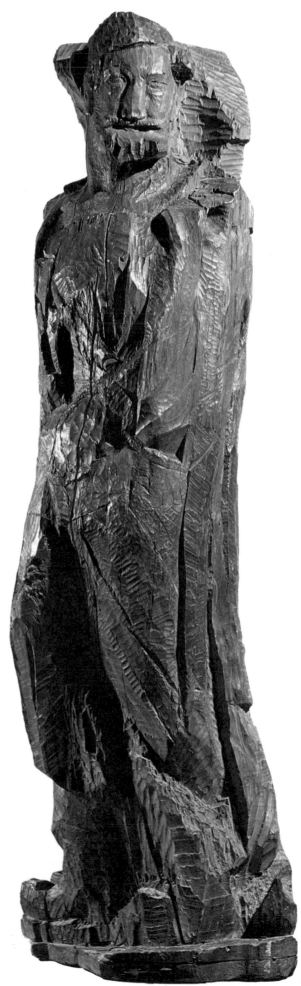

SERGEI KONIONKOV

283 *Stepan Razin*. 1918–19. Wood, 252 × 57 × 63 cm.
The Russian Museum, Leningrad

Part of the sculptural group *Stepan Razin and His Men*,
which was erected on May 1, 1919, in Red Square in Moscow.

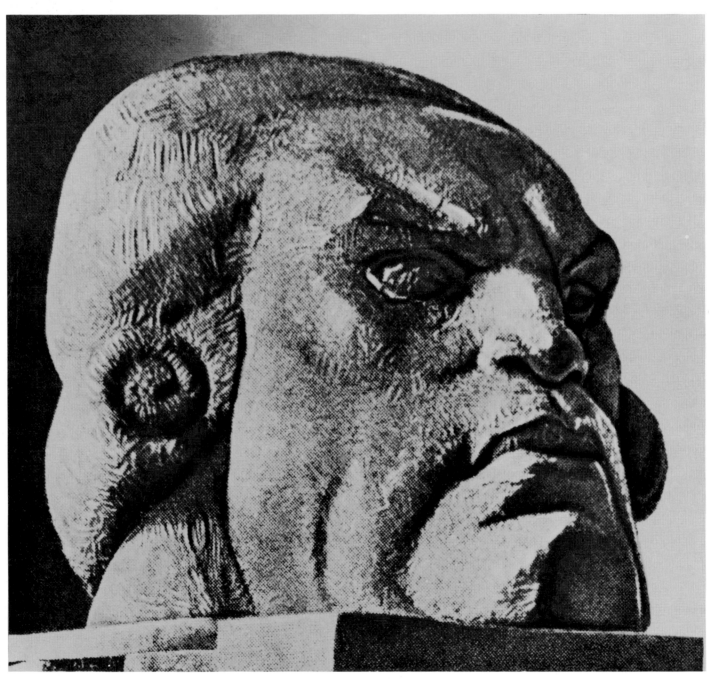

284

NIKOLAI ANDREYEV

284 Memorial to Danton. 1918. Gypsum. Photograph
Erected in Revolution Square in Moscow. Not extant

SARRA LEBEDEVA

285 Robespierre. 1920. Bas-relief. Gypsum, 54 × 40 × 11 cm.
The Russian Museum, Leningrad

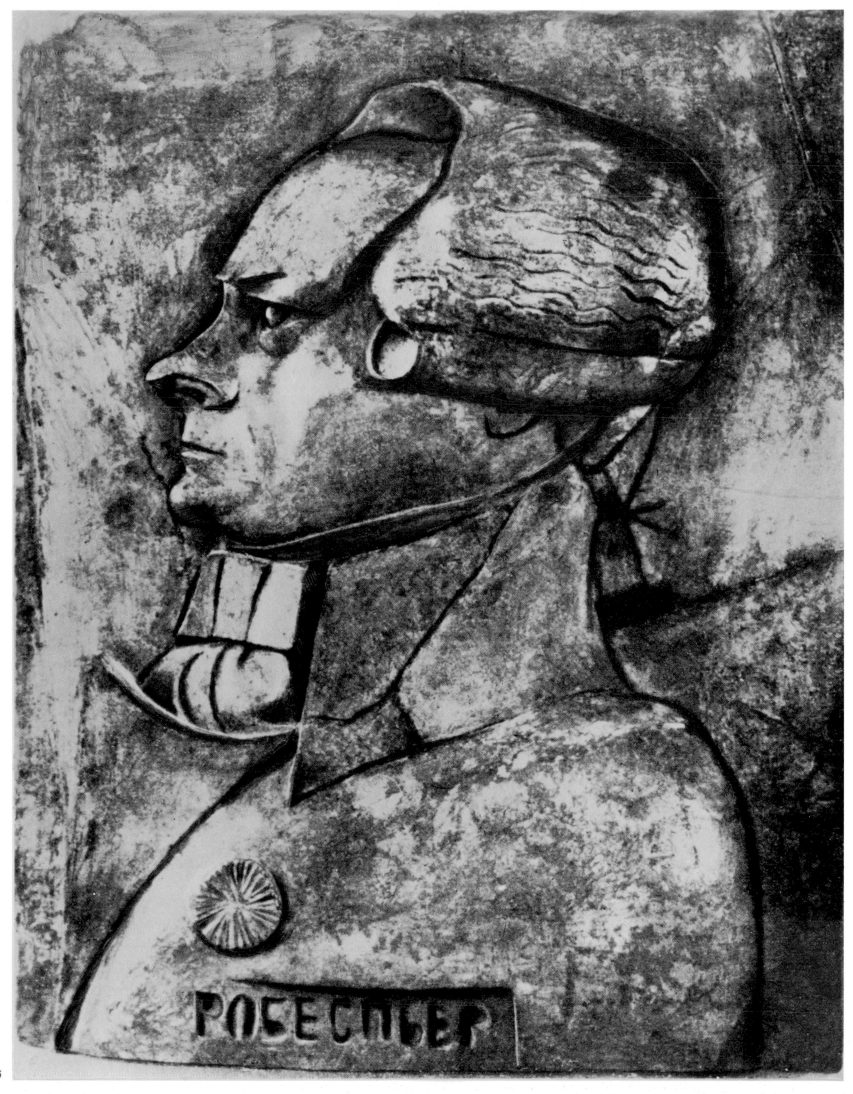

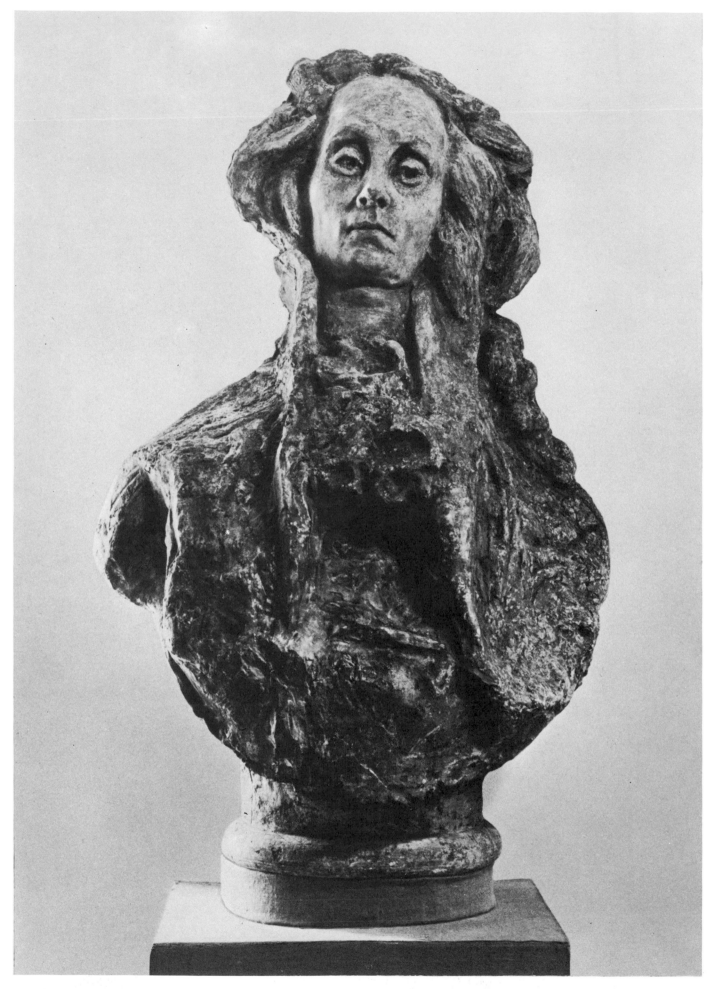

LEONID SHERWOOD

286 Memorial to Alexander Radishchev. 1918.
Gypsum, 112 × 98 × 42 cm.
Shchusev Museum of Architecture
and Architectural Research, Moscow

First memorial erected in implementation of Lenin's plan
for monumental propaganda. Unveiled in Petrograd on September 22, 1918;
a replica, in Moscow on October 6, 1918.

Alexander Radishchev (1749–1802) was a Russian writer.
In his book *Journey from St. Petersburg to Moscow,* he strongly
condemned serfdom and the autocracy.

287

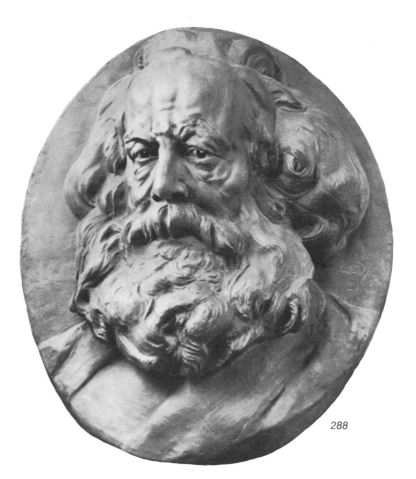

288

289

NIKOLAI ANDREYEV

287 *Portrait of Alexander Herzen*. 1920. Bas-relief.
Granite chips on cement, 88 × 57 × 10 cm.
The Tretyakov Gallery, Moscow

Alexander Herzen (1812–1870) was a Russian revolutionary democrat, philosopher, and writer.
While in exile from Russia he published the first Russian revolutionary newspaper, *The Bell*.
Lenin thought highly of this activity of Herzen's.

IVAN SHADR

288 *Portrait of Karl Marx*. 1921. High relief. Bronze, 83 × 71 × 27 cm.
The Tretyakov Gallery, Moscow

289 *Portrait of Karl Liebknecht*. 1921. High relief. Bronze, 60 × 55 × 18 cm.
The Tretyakov Gallery, Moscow

Karl Liebknecht (1817–1919) was a prominent figure in the German
and international working movements.

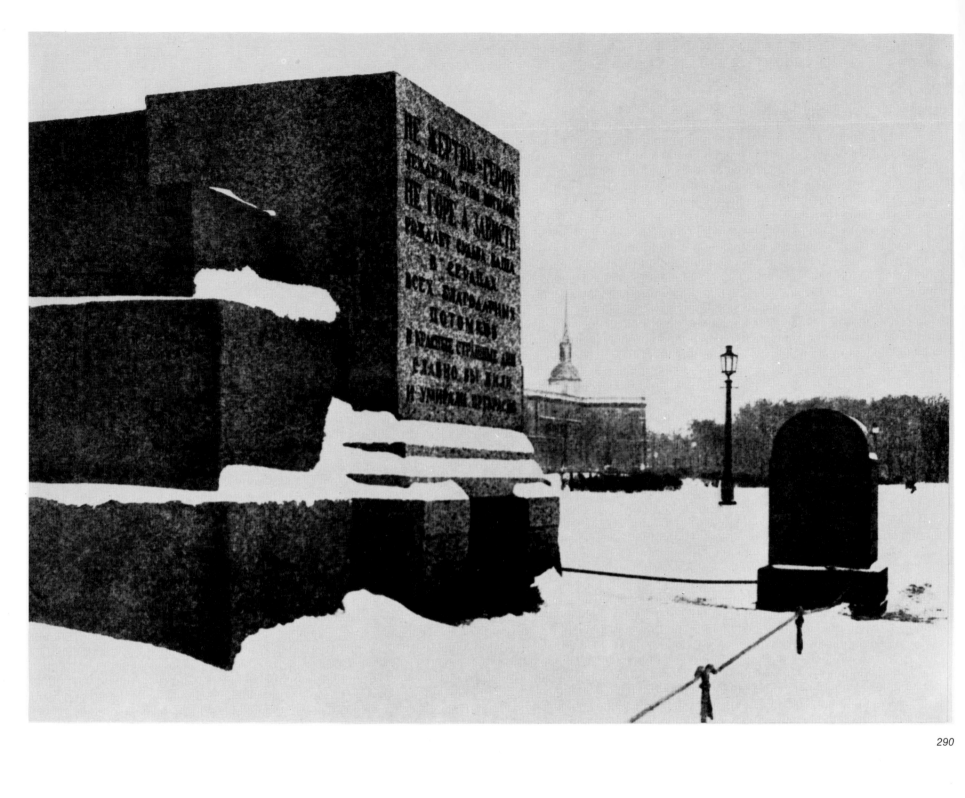

290

From depths of oppression,

Need and darkness,

You, proletarian,

Have arisen

To win in struggle

Your freedom, your fortune.

You will bring happiness

To all mankind

And break their bonds

Of slavery.

We know not all

The heroes' names

Who gave their blood for freedom.

But grateful man,

The human race,

Never will forget them.

This monument is raised for ever

In memory and honor of them all.

TEXTS OF GRANITE INSCRIPTIONS
BY ANATOLY LUNACHARSKY

LEV RUDNEV

290 *To Those Who Fell Fighting for the Revolution.*
Memorial on the Field of Mars in Petrograd. 1921.
Photograph

VICTOR SINAISKY

291 *Ferdinand Lassalle.* 1921. Granite, 156 × 120 × 90 cm.
The Russian Museum, Leningrad

The first version of this monument was made in gypsum
in 1918 and erected on Nevsky Prospekt in Petrograd.

Ferdinand Lassalle (1825–1864) was an active member of
the German working movement.

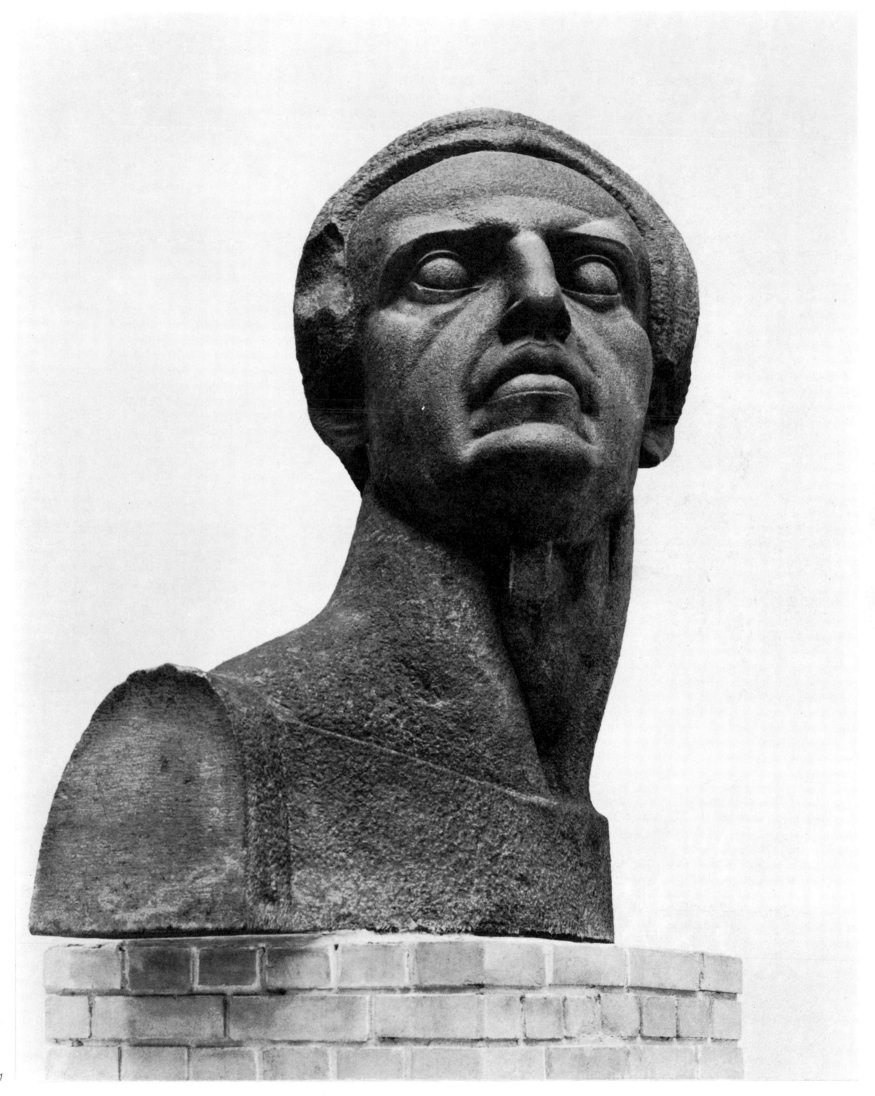

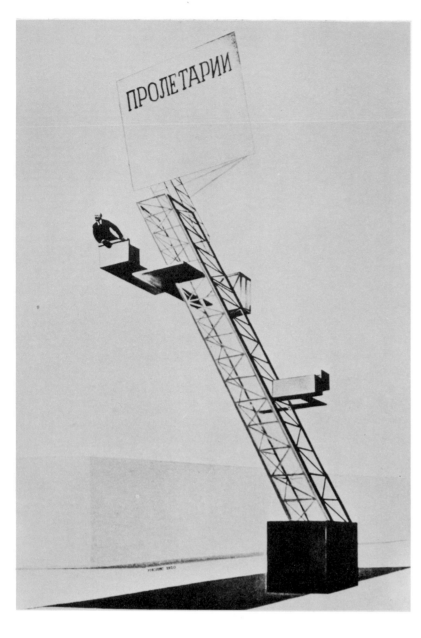

292

294

293

LAZAR (EL) LISSITZKY

292 *Lenin Tribune*. 1920.
India ink, gouache, and black lead on paper, 63.8 × 47.9 cm.
The Tretyakov Gallery, Moscow

293 Design for a rostrum. 1920.
India ink, gouache, and black lead on paper, 15.9 × 14.4 cm.
The Tretyakov Gallery, Moscow

NIKOLAI KOLLI

294 *The Red Wedge*. Design for an architectural construction. 1918.
Black lead and crayons on paper, 30.5 × 22.8 cm.
The Tretyakov Gallery, Moscow

VLADIMIR TATLIN

295 *Model for the Tower-Monument to the 3rd International*. 1919–20. Photograph

VICTOR and ALEXANDER VESNIN

Designs for the festive decoration
of the Moscow Kremlin to celebrate
the First Anniversary
of the October Revolution. 1918.
Shchusev Museum of Architecture
and Architectural Research, Moscow

296 Pedestal with flags. Watercolor, crayons,
and black lead on paper, 33.9 × 49.9 cm.

297 Oruzheinaya Tower. Watercolor, crayons,
and black lead on paper, 26 × 22 cm.

298 Tainitskaya Tower. Watercolor, crayons,
and black lead on paper, 23.2 × 25.7 cm.

296

297

298

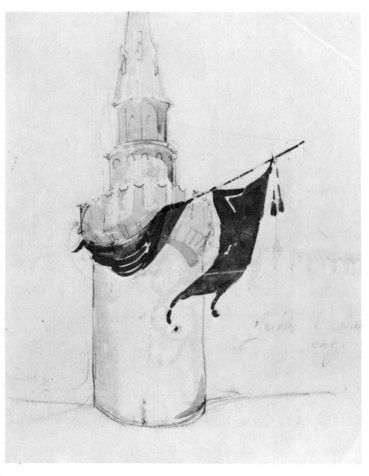

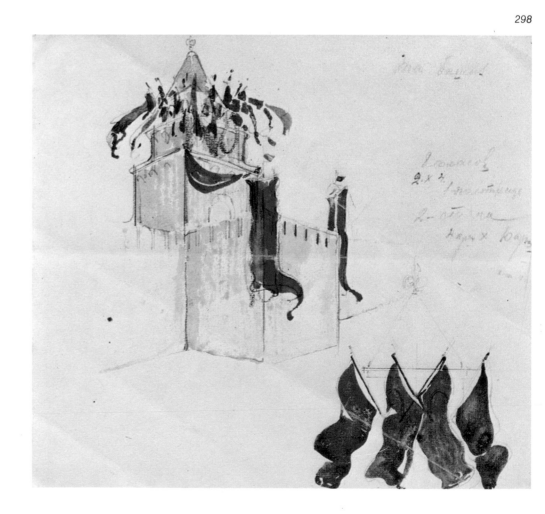

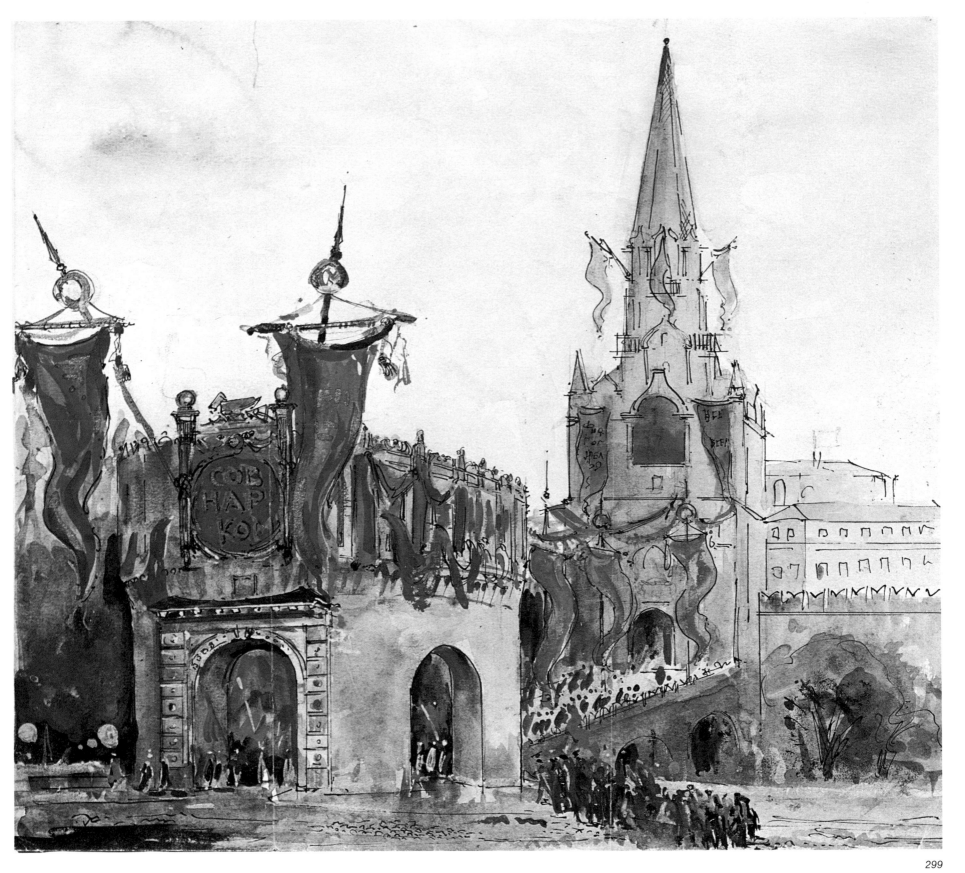

299

VICTOR and ALEXANDER VESNIN

Designs for the festive decoration of the Moscow Kremlin
to celebrate the First Anniversary of the October Revolution. 1918.
Shchusev Museum of Architecture and Architectural Research, Moscow

299 Trinity and Kutafya Towers.
 Watercolor, black lead, and crayons on paper, 31.6 × 35 cm.

To glorify Freedom, let us decorate all the empty fences, roofs, frontages, and pavements, just as the world's cathedrals were born under the inspired hammer blows of the great miracle of art which is youth.

Poets, painters, musicians, throw caution to the winds and ring out with all the bells of spring.

Poets – take up your brushes and poster-size sheets of verse, your ladder and paste, and proclaim the truth of life on the streets. Be suitors before her, before the Great Herald, the Revolution.

Painters – great Burliuks [David Burliuk: Russian Futurist poet and painter] – nail your pictures to the houses, as if for a carnival. Drag bales of posters about with you, and with your genius paint walls, squares, signboards, and shop windows.

VASILY KAMENSKY
FROM THE *DECREE ON WALL LITERATURE,
STREET PAINTING, MUSIC FROM BALCONIES,
AND CARNIVALS OF THE ARTS.* 1921

300

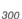

NIKOLAI TYRSA

300 Design for the festive decoration of a street. 1918. Petrograd.
Watercolor on paper, 21.6 × 27.9 cm.
The Russian Museum, Leningrad

NIKOLAI LAKOV and G. GRÜNBERG

301 *Birth of a New World.* Design for a wall painting in Tverskaya Street. 1918. Moscow.
Watercolor, black lead, and crayons on paper, 30.9 × 64 cm.
The Tretyakov Gallery, Moscow

NATALYA AGAPYEVA

302 *Peddler.* Costume design for a festive carnival procession. 1918. Moscow.
Watercolor and black lead on paper, 35.5 × 22.2 cm.
Private collection, Moscow

IVAN ALEXEYEV and OLGA ALEXEYEVA

303 Design for the festive decoration of Okhotny Riad in Moscow. 1918. Moscow.
Watercolor, gouache, and pencil on paper, 35.8 × 60.2 cm.
The Tretyakov Gallery, Moscow

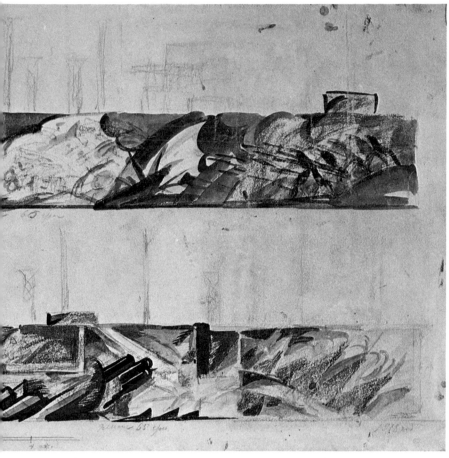

301

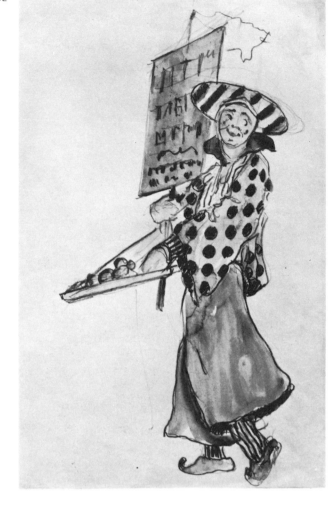

302

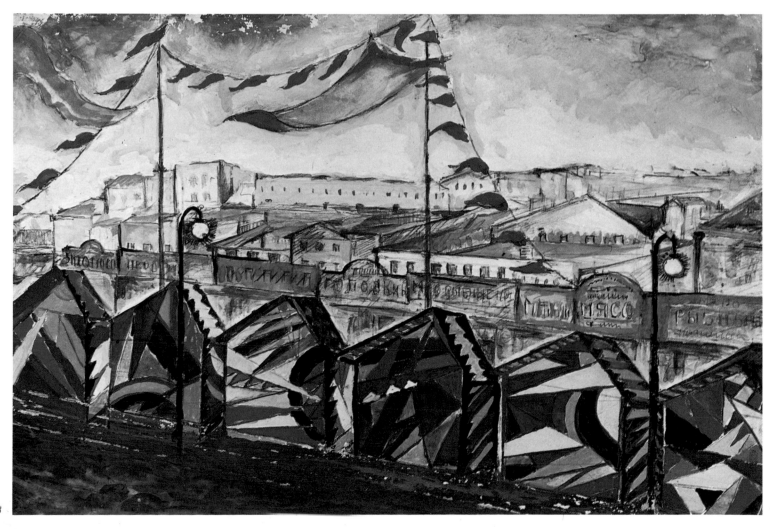

303

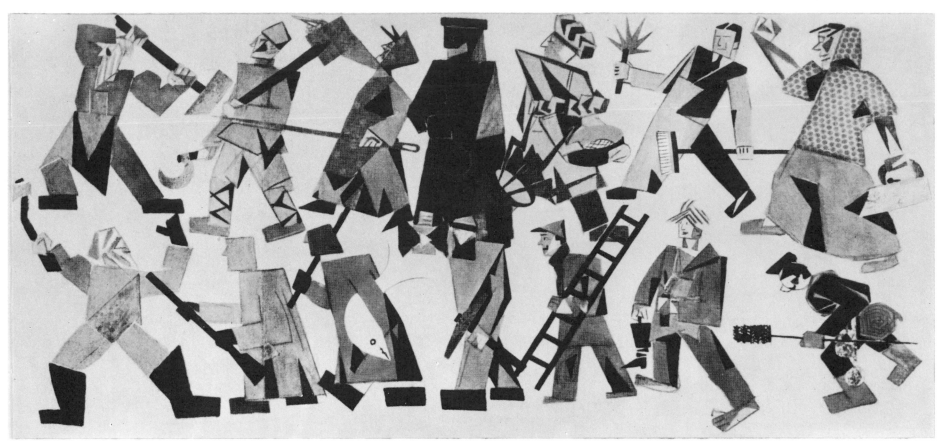

304

We are the architects of earths,

the planets' decorators;

We are the wonder makers.

The sunbeams we shall tie

in radiant brooms, and sweep

the clouds from the sky

with electricity.

We shall make honey-sweet the rivers of the world.

The streets of earth we'll pave with radiant stars . . .

Today these are but doors of theatre properties,

tomorrow their poor stuff

will be replaced by firm realities.

We know that well,

we trust in it

and now we tell

the news to you.

Come to us from the hall!

Come hither one and all.

Come hither, Actor, Poet, Director.

VLADIMIR MAYAKOVSKY.
EXCERPT FROM *MYSTERY-BOUFFE*. 1918

VLADIMIR MAYAKOVSKY

From the setting for *Mystery-Bouffe*. 1919.
Mayakovsky Memorial Museum, Moscow

304 "*The Unclean.*" Costume designs.
Watercolor and appliqué on paper, 74.5 × 165 cm.

305 Decor design. Mixed mediums on paper

305

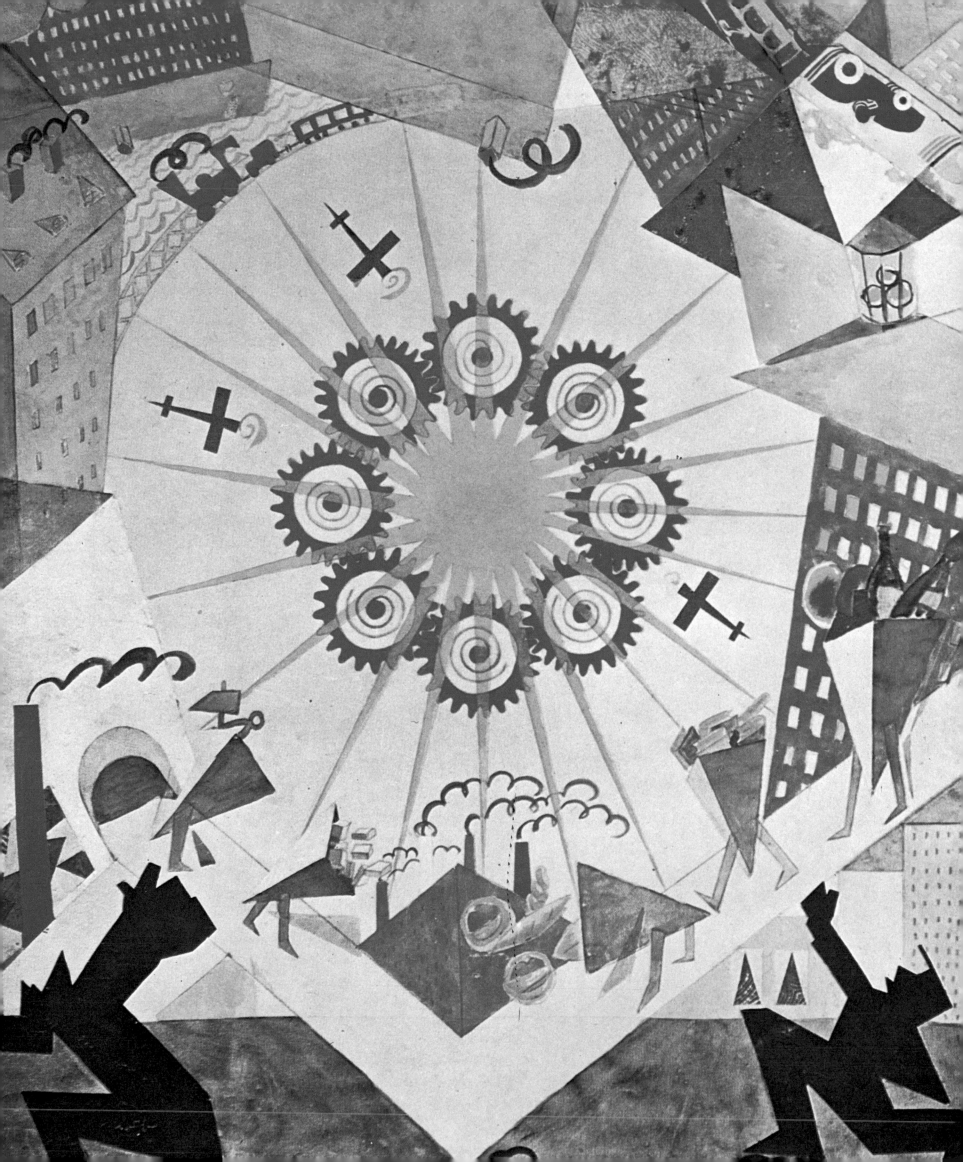

КОММУНАЛЬНЫЙ ТЕАТР МУЗЫКАЛЬНОЙ ДРАМЫ.

7, 8 НОЯБРЯ н/с.

МЫ ПОЭТЫ, ХУДОЖНИКИ, РЕЖИССЕРЫ и АКТЕРЫ ПРАЗДНУЕМ ДЕНЬ ГОДОВЩИНЫ

ОКТЯБРЬСКОЙ РЕВОЛЮЦИИ

Революционным спектаклем.
нами будет дана:

I КАРТ. БЕЛЫЕ и ЧЕРНЫЕ БЕГУТ ОТ КРАСНОГО ПОТОПА.

II КАРТ. КОВЧЕГ. ЧИСТЫЕ ПОДСОВЫВАЮТ НЕЧИСТЫМ ЦАРЯ и РЕСПУБЛИКУ. САМИ УВИДИТЕ ЧТО ИЗ ЭТОГО ПОЛУЧАЕТСЯ.

III КАРТ. АД В КОТОРОМ РАБОЧИЕ САМОГО ВЕЛЬЗЕВУЛА К ЧЕРТЯМ ПОСЛАЛИ

IV КАРТ. РАЙ. КРУПНЫЙ РАЗГОВОР БАТРАКА С МАФУСАИЛОМ.

V КАРТИНА. КОММУНА! СОЛНЕЧНЫЙ ПРАЗДНИК ВЕЩЕЙ и РАБОЧИХ.

РАСКРАШЕНО МАЛЕВИЧЕМ. ПОСТАВЛЕНО МЕЙЕРХОЛЬДОМ и МАЯКОВСКИМ. РАЗЫГРАНО ВОЛЬНЫМИ АКТЕРАМИ.

„!МИСТЕРИЯ БУФФ!"

ГЕРОИЧЕСКОЕ, ЭПИЧЕСКОЕ и САТИРИЧЕСКОЕ ИЗОБРАЖЕНИЕ НАШЕЙ ЭПОХИ, СДЕЛАННОЕ

В. МАЯКОВСКИМ.

Билеты на 7-е и 8-е ноября в распоряжении ЦЕНТРАЛЬНОГО БЮРО.

9-го ноября „МИСТЕРИЯ-БУФФ" открытый спектакль.

НАЧАЛО В 6½ ЧАС. ВЕЧЕРА.

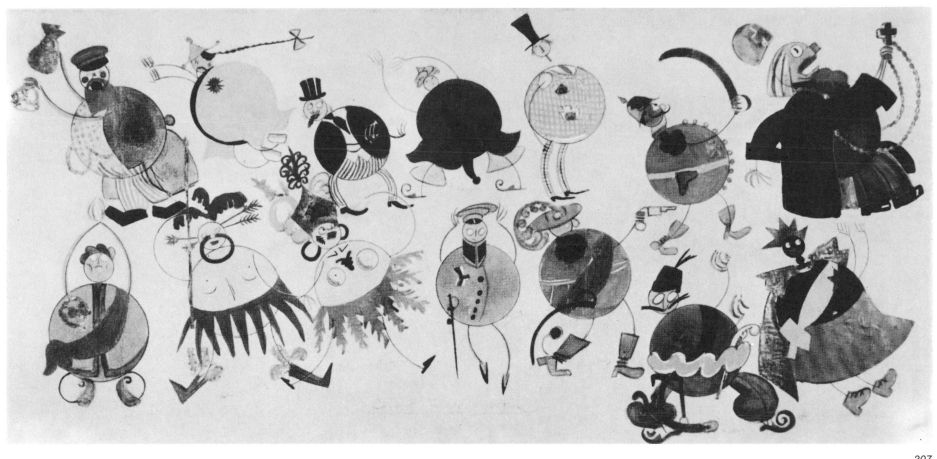

307

VLADIMIR MAYAKOVSKY

From the setting
for *Mystery-Bouffe.* 1919.
Mayakovsky Memorial Museum, Moscow

306 Advertisement
 for the first production

307 *"The Clean."* Costume designs.
 Watercolor and appliqué on paper,
 75 × 166 cm.

NINA EISENBERG

308, 309 *She, Spichkin.* Costume designs
 for the Blue Blouse Theatre. 1923.
 Watercolor on paper.
 Bakhrushin Theatre Museum, Moscow

310

311

312

313

ALEXANDER GOLOVIN

310, 311 Costume designs
for Lermontov's drama *Masquerade.* 1917.
Watercolor on paper.
Bakhrushin Theatre Museum, Moscow

312 Decor design
for Lermontov's drama *Masquerade.* 1917.
Tempera on cardboard.
Bakhrushin Theatre Museum, Moscow

KONSTANTIN YUON

313 Decor design
for Gorky's play *Old Man.* 1919.
Watercolor on paper.
Bakhrushin Theatre Museum, Moscow

FIODOR FIODOROVSKY

314 Decor design
for Bizet's opera *Carmen.* 1922.
Gouache, lead white, and varnish.
Museum of the Bolshoi Theatre, Moscow

314

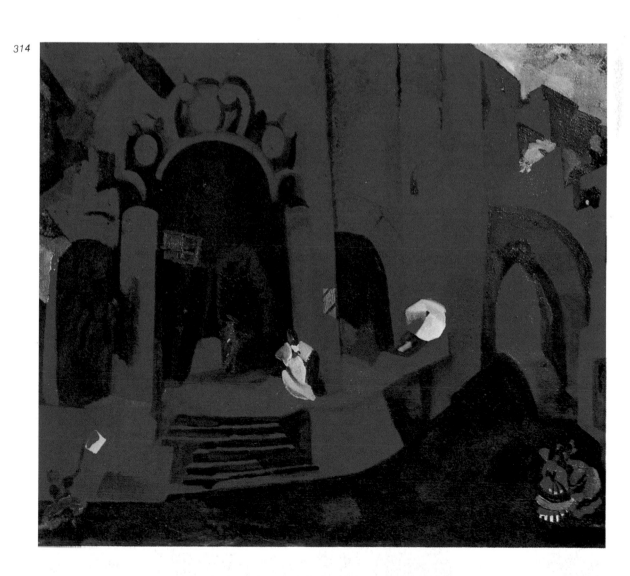

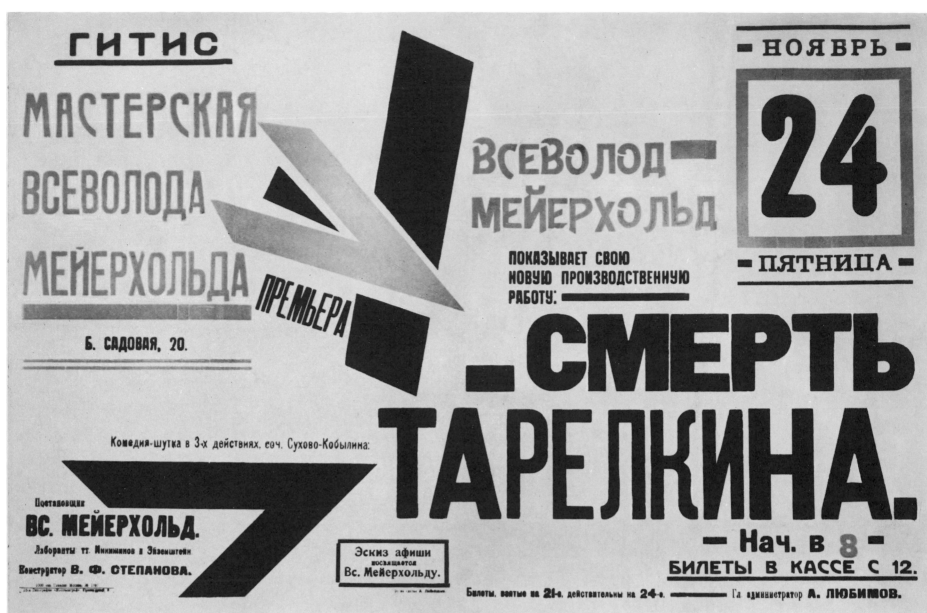

315

ПОЛУТАТАРИНОВ

МАВРУША

VARVARA STEPANOVA

315 Advertisement for the first
 production of Sukhovo-Kobylin's play
 Tarelkin's Death
 in the Meyerhold Theatre. 1922

316, 317 *Polutatarinov, Mavrusha.*
 Costume designs
 for Sukhovo-Kobylin's play
 Tarelkin's Death. 1922.
 India ink on paper.
 Bakhrushin Theatre Museum, Moscow

GEORGY
and VLADIMIR STENBERG

318 Advertisement for the guest
performances of the Moscow
Kamerny Theatre abroad. 1923

GEORGY YAKULOV

319 Decor design for Hoffmann's play
Princess Brambilla. 1920.
Watercolor on paper.
Bakhrushin Theatre Museum, Moscow

ALEXANDER BENOIS

320 Decor design for Stravinsky's ballet
Petrouchka. 1920.
Watercolor on paper.
Museum of the Bolshoi Theatre, Moscow

IGNATY NIVINSKY

321 Decor design for Gozzi's play
Princess Turandot. 1922.
Watercolor on paper.
Bakhrushin Theatre Museum, Moscow

322, 323 Costume designs for Gozzi's play
Princess Turandot. 1922.
Watercolor on paper.
Bakhrushin Theatre Museum, Moscow

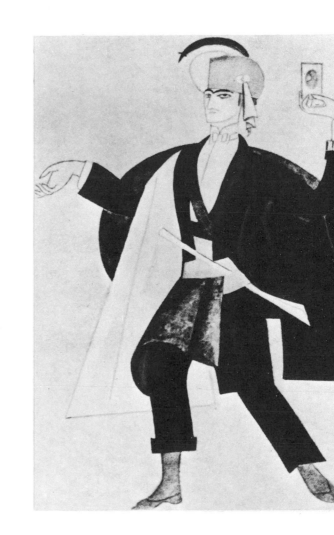

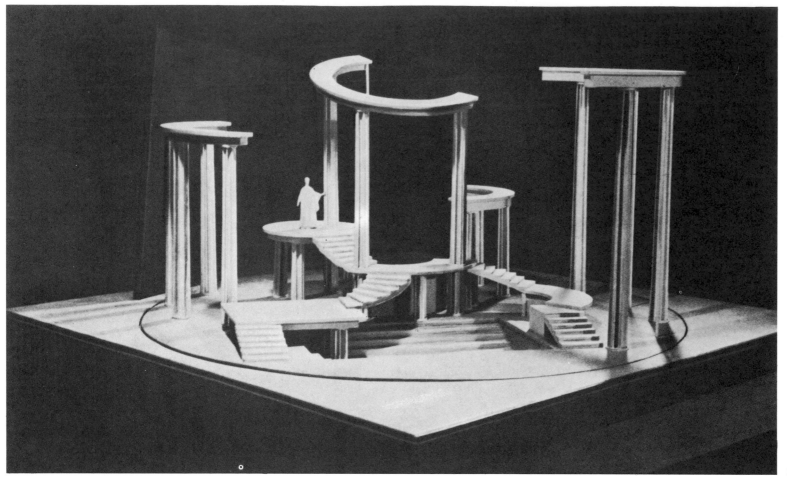

324

ISAAC RABINOVICH

324 Set for Aristophanes' comedy *Lysistrata*. 1923.
Bakhrushin Theatre Museum, Moscow

LIUBOV POPOVA

325 Set for Crommelynck's farce *The Magnanimous Cuckold*. 1922.
Bakhrushin Theatre Museum, Moscow

325

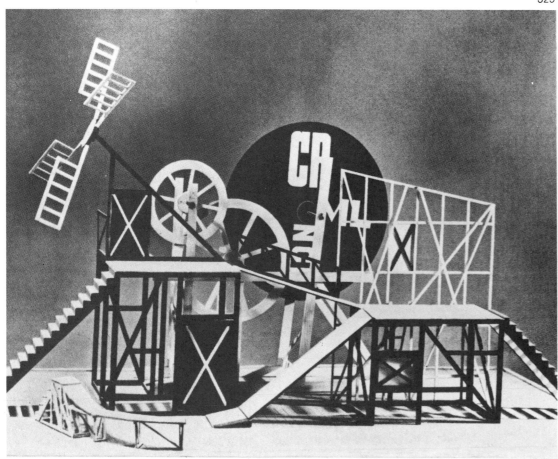

Plays were presented in the great old theatres and in theatres newly born, in large halls and in little clubs, on the steps of palaces and on the streets.

What stage designs made their appearance then! Old-style decorated pavilions as well as extraordinary constructions presaging the buildings of the future or simply embodying the artist's power of fantastic conception.

In discussion what was old was rejected pitilessly, but on the stage it was carefully preserved. Meyerhold, Stanislavsky, Vakhtangov, Tairov, Mayakovsky — hand in hand with these names, with the new theatre productions, a new theatre artist was being born too. Figurative art in this context became a live spectacle, an integral part of theatre for the people.

ALEXANDER VESNIN

326, 327 Costume designs for Claudel's play
L'Annonce faite à Marie. 1920.
Watercolor, gouache,
and bronzing on paper.
Bakhrushin Theatre Museum, Moscow

326

327

328

329

ALEXANDRA EXTER

328, 329 Costume designs for Shakespeare's tragedy
Romeo and Juliet. 1921.
Gouache and lead white on cardboard.
Bakhrushin Theatre Museum, Moscow

To the deepest recesses of Russia, where there were neither museums nor galleries, to the revolutionary fighting lines of the Civil War sped rolling stock never seen before – the agit-prop trains.

On the still smoldering field of battle, in an out-of-the-way siding, in remote provincial towns, a train of this sort would become the rostrum, the focal point for passionate, feverish political discussions.

330

331

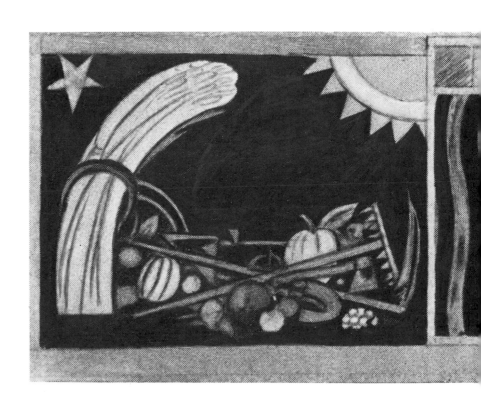

The audacious and brilliant decoration of the cars, uniting the directness and clarity of the poster with the gaiety of the painted panel, helped people to appreciate art, through art to love their country, to understand the Revolution, through art to hate their enemies.

The winds blowing across those distant tracks and the passage of time did not spare the cars' fragile decoration, "monumental propaganda on wheels" has come down to us only in a few sketches and photographs. But even what one still can see on the pages of old books is a happy memory: the evidence of the heroic fate of the agit-prop trains.

332

333

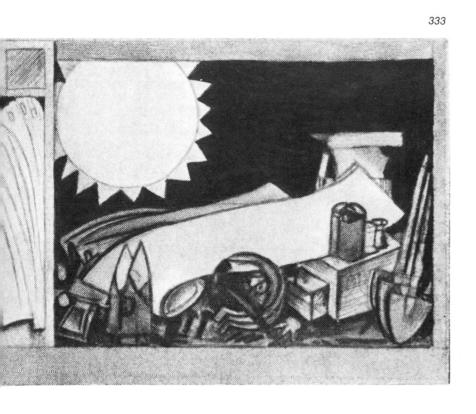

VASILY YERMILOV

330–33 Details of the painting of the agit-prop train "The Red Ukraine." 1921

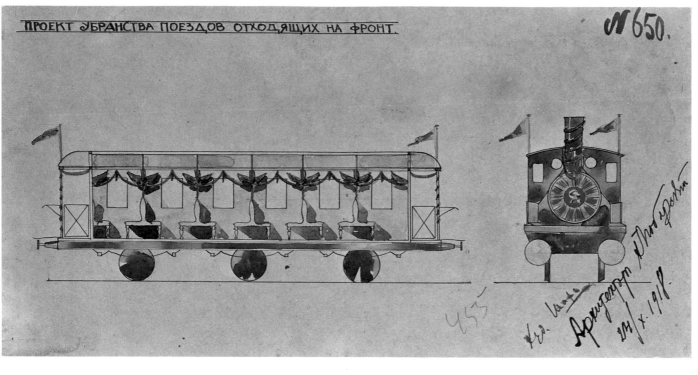

ПРОЕКТ УБРАНСТВА ПОЕЗДОВ ОТХОДЯЩИХ НА ФРОНТ.

B. SHAKH and GRIGORY LIUBARSKY

334 Design for the decoration of trains leaving for the front. 1918.
Watercolor, India ink, and pen on paper, 24 × 41.1 cm.
The Russian Museum, Leningrad

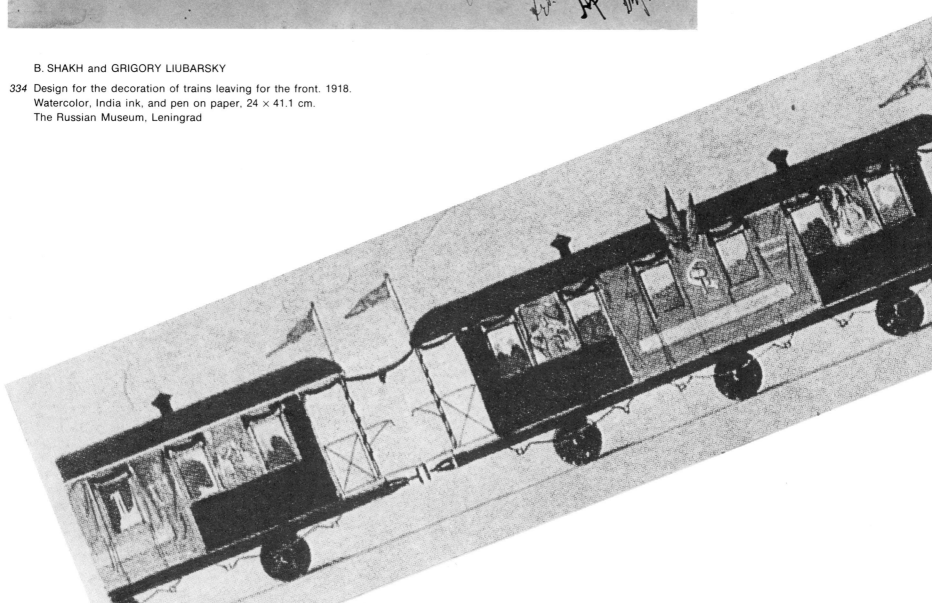

336 Car of an agit-prop train. 1918–19. Photograph

337 Banner of the agit-prop train "The Red Cossack." 1920. Photograph

B. SHAKH and GRIGORY LIUBARSKY

335 Design for the decoration of trains leaving for the front. 1918.
Gouache, India ink, and pen on cardboard, 26.5 × 75 cm.
Museum of the Great October Socialist Revolution, Leningrad

335

337

336

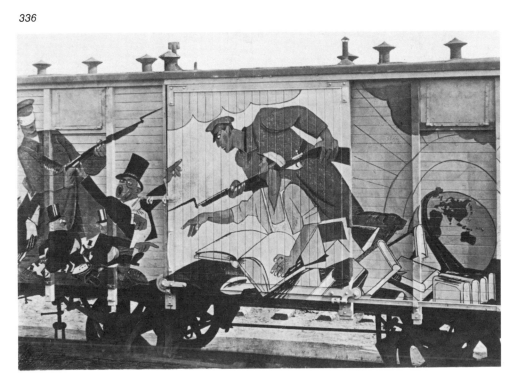

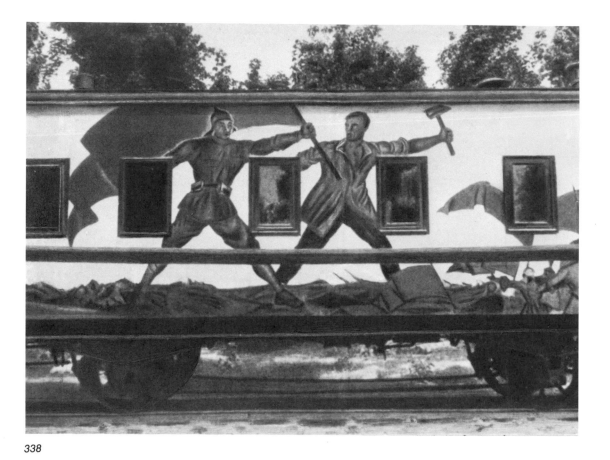

338

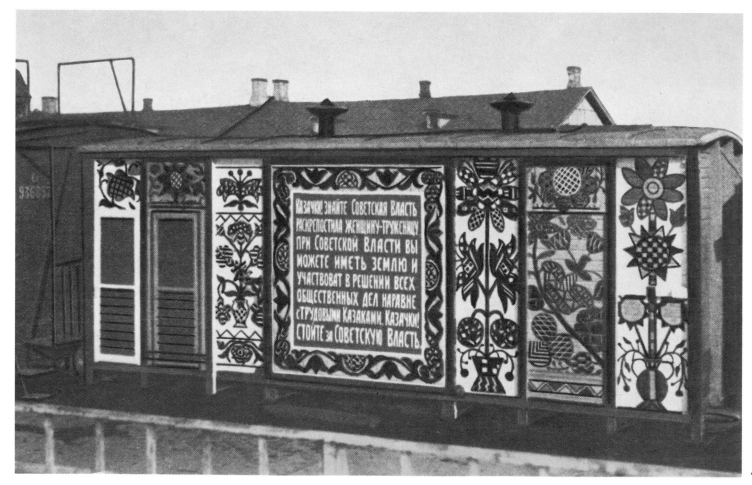

339

338 Car of the agit-prop train
"The October Revolution." 1919. Photograph

339 Car of the agit-prop train
"The Red Cossack." 1920. Photograph

340 Poster design for an agit-prop train.
The Tretyakov Gallery, Moscow

340

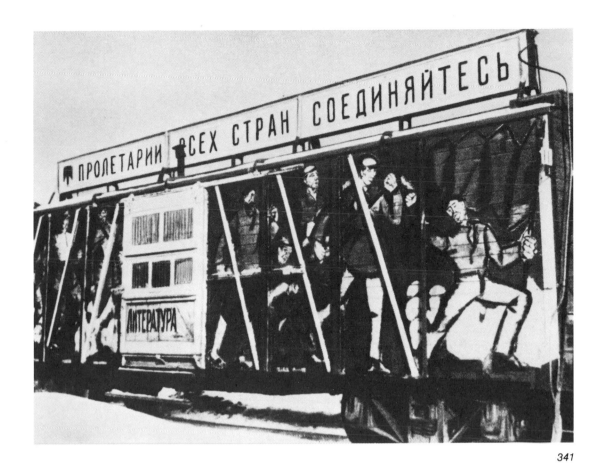

341 Car of an agit-prop train. 1918. Photograph

IVAN MALIUTIN

342 Model of an agit-prop train car. 1919.
 Bakhrushin Theatre Museum, Moscow

341

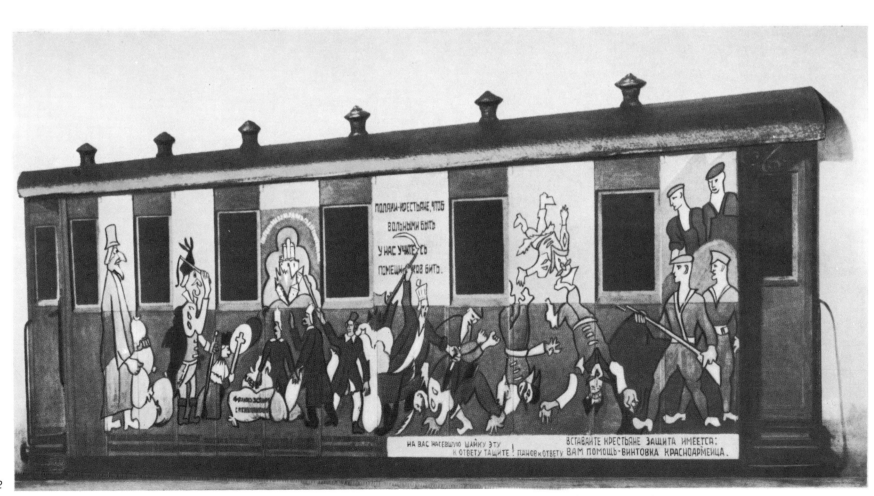

342

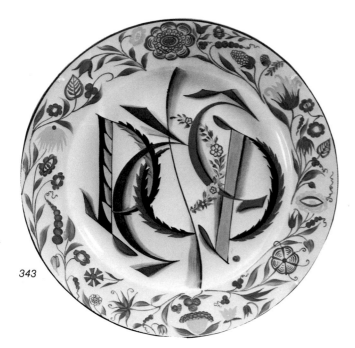

343

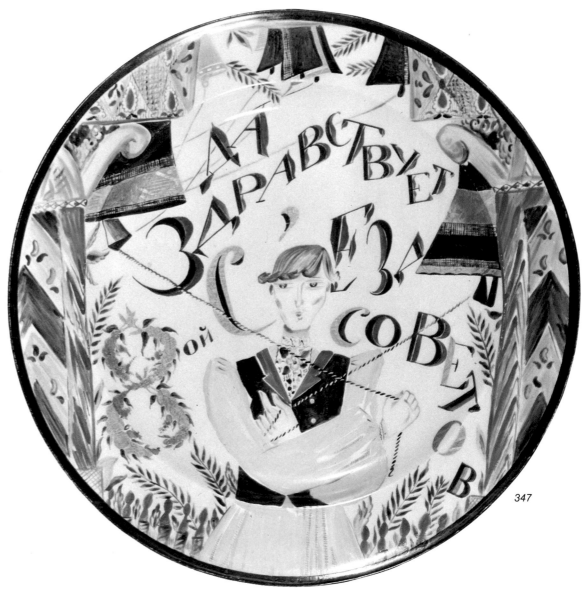

347

344

345

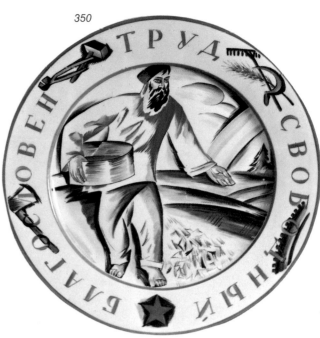

350

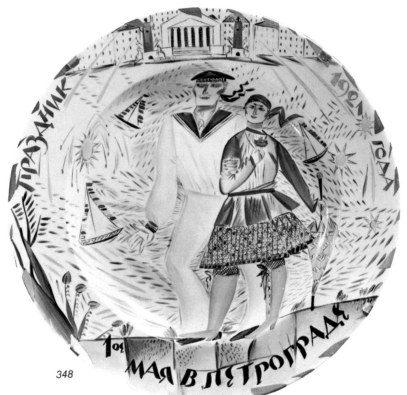

348

346

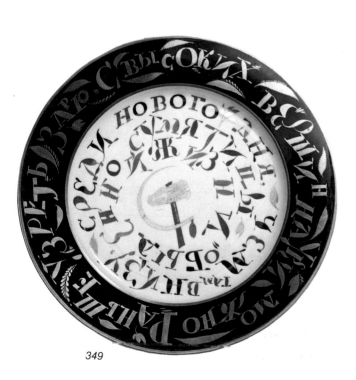

349

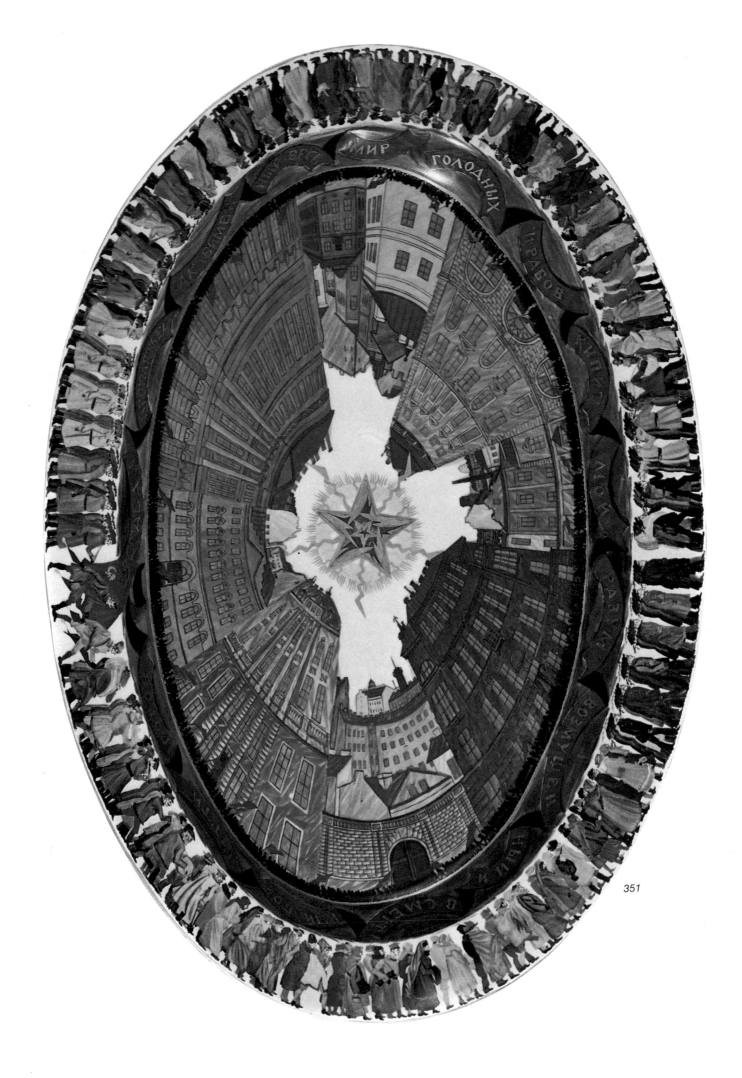

MARIA LEBEDEVA

351 Dish with the text of the "Internationale." 1920

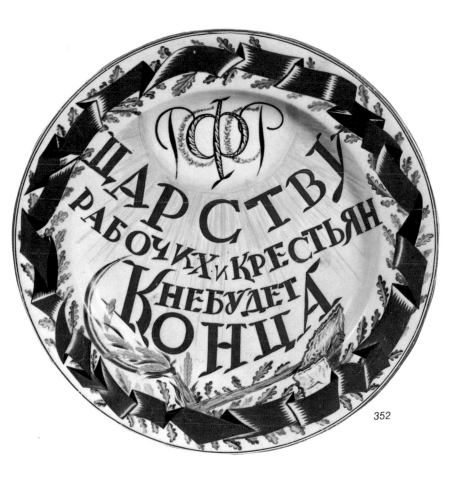

352

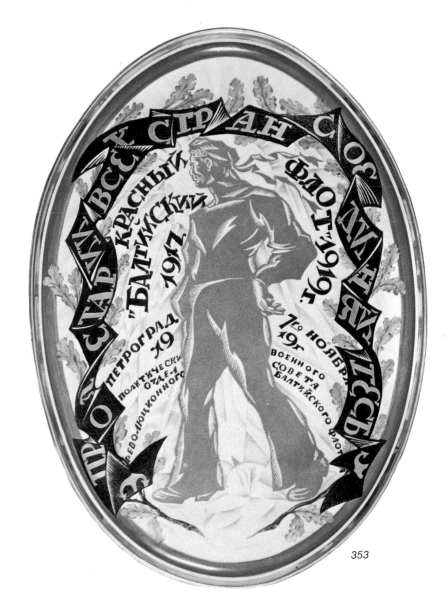

353

The Revolution rejected luxury. The decoration of china stopped being mere embellishment and, while remaining an art, became an art quite different from that of former times — a symbolic art closely related to that of the poster.

Porcelain was painted elegantly and concisely. The themes of the new world were introduced vigorously and unerringly into the gentle conventions that had formed over the centuries. Sumptuousness and profusion of forms passed away. Porcelain began to speak in the language of ornament, of allegory, with the expressiveness of a spare drawing, with the sonorous chords of restrained color. Artists would include in their designs the texts of slogans; not for nothing was the porcelain of that time called propaganda porcelain.

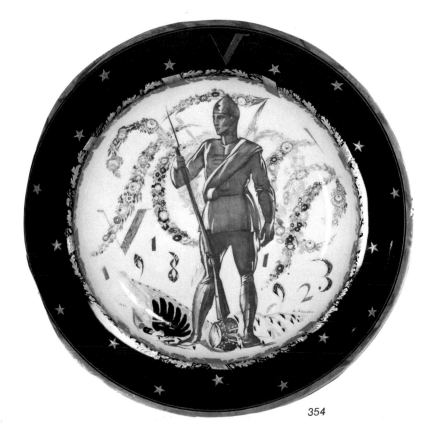

354

SERGEI CHEKHONIN

352 Plate with the inscription
"The reign of workers and peasants will never end." 1920

353 "The Red Baltic Fleet." Dish. 1920

MIKHAIL ADAMOVICH

354 "Five Years of the Red Army." Plate. 1923

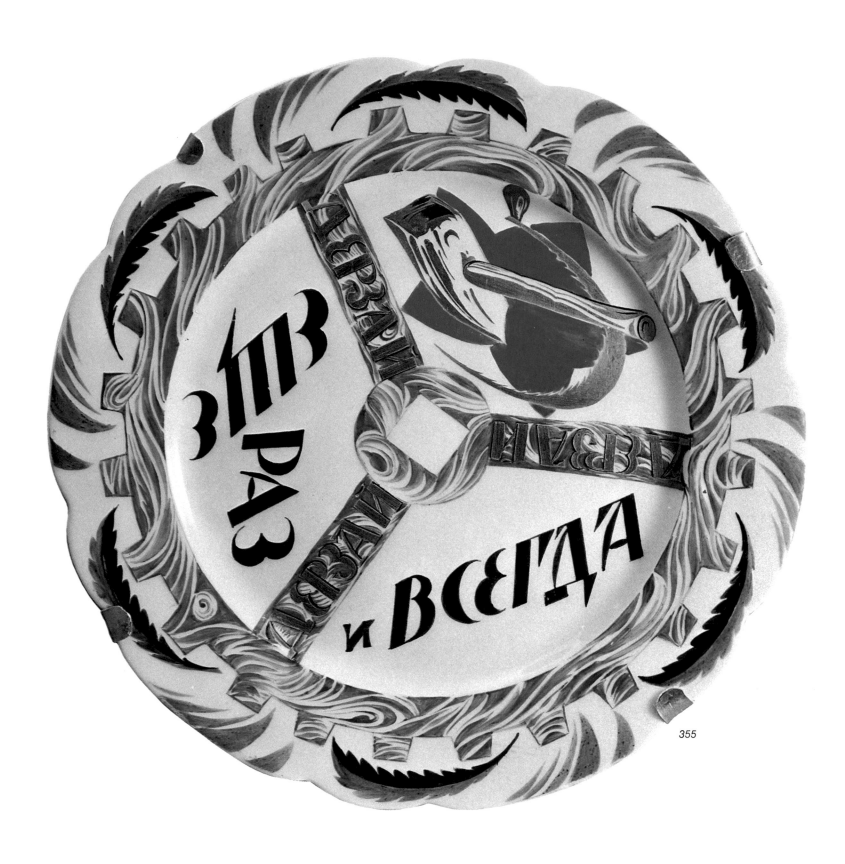

355

RUDOLF VILDE

355 Plate with the inscription
"Be daring now and forever." 1921

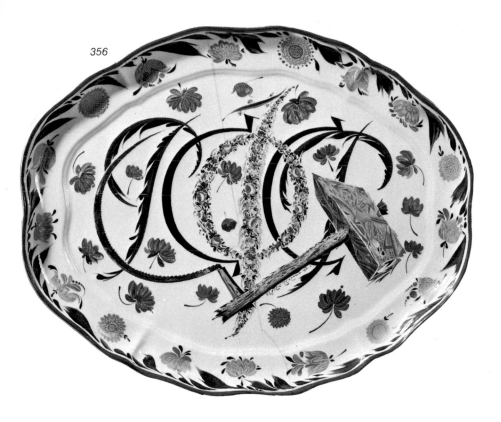

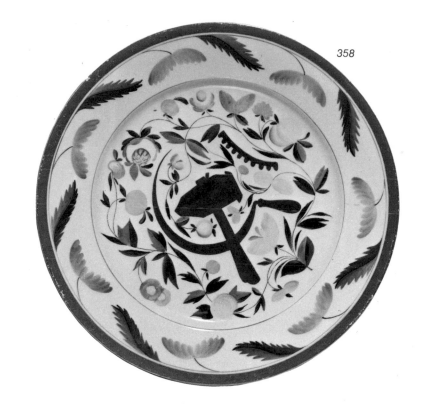

SERGEI CHEKHONIN

356 Plate with the emblem of the RSFSR. 1921

357 "Coral Ribbon." Plate. 1919

358 Plate with the Hammer and Sickle set in flowers and fruit. 1919

BAZILKA RADONIČ

359 "The New Government." Plate. 1921

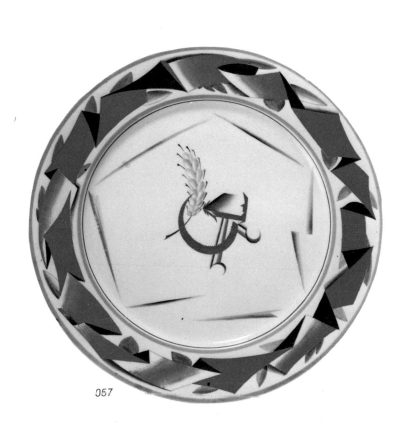

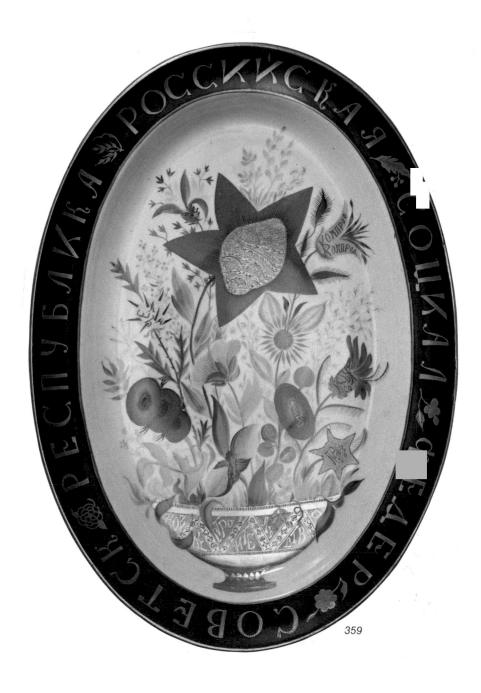

360

Stamps of the RSFSR

360 The Liberated Proletarian. 1921

361 Hand with sword severing the chain. 1918
Stamp from Soviet Russia's first stamp issue

362 The Fifth Anniversary of the October Revolution. 1922

Stamps of the USSR

363–65 The First Agricultural and Domestic Industry Exhibition of the USSR. 1923

361

362

363

364

365

366

367

368

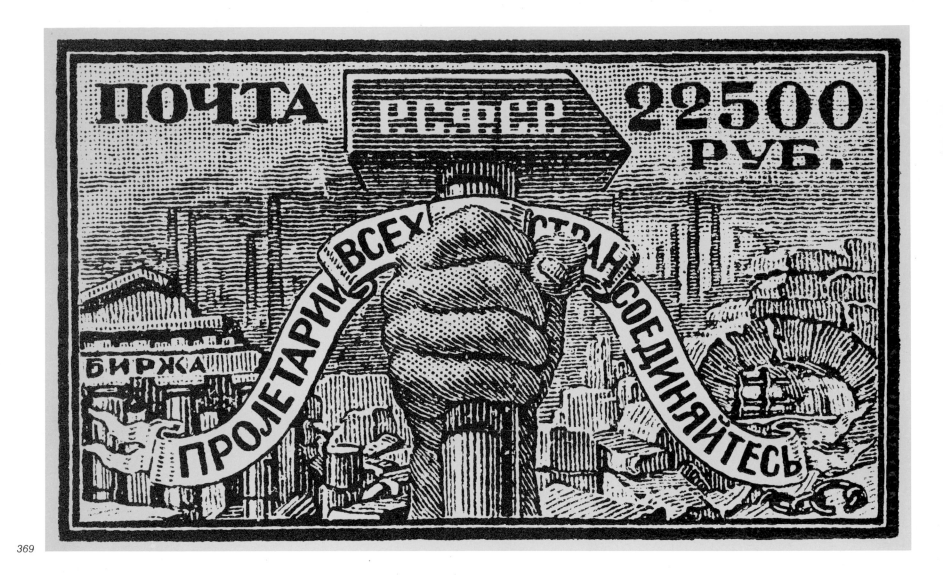

369

370

371

373

Sculpture, which was not intended for the streets and squares, was, like painting, slowly and intently looking upon its environment – that is to say, at man.

A sculptor has no other subject. Among the busts that appeared were those that suggested the spirit of the age: the spirit of men of a revolutionary epoch. Sculptors searched unremittingly for a plastic language, spare but passionate, a language both consonant with the times and capable of outliving them. In years of great change art has the gift of standing above the hurly-burly and achieving an ascetic clarity.

IVAN SHADR

372 *Sower*. 1922. Bronze, 110 × 150 × 65 cm.
The Tretyakov Gallery, Moscow

373 *Soldier*. 1922. Bronze, 92 × 60 × 62 cm.
The Tretyakov Gallery, Moscow

374 *Worker*. 1922. Bronze, 75 × 68 × 59 cm.
The Tretyakov Gallery, Moscow

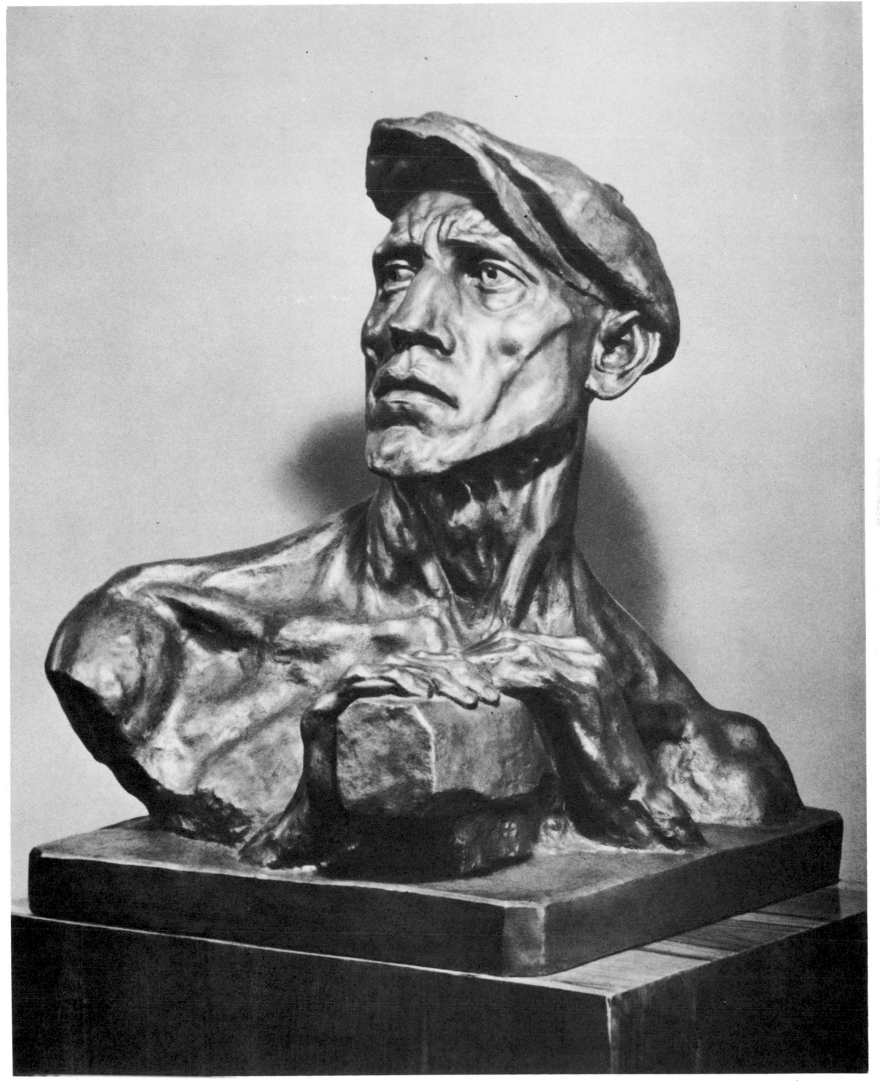

375

NATHAN ALTMAN

375 *Lunacharsky*. 1920. Bas-relief.
Gypsum coated with bronze, 63.2 × 46 cm.
The USSR Museum of the Revolution, Moscow

376

NATHAN ALTMAN

376 *Khalturin*. 1920. Bas-relief.
Gypsum coated with bronze, 61 × 46 cm.
Lenin's study in the Moscow Kremlin, Moscow

Stepan Khalturin (1856–1882) was a worker, revolutionary,
and organizer of the Northern Union of Russian Workers.

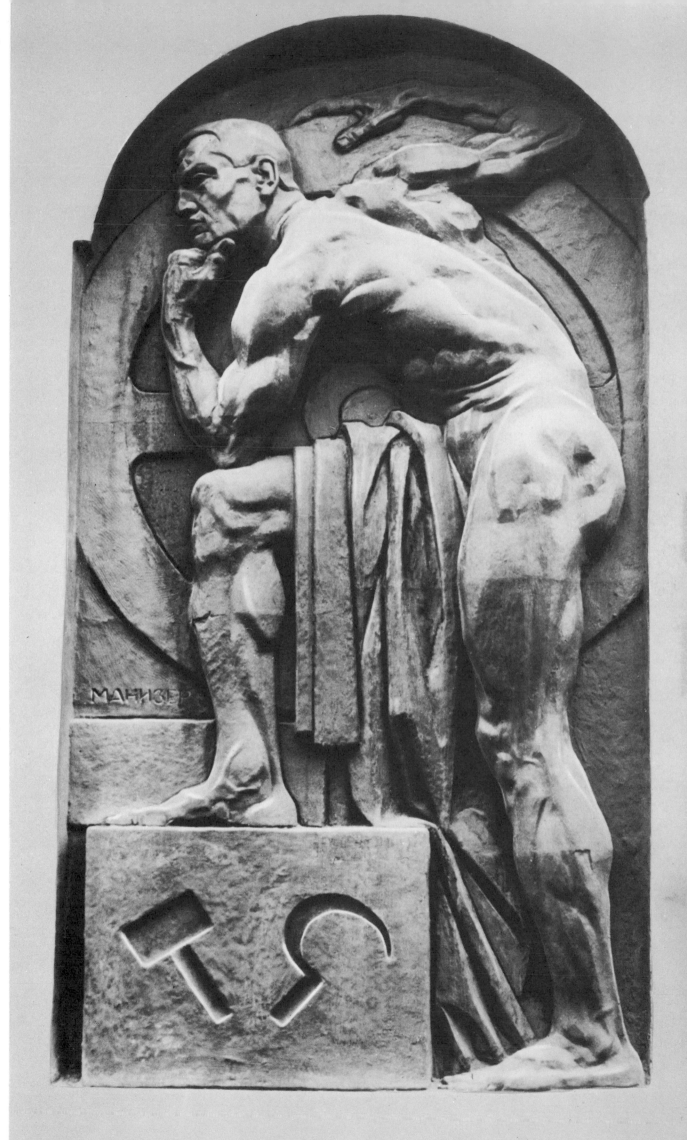

MATVEI MANIZER

377 Worker. 1920. Bronze

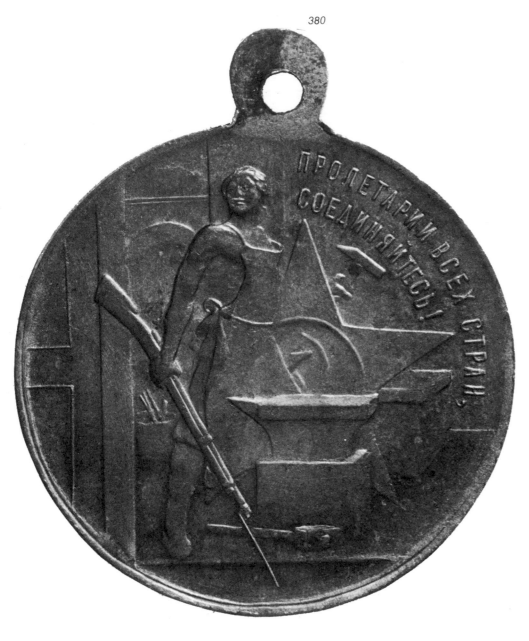

380

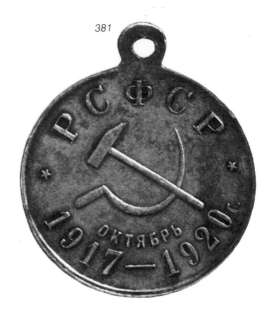

381

378

379

UNKNOWN ARTIST

378 Commemorative medal marking Karl Marx's Centenary
and the First Anniversary of the October Revolution. 1918

379 Commemorative medal marking the First Anniversary of
the October Revolution. 1918

ANTON VASIUTINSKY

380, 381 Commemorative medal marking the Third Anniversary of
the October Revolution (obverse and reverse). 1920

382 "Lenin's Last Hide-out near Sestroretsk Station. July 17, 1917."
Plaquette. 1925

382

383

DANIIL STEPANOV

383, 384 Commemorative medal marking the Second Anniversary
of the October Revolution (obverse and reverse). 1919

384

INDEX OF ARTISTS' NAMES AND WORKS REPRODUCED

LIST OF CREDITS

The Publishers wish to thank
the following museums
and galleries for permitting
the reproduction of works in
their collections:

THE CENTRAL LENIN MUSEUM, MOSCOW

THE USSR MUSEUM OF THE REVOLUTION,
MOSCOW

MUSEUM OF THE GREAT OCTOBER
SOCIALIST REVOLUTION, LENINGRAD

THE TRETYAKOV GALLERY, MOSCOW

THE RUSSIAN MUSEUM, LENINGRAD

BAKHRUSHIN THEATRE MUSEUM, MOSCOW

MAYAKOVSKY MEMORIAL MUSEUM, MOSCOW

SHCHUSEV MUSEUM OF ARCHITECTURE
AND ARCHITECTURAL RESEARCH, MOSCOW

MUSEUM OF THE HISTORY OF LENINGRAD

MUSEUM OF THE LOMONOSOV PORCELAIN
WORKS, LENINGRAD

MUSEUM OF FINE AND APPLIED ARTS, SMOLENSK

ART MUSEUM, GORKY

ART MUSEUM OF THE UZBEK SSR, TASHKENT

ART GALLERY OF ARMENIA, YEREVAN

MUSEUM OF THE BOLSHOI THEATRE, MOSCOW

SHEVCHENKO ART GALLERY, ALMA-ATA

HISTORY AND ARCHITECTURE MUSEUM, PSKOV

MUSEUM OF THE USSR ARMED FORCES, MOSCOW

BRODSKY MEMORIAL MUSEUM, LENINGRAD

Издательство «Аврора», Ленинград, 1978
Изд. № 3177

Printed and bound in Finland

И $\frac{80103\text{-}190}{023(01)\text{-}78}$ без объявления

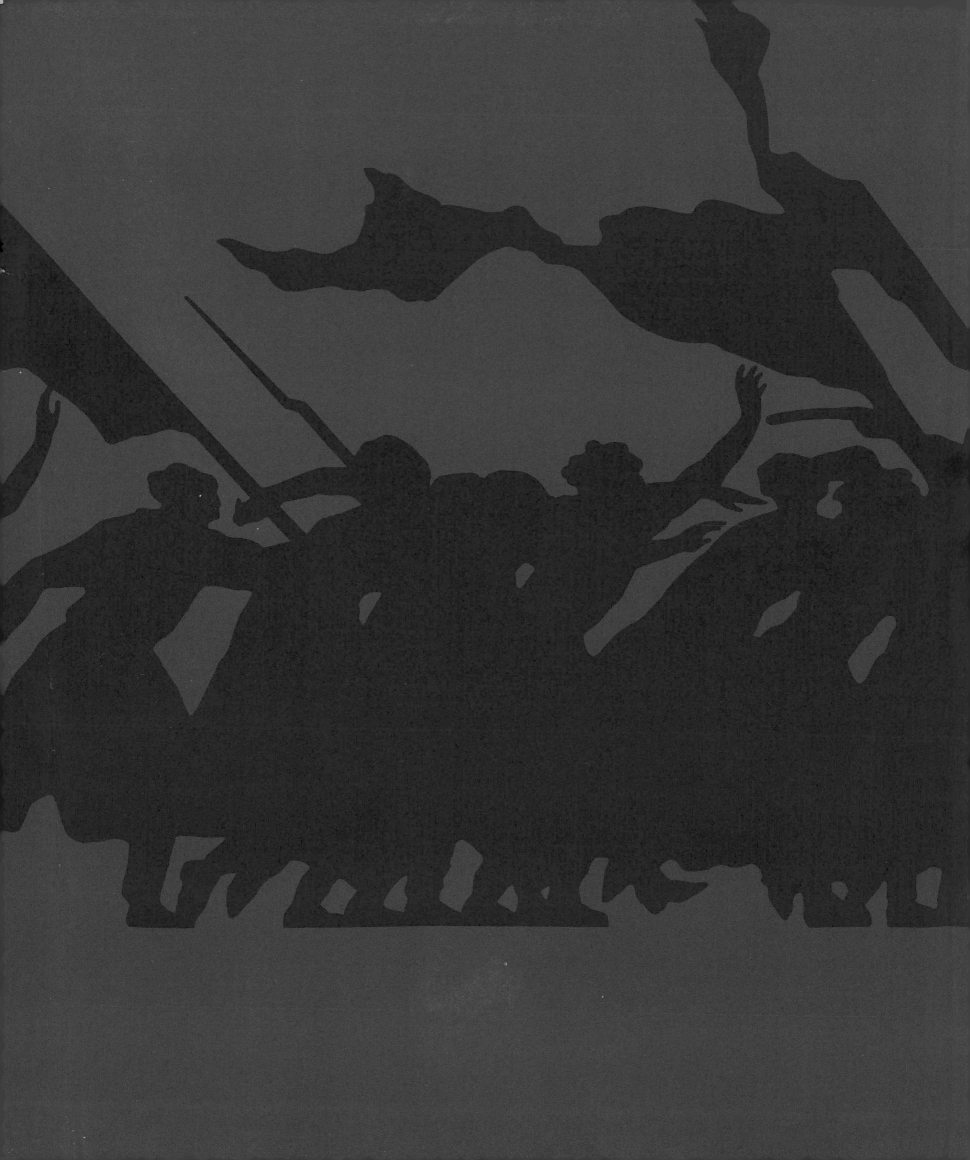